# GIFT *of* WINGS

CARL E. HIEBERT

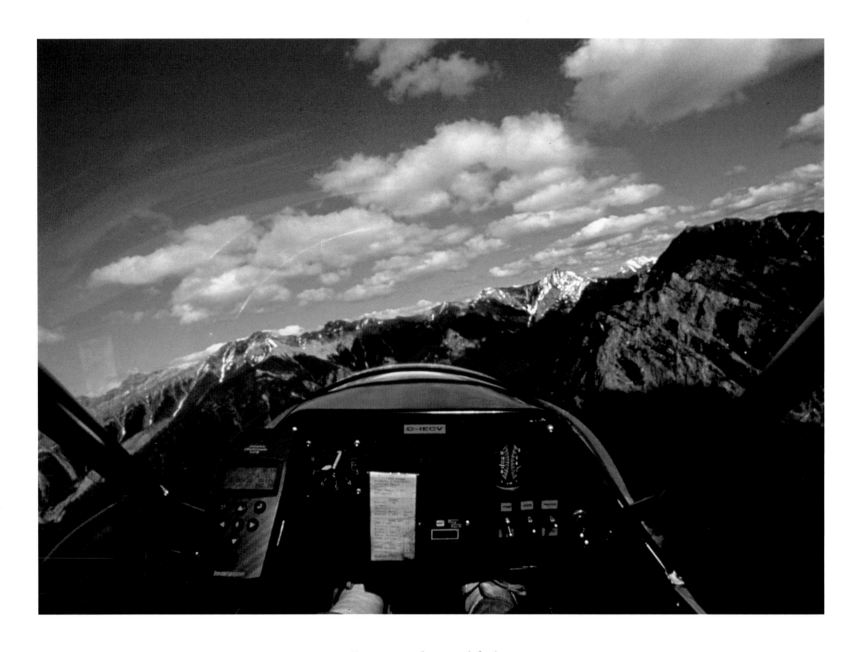

*To my mother and father*
*and thousands of other kindred pioneering spirits who came to*
*this country as children, hopeful with dreams.*
*Their lives were enriched by what*
*this country gave them.*

*An*
AERIAL CELEBRATION
*of* CANADA

# GIFT *of* WINGS

## CARL E. HIEBERT

# A BOSTON MILLS PRESS BOOK

Canadian Cataloguing in Publication Data

Hiebert, Carl, 1947–
Gift of wings : an aerial celebration of Canada

ISBN 1-55046-129-X

1. Hiebert, Carl, 1947–  . 2. Canada – Aerial
photographs. 3. Aerial photography – Canada.
4. Photographers – Canada – Biography. 5. Air
pilots – Canada – Biography. 6. Paraplegics –
Canada – Biography. I. Title.

FC59.H54 1995    779'.99710647'092    C95-930571-8
F1017.H54 1995

The publisher gratefully acknowledges the support of
the Canada Council, Ontario Arts Council, and Ontario
Publishing Centre in the development of writing and
publishing in Canada.

The photographs in this book have not been
mechanically or electronically altered in any way.

Photographs:

Front Cover: Marie-Ville, Quebec
Page 6: Point Pelee, Ontario
Page 10: Birtle, Manitoba

Photo Credits:

Page  7: Mirko Petricevic
Page 12: Mike Whitman
Page 19: Alan Ralston
Page 20: Richard Reny
Page 22: Mirko Petricevic
Page 30: (Painting) Lance Russwurm
Page 32: Al Neufeld

Grateful acknowledgment is made for permission to quote
excerpts from the lyrics from "The Pits" by Buddy
Wasisname and the Other Fellers. Copyright ©1992 Third
Wave Productions. Used by permission.

First published in 1995 by
The Boston Mills Press
132 Main Street
Erin, Ontario
N0B 1T0
(519) 833-2407   fax: (519) 833-2195

An affiliate of
Stoddart Publishing Co. Limited
34 Lesmill Road
North York, Ontario
M3B 2T6

Typesetting and design by
Sue Breen and Chris McCorkindale
McCorkindale Advertising & Design

Printed in Canada

# FOREWORD

have loved flying all my life. No airplanes flew overhead when I was a child, but I knew they existed, and watching gulls in flight made my insides ache with wordless longing. As a teenaged reporter on the *Brantford Expostitor* in the early 1940s, it was my job to cover the Royal Canadian Air Force base on the outskirts of town, where bomber pilots were trained, many of whom were killed only months later in the night skies over Germany. As soon as the war ended I went to the nearest flying field—the site is now home to a Toronto shopping mall—and enrolled for flying lessons. By the end of that summer I was a licensed pilot, doing blissful loops high above harvest fields.

Now in my seventies, I am flying a glider, but I still find it difficult to explain what draws a person to the skies. For most pilots, I think, flying touches some inchoate spiritual need. I have a sense of euphoric well-being when I fly, and I suspect that the same private ecstasy rises in the hearts of all pilots. Humans are shattered beings, but pilots heal themselves in the sky. Flying is an impudent act, a metaphor for freedom.

This phenomenon of liberation is nowhere more evident than in the extraordinary achievements of Carl Hiebert. Carl is a Mennonite, raised by pious people from whom he derived a nature that is both stout-hearted and mystic. He was a young, adventurous man when he broke his back leaping into space in a hang-glider. Now he finds solace for his paralysis by soaring in an airy unlikely-looking aircraft known as an ultralight. Though he can't walk, a quirk of his paraplegia permits him enough movement in his legs to push the rudder pedals.

He parks his wheelchair beside the runway and regains his sense of physical wholeness in the air. The pleasure of this transformation shapes his delight in what he sees below him, a countryside of lakes and mountains so beautiful that he was compelled to take along his cameras and photograph it for the earth-bound as an act of love and collegiality. From that sprang a decision to photograph the whole country, a daft plan if there ever was one.

But he has done it. Twice. Carl Hiebert has crossed Canada in his charming ultralight, taking pictures along the way and writing about his journey with a poet's voice. The photographs in this book are stunning reminders to Canadians that what unites us all is love of our land. In a time of turmoil for Canada, Carl Hiebert offers a peaceful, restorative vision of our nation, and of ourselves.

June Callwood

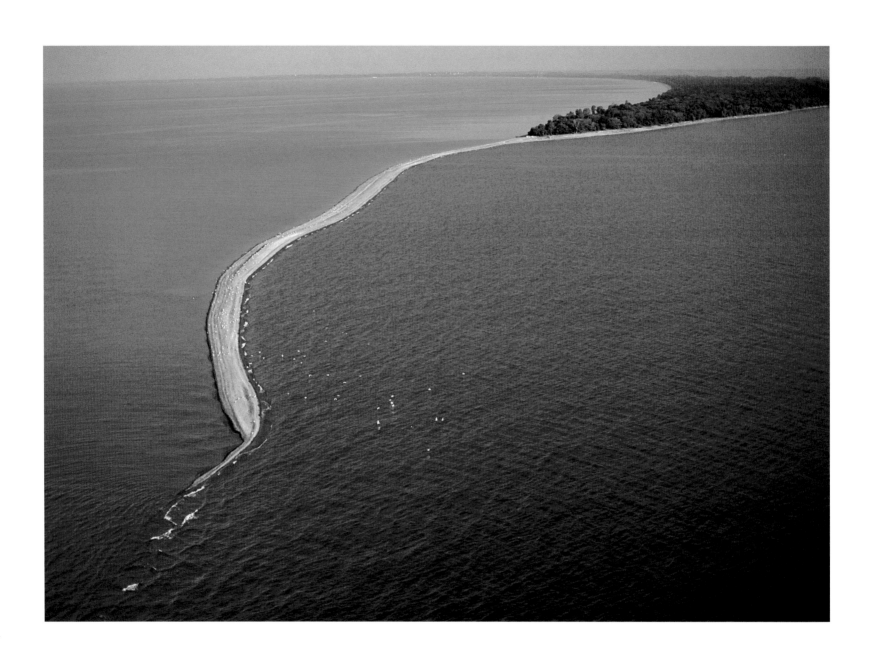

# PREFACE

*Ah, but a man's reach should exceed his grasp. Or what's a heaven for?*

Robert Browning

"You have to be crazy," Alex replied. "You can't fly an ultralight across Canada."

But why couldn't I fly an ultralight across Canada? Just because no one had done it before was not a good enough reason not to try. Was I crazy? With some persuasion, I could be convinced that ultralights weren't exactly designed for 5,000-mile cross-country flights. The machine I was flying at that time was so light I could actually lift it off the ground and take off and land on my feet. With only a 15-horsepower engine, it was quite easy to fly backward on a windy day, and I once did so for three miles. As ultralight pilots, we were a fledgling breed of aviators, and it was not uncommon for the media to present us as thrill-seeking daredevils in our "motorized lawn chairs."

Somehow, through five years of craziness and tragedy, the dream survived, and on August 28, 1986, the floats of my ultralight splashed down in the Pacific Ocean after a 58-day flight across Canada. During the summers of 1993 and 1994, I completed a second cross-Canada flight.

This book is the story of those two journeys. It is also a celebration of Canada—its landscapes, people, and the stuff dreams are made of. The inspiration for this book came from two sources: the encouragement I received to share my personal story, and my passion to celebrate Canada through aerial photography.

I am a proud Canadian and feel blessed to live in a country that is immeasurably rich in its resources and its people, its institutions and its achievements. Time and time again during my flight, I was amazed by the variety and magnificence of our land. Between our Atlantic and Pacific coasts lies some of the most colourful geography found anywhere in the world. It is time to admire that treasure.

To fly and photograph this land has been a privilege for me. As a child, I was told that God lived in the heavens. That made perfect sense to me because it meant the Creator had the best seat in the house. It is impossible to ever tire of viewing our planet from aloft. Even with 2,000 hours of ultralight air time, I still regularly experience flights after which I find myself saying, "This has been the perfect flight." The world moves toward perfection when viewed from the sky. Georg Gerster, the master of aerial photography, probably said it best: "Seen from above, the world appears as fresh and unsullied as in Genesis." Everything seems more purposeful and integrated into a design much grander than one can imagine on the ground. It is visual poetry.

Although this book is a collection of aerial photographs, it will not take you on a comprehensive bird's-eye tour of Canada's most popular sites, such as Lake Louise or Niagara Falls. Stunning places they are, but they have been photographed many times before and are central to most pictorial books of Canada. My intent was to discover some of the more intimate and unusual views this country has to offer. Where I have photographed the expected, I have tried to do so with a fresh perspective. Many of these photographs appear to be abstract art. A few are included not because of their inherent artistic merit, but because of the

unusual statement they make about who we are as Canadians. The photographs are as diverse as the land itself.

Editing 14,000 images down to the 141 found in this book seemed an impossible task, but as you view this selection, I hope you will share at least part of the absolute joy I experienced while taking them.

The photographs are not grouped by province, for political boundaries do not exist to a pilot. Rather, the land is a seamless tapestry and is seen geographically, from the Maritimes to Central Canada, the Prairies, and finally the Rocky Mountains. I have included some of my journal notes, taken from my second cross-Canada flight, to give you a sense of how these photographs came to be. The book also contains part of my personal journey, a brief autobiography. It explores some of what I have learned these last few years. Perhaps, in these reflections, you will find a small nugget, an unusual coloured stone worth putting in your pocket. If that happens, this book will have served its purpose.

Writing this story was a surprisingly difficult process. I realized that in many ways my story is not unique. Perhaps it contains more drama than some, but mostly it is quite common. Virtually all of us have experienced both tragedy and triumph. We have all collected red ribbons, and in other races we've been last. Life is often bittersweet.

Sometimes I think the real stories that need to be told are of the unsung heroes. The young girl who unexplainably develops a brain tumour but still doggedly fights to be the best she can be, given her limitations. The parents who dedicate their lives to support her. The single mother with three children who goes back to college and enters the work world with a rejuvenated ability to support her family. The CEO whose 27-year career ends with a corporate merger and who now works part-time driving a taxi. These are the proclamations of quiet determination, the wellsprings of the incorrigible human spirit of real people I have met on my travels. They are not found in news story headlines, but they live in every neighbourhood.

The adventures I've experienced are the world's adventures. Your discoveries may have nothing to do with airplanes, but they will be just as significant, just as meaningful. We each walk a path that is uniquely ours. The capacity to dream, to risk and to live fully lies within each of us.

Welcome to my personal perspective of life and of this country. I hope you will enjoy the view.

# ACKNOWLEDGMENTS

It is amazing. A completed book in your hands offers almost no indication of what preceded its birth. This project has been three years in the making, and my journal notes contain several pages of names—the people whose generous support made it possible. Only some are listed here, but I am truly grateful to all of you. Each of you contributed to the project's success. My thanks to...

My persevering ground crew, Tom and Mary, who hung in there through those grey-sky days. To Mirko, Sharon, Hank and Janet, for your additional support.

My editorial friends: Cathy, Gerry, Johny, Ardythe, Lee, and Reva. This book would have many blank pages if it were not for your encouragement and many welcomed suggestions.

Cathy, for your keen assistance in rewriting captions.

The aviation community, especially Chuck Keuthan, Kodiak Research, Air Canada.

Many helpful hands along the way—Ron Dennis, Paul and Rudy, Paul Cassel, John Bradley, Luc Bouchard, Aviation Career Academy, Wayne Grims, Ian Coristine, Bob Agombar, Brian Jose, Dave Loveman, Fred Glasbergen, Arnie Lepp, Dale Porter, and all those who generously donated overnight hanger space.

Understanding and helpful air traffic controllers.

The Corley family of DSC labs, for your enthusiastic support and for processing my film. And to Romana, for your darkroom magic.

Air Canada, for your help in shuttling me around Canada for the book's promotion.

Canon Canada, for your equipment sponsorship and technical support.

Provincial Ministry of Tourism personnel, and the many others who responded to my research questions about these photos.

Sue and Chris, book designers second to none— you were a delight to work with.

John Denison, Boston Mills Press, and Stoddart Publishing, for grabbing the vision and coming on board.

Noel Hudson—a more easy-going editor would be hard to find.

To Bill Mactaggart of Midland Walwyn, for welcomed financial assistance.

The "Investors"—16 Rotarians who dug deep into their pockets to provide the critical seed money for this project: G. Jocius, B. Mactaggart, C. Whittaker, B. Winegard, B. Cullen, J. Mercer, J. Estill, N. Clayton, K.C. Tam, R. Willoughby, P. Starr, B. Skerrett, G. Otterbein, D. Weiler, D. Marshall, G. Robinson.

The "Committee" and the Guelph Rotary Club. I have never worked with a more exciting group of doers and visionaries.

A special thanks to Ginty Jocius, who first asked, "Carl, what is the next dream?" and then committed to helping make it happen.

Thank you all.

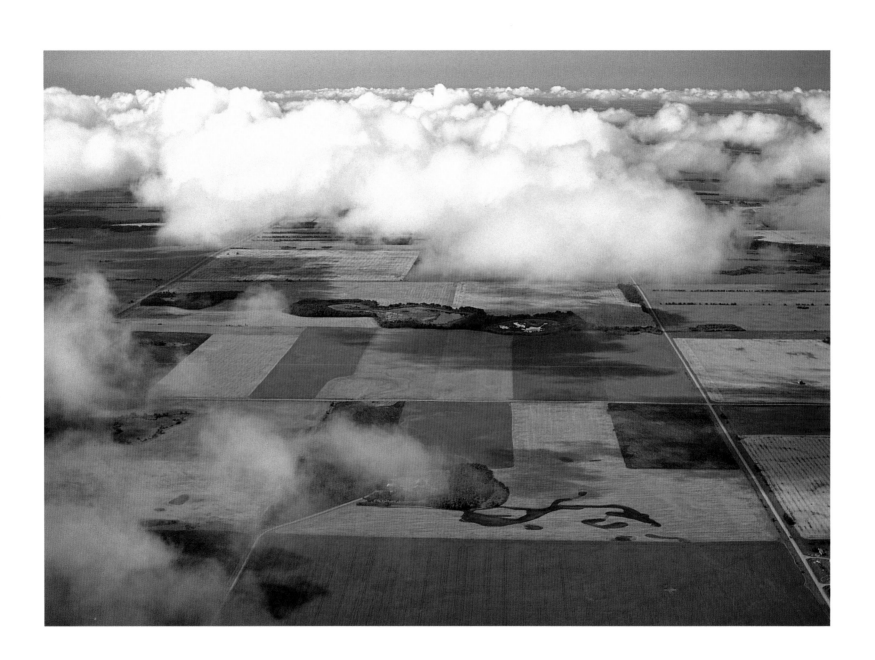

# GIFT OF WINGS

July 1, 1986. Canada Day. The day I've been waiting for. I glance at my watch again. Ten minutes after ten. We're only a few minutes behind our scheduled departure time.

A third tug on the seatbelt. Tight. It's time to go. "Let's do it," I yell, and then I watch as my crew shoves the ultralight off the beach and into the Atlantic. As soon as the floats are riding the waves, the aircraft is turned around to face the open sea. I go through the checklist once more. Helmet...tight. Seatbelt...tight. Controls...free. Fuel...full tanks. Choke...on. Throttle...set. I glance behind to ensure no one is near the propeller. "Clear," I yell, and reach forward to push the starter button. On cue, the two-stroke, 47-horsepower Rotax engine sputters to life and then settles into its familiar staccato.

This is it. It is finally happening. I let out a sigh that seems to have been trapped inside me for months. There is a trancelike feeling to this scene I have imagined hundreds of times before. I clench my fist and exhale a "Yes" that comes straight from the gut. My cross-Canada ultralight odyssey is about to begin.

---

In truth, the beginning occurred five tears earlier. It happened on a perfect autumn day. It happened in a fraction of a second.

The day certainly carried no hint of disaster. About twenty-five of us met that September afternoon on top of Hammondsport Hill. Our love of hang-gliding had brought us to this 800-foot ridge in upper New York State. On previous visits, this place had given us countless hours of graceful flight, and we anticipated that this day would bring more of the same. Hammondsport was one of my favourite sites. It held lots of good memories. My first high-soaring flight had taken place here just two years earlier. For almost three hours that day I had wheeled and danced in the skies, having finally thrown off my shackles as a student pilot. The experience was overwhelming. Immediately after landing, I tried to capture some of the passion by writing this poem:

THE WIND AND I

*Face to face*
*The wind and I have met*
*At some precipitous edge*
*And have waited for*
*That almost hallowed moment.*
*Standing just, within gravity's grasp,*
*Waiting, waiting*
*For that perfect, God-sent breath*
*To loose the hand*
*And free the captive man.*
*For therein lies the marriage*
*Of mind and soul,*
*Of wind and sail*
*Cemented, consummated*
*As the wind and I*
*Clasp hands and dance*
*Through hallowed halls of ecstasy,*
*To wheel and dance*
*On self-grown wings*
*And soar to heights*
*Not dreamed by common man.*

Hang-gliding was captivating. Much more so than the other sports I had pursued over the years—motorcycling, scuba-diving under ice, barefoot water-skiing, sky-diving. The first time I cleared a grassy hillside by just a few inches, with an old trainer hang-glider strapped to my back, I knew I had discovered the ultimate sport and the purest form of

human flight. It was magical, spiritual, and imparted a wonderful freedom. A red-tailed hawk once swooped in and positioned itself less than 20 feet off my right wingtip. In perfect formation, we spiralled upward, at times with eye-to-eye contact. Who was this outrageously sized, dazzlingly coloured cousin of his?

The very act of flying felt supernatural. No engine or mechanical controls to encumber the process. The only sound was the steady *hissssh* of the passing breeze. I hung comfortably in a horizontal body harness, and by shifting my weight slightly to one side, I could bank the glider into effortless 360-degree turns. Around and around I spun, the horizon becoming as blurred and distant as the earthbound concerns left behind on takeoff. It was the perfect playground—just the wind, the sky, and me. One flight in the Rocky Mountains took me to over 11,000 feet, high above the snow-capped peaks. Often, at the end of my dance in the skies, I would land lightly in a couple of steps, a feather-soft embrace of the earth. Nothing could touch this. It was an instant love affair.

In less than two years, I went from my first lesson to flying in the Canadian National Hang-Gliding Championships. I even considered moving to the Rockies and becoming a full-time air junkie. Not surprisingly, my other weekend activities had quickly faded. I had found my sport.

⇒⊳●◅⇐

Hammondsport, September 12, 1981. As one of the instructors, I was the "wind dummy" for the day, the first one to launch and verify wind and thermal conditions. A cold front had just passed through. There was some concern about the gustiness, but by two o'clock it looked settled enough. "Clear," I yelled. I pushed out on the glider's control bar and into the inviting wind, eager to grab the first thermal and corkscrew up to 3,000 or 4,000 feet above the valley. It was to be my shortest flight ever. Just as my right foot pushed off from the hill, a gust of wind stalled the wing. Instinctively, I pulled in the control bar to regain speed and control. The glider nosed down, but unfortunately, the hill wasn't steep enough to allow much manoeuvring. *Thwiiiit.* I heard the sound of my left wingtip catching the top of a 3-foot sumac bush. The glider started to turn back toward the hill with the left wing now completely stalled. There was nothing I could do but ride it out. At the most, I was 15 feet in the air. I knew I was going to crash but didn't think it would be that serious—perhaps a broken ankle, but more likely a severely bruised ego. I pushed out hard on the control bar just before touchdown, tilting the glider's nose upward to slow its speed and minimize the impact. Whack! I smashed through the low-lying bushes. A branch slapped across my face and then...quietness. Total, surrealistic quietness.

As anticipated, the crash wasn't at all violent. The only obvious damage was a scraped finger and a scratch on my nose. But at the exact moment of impact I had felt a twang as if some internal rubber band had snapped off its hooks, relieved of its tension. Suddenly, I had the sickening feeling that something overwhelming, something irrevocable had happened. I wondered where I was injured. I glanced at my control bar and then at the hilltop, which I could see just beneath my glider's orange

sail. My eyes were okay. No problem with focus or clarity. Neck...pain-free rotation in both directions. Good. Arms...full movement. My hope was building. Maybe this wasn't so bad after all. Legs...what? No movement? I must have broken them both. But if that were the case, I should still be able to move them somewhat. This time I made a concerted mental effort to flex my muscles. Nothing. Nothing moved! With a curious and hesitant hand, I reached down to touch them. Nothing. There was no sensation. And then it hit me. I had broken my back. I was paralysed!

I lay quietly, pinned lightly under my once graceful flying machine, less than a 100 feet from the launch point. My friends were waiting—waiting for me to call up that everything was okay so they could get on with their flights. Before I could make that yell, however, I needed to grasp what had just happened. My thoughts during the next 30 seconds were planted indelibly in my brain. As improbable as it sounds, it was as though someone was writing these exact words in my journal: "I've broken my back. I'm going to spend the rest of my life in a wheelchair. I don't think I can handle this...I don't think I want to live." There was a short pause, and then, almost in the same thought, I found myself insisting, "No...I still have my mind. I need to see this as a challenge. The issue here is not my broken back, it's my attitude. How I handle this is up to me."

It was the most dramatic turning point in my life, a radical redefining of who I was, who I could be. In the space of a few seconds, I had to make the transition from a world that celebrated physical activity to being in a wheelchair. Only then did I finally yell for help. Somewhere, a curtain rustled stage left. Somehow, my life's play would continue.

—————>➤●◄—————

My new home following the accident was an electric circle bed in Kitchener–Waterloo Hospital. The contraption seemed more befitting of a midway than a neurology wing. No doubt it had been designed by George Ferris. Had it been a two-seater I would have charged admission and given rides—after all, the original Ferris wheel was called the Pleasure Wheel. This one, however, had a different purpose. Its two vertical, hoola-hoop-like rings supported a mattress that had become my bed. Every four hours I was sandwiched between this and another mattress, and the entire unit was rotated 180 degrees. Nice trick. For the next "shift" I lay upside down. This process ensured I wouldn't develop bed sores or pneumonia while my vertebrae completed their measured but natural process of fusion. It also meant my friends had to lie on the floor and stare upward through a hole in the mattress for a face-to-face conversation. "You'd better get used to it," the staff informed me. "You'll likely be here for a couple of months." Patience had never been my forte. I knew this is going to push the outer limits of the envelope.

Those were strange days of living in limbo, caught between who I once had been and this radically redefined body. The simplest question swirling through my mind was also the most profound: "Who am I?" I pulled off my bed sheet and stared at the unfamiliar body that would not move and had no feeling from the chest down. How could this still be me? From Mr. Jock to this, all because one connection had been broken? It seemed impossible.

One of the first insights into my predicament came from Cathy, a staff nurse I had befriended. She'd been around long enough to realize there was much more to the healing process than just repairing the physical body. It was the healer within that needed to be activated. It was during one of our lengthy and insightful conversations that she offered, "Well, Carl, you have to realize you really are an ideal candidate to be a paraplegic!" I was dumbfounded. What sort of twisted humour was

*The secret of success in life: Prepare for opportunity when it comes.*

Benjamin Disraeli

this? An ideal candidate to be paralysed? She went on to explain: "Think about it. Aside from your broken back, you're in excellent health and you've got good upper-body strength. You have a great support network of friends, some financial security, and a home and a job to go back to." I needed a couple of days to think that one through, but in the end, I had to agree with her: Given the circumstances, things were about as good as they could be.

—————

I had known for some time that humour is as fundamental to this life as is the occasional Mars bar. Someone once suggested that after God created the world, and Adam and Eve, he invented humour to keep the whole thing from collapsing. In a more recent application, Norman Cousins, author of several books on self-healing, claimed to have laughed his way to wellness. Science now acknowledges that laughter is a tranquillizer. There is a direct relationship between laughter and the release of endorphins, natural painkillers, in the brain. A good laugh is capable of bringing us out of today's crisis, breaking the stress cycle, and returning us to productivity and creativity.

My hospital recovery days were an ideal time to test this belief, and the results ranged from water fights with staff to being wakened at 2 A.M. to hear a new joke. Laughter bathes the soul, and the ability to laugh at ourselves and our predicaments is a sign of health and the beginning of wellness.

The best humour of course is spontaneous. Many months after I left the hospital, I was involved in an incident on an airport bus when a dozen of us bleary-eyed travellers caught the 5:30 A.M. ride. Thanks to delayed flights the previous day, we had all missed connecting flights and spent an unwanted night in Toronto. Suffice it to say, we were not happy travellers that morning. To add to the underlying tension, we had a crazed driver, a budding Mario Andretti who saw the airport drive as his chance for the checkered flag. The tension mounted. And then the magic moment of humour. As we careened around a corner, I was able to catch my wheelchair just before it flew down the aisle. I looked at the driver, turned back to the passengers, and offered this: "And you want to know how I ended up in the wheelchair? Drove with this guy last year." Suddenly a busload of strangers united in a common bond of laughter. Smiles appeared, tensions eased, and all was a little brighter in the world.

—————

I experienced a profound healing from the spiritual realm. I had always believed that I was Body, Mind and Spirit. At least I'd known that intellectually. It now became a knowledge of the heart, as well. I stared at this strange body for hours at a time and reflected on my being. Obviously, I was broken physically, but that was only one dimension of existence. Neither my mind nor my spirit needed to be destroyed by what had happened. And knowing that ultimately the most important part of my essence was spiritual, I realized that my broken back, in the greater scheme of things, was a secondary issue. Had my whole identity been tied up in my physical being—the old Mr. Jock—this accident might have been devastating. My challenge was to keep my mind and spirit alive, for they knew nothing of the limitations of wheelchairs.

For years, growing up in a Mennonite community, I had often heard of "God's love." I believed it existed but had never sensed it personally. Now, for the first time in my life, I was in a situation of need. Suddenly, the love and the healing were there, given through the caring hands of friends. Friends who cried with me. Who took me home on weekend passes. Who offered their homes to live in until I was ready to be on my own. Friends, who through all of this said, "We care." The experience was profoundly moving. Friendships are perhaps one of God's greatest gifts.

There was also a healing in learning from others. Within a couple of weeks of entering the hospital, I asked my assigned social worker how I could contact other paraplegics who had dealt successfully with this situation. I was informed that I probably was not ready for that yet. It was even suggested I might be avoiding the important stages of denial, anger, bargaining, grief and acceptance. I thought Kübler-Ross had reserved these steps for the dying, but they appeared to have been extended to include the spinal cord injured. Unfortunately, I was caught up in more immediate issues, such as trying to design a set of training wheels for my Honda Goldwing motorcycle. I never did work through those important stages, but then neither were my training wheels ever built. Perhaps it was a fair trade-off.

Thanks to the efforts of my family doctor, I met Clare, a paraplegic who had re-established a meaningful life for himself. What a fortunate encounter. Clare was articulate, positive, and living life fully. Within a half hour of our meeting, his wheelchair became incidental in my eyes. He had chosen to focus on what he could do with his life rather than on his limitations. Our time together was a tremendous inspiration to me. He spoke with credibility when he said the issues I'd face in the future would be quite manageable. We met several more times, and his quiet determination became an unexpected boost in preparing myself for life outside hospital walls.

My most profound healing occurred well beyond the boundaries of traditional medicine. It was clearly a quest in the spiritual realm. As I contemplated my new body-mind-spirit composition, it occurred to me that I would do well to spend more time examining my spiritual essence. I was particularly immersed in these thoughts one afternoon and was searching for an affirmation. Ironically, I hoped the affirmation would be reflected in my physical being. I wasn't specific in defining the terms of this change, but rather tried to free my mind and be open to that "still, small voice within."

The answer came that evening as I was getting ready for bed. As I pulled off my right sock, I was startled to see my big toe move ever so slightly. My toe moved? Was this an illusion or a nervous twitch, or did I actually do this? I relaxed in my chair and concentrated on doing it again. It was tremendously difficult.

The problem was that it had been almost three months since any part of my lower body had moved. Not only had my muscles atrophied, but I had also lost the "mental circuitry" needed to activate whatever muscles remained. I had to somehow re-establish the neurological connections between my brain and my lower extremities. Initially, it seemed impossible. I experimented for several minutes before there was a repeat performance. The key was to close my eyes and, with undivided concentration, visualize a pathway of information from my head to my feet. Yes. I did it. My toe moved again!

With continued effort, I finally moved my left big toe as well. There was no doubt. This was an unquestionable miracle! My medical diagnosis was paraplegia with "no voluntary motor function." Yet, on the day of my asking, I was given this unexplainable movement.

It was now 1:30 A.M., but that was no reason not to spend the next hour ecstatically calling my friends to share this mind-boggling event. My toes moved! Friends arrived, sneaked into my room with a bottle of champagne, and we watched and celebrated these amazing symphonic toe movements late into the night.

My dedicated therapist arrived early the next morning to perform strength and motion tests. We were both awestruck to discover I had weak movement in every major muscle group of my lower body. We hugged and cried together out of sheer joy.

This healing, of course, made no sense from the viewpoint of traditional medicine. I had been told I would never move my lower body again. It surprised me that the medical specialists basically shrugged off the report of my recovery. There seemed to be little interest in something that did not fit with their understanding. One doctor had to be called three times before he could be convinced of what had happened. When he finally did arrive, his response was, "I understand there's been a slight change in your physical status." I told him he'd just won the Best Understatement of the Year award. "A significant spontaneous improvement in the lower extremities" was noted in my medical records. It seemed to me the word "miracle" was easier to spell.

My family doctor was one of the few who understood the essence of what had occurred. He said simply, "I've been practising medicine for thirty- one years and have only witnessed two miracles. This is one of them."

The gift of healing continued as my muscles gradually regained strength. Within a few days, by supporting myself with parallel bars, I could stand. (After weeks of sitting, it was amazing how short everyone looked.) With four months of therapy, I learned to walk short distances by using quad canes. Although the wheelchair remains my primary transportation, this profound recovery proved a tremendous advantage in accessing narrow doorways, short flights of stairs and other barriers.

These days of remarkable improvement gave me much cause for reflection. Why had this miracle happened? It was some time before the irony struck me: there was no explanation. By definition, a miracle is the exception, a contradiction to known scientific laws. I remain awestruck, humbled and forever grateful for this God-given healing. It was nothing I had earned. It was nothing that could be reproduced by religious formulae.

It was fascinating to watch the reaction of others. To most of the medical profession, I was a misfit.

A number of well-wishers suggested my recovery was due to my positive attitude and determination. Others thought the initial medical diagnosis had been incorrect. But I knew better. On the very day I asked for an affirmation, I was given this gift.

One of my biggest fears was the question of what would happen to my friendships. I was single and was blessed with a significant number of friends who were integral to my life. Just a few weeks prior to my accident I had seen the movie *Eye of the Needle*, based on Ken Follett's novel. In it, a dashing Spitfire pilot and his bride are involved in a tragic car accident that leaves him a paraplegic. With a shattered self-image and a belief he will no longer be accepted by his friends, he moves to a remote island and becomes a social recluse—even to his wife. The scenes from this movie played over and over again in my mind. Would the same thing happen to me? I could deal with my broken back, but to lose my community of friends would be crushing. Most of my friendships had been founded on shared activities, from scuba-diving to hang-gliding. Now that I was no longer a player in these arenas, had our common ground been removed? Without the shared activities, would our friendships die a predictable death?

Once again, I was blessed. I had the right people in my life at the right time. A friend, a psychologist, had just moved back to Southern Ontario. We visited regularly on her days off, and in our time together she was able to help me verbalize and work through my fears. In the end, they proved to be mostly ill-founded. Although a few friendships did fade away, more significant was that others became even more meaningful. As my friend Shirley explained, "Finally, you've got time to talk and just 'be' instead of always racing around with all your activity." I began to realize there was much truth in what she said. We were, after all, called human "beings."

Another major step in my healing came in the

form of a quote originally attributed to Cervantes, from *Don Quixote*: "When one door is shut, another opens." The Hindus had gone one step further and said, "When one door is shut, a thousand are opened." I was content to settle for one or two. That simple but poetic metaphor became a major illumination for me. It underlined once again that my key issue was one of perspective. The closed door was obvious. I could easily make a list several pages long of all the things I could no longer do. My challenge was to search out untried doors. They were there, somewhere. It was my job to find them.

And so, the days of healing were much easier to cope with than I would have imagined. Only once was I aware of a confrontation with depression—a dramatic metaphorical encounter. Shortly after lunch one Saturday, I sensed a cloud sinking over me, overwhelming in weight and darkness. It seemed to contain the entire dark side of my experience, and would bring a virtual battle with the devils. There was an uncanny fear that should it envelop me, I would be lost forever in its swirling mass of grey. Urie. I had to call my friend Urie. Of the spiritual mentors in my life, he was one of the more significant. Within an hour, he arrived at my bedside, and we spent the balance of the afternoon together. What we talked about seemed incidental. It was his presence that dispelled the encroaching depression. A lightness came back into the room and, with it, the sense that I would have to fight this battle only once.

Had I been warned of my accident ahead of time, this journey would have been too much to contemplate. Suicide might have been the easier choice. Yet only once, in that brief moment immediately following my crash, did taking my life cross my mind. Mostly, it remained clear to me that I had been presented with the challenge of my life, literally, and it was my responsibility to make the best of it.

After a six-week confinement in my rotating bed, my vertebrae finally fused sufficiently to allow me to transfer to the rehabilitation wing. At first, my progress seemed agonizingly slow—discovering how to roll over in bed, sit up, slip on a pair of socks. It was hard to believe these were the same feet that once allowed me to water-ski barefoot, on one foot, at 45 miles per hour, and do a wake crossing. Now I felt like a baby when faced with the simple but daunting tasks of daily survival. Perhaps this "newborn" metaphor was apt. I was, in effect, going through a birthing process, arriving unexpectedly in this world of limitations, frustrations and challenges.

My rehabilitation period brought its own surprises. I particularly remember the first day my physiotherapist helped me to sit up on the edge of the bed. As soon as she removed her supportive hand, I toppled to the left. I couldn't even sit! I lay on the bed with my mind numbed, trying to come to grips with this devastating realization. Come on, Hiebert, get a hold of yourself. Look at this logically, I thought.

"Given a similar injury," I asked, "have others learned to sit up on their own? Is it really possible for me to learn this?"

"Absolutely," she reassured me. "It's just going to take time. You can do it."

That moment was another turning point. If others had done it, then so could I. It was my responsibility, and mine alone, to see this as an unprecedented challenge. Just a few months earlier, I had been ready to attempt barefoot water-skiing, backward. Now, I faced the fundamental challenge of re-learning basic body control. The tasks had changed, but not the rules. It was still a matter of effort and concentration.

I was told my rehabilitation would last three to four months. I countered that my target was to be out of there in four weeks, and, in so doing, gave myself a new goal in this world of pale green walls, wheelchairs, floor mats and weights. Little did I know the best therapy was yet to come.

Just two weeks after I began rehabilitation, my old hang-gliding buddy, Bob Tessier, came to visit on a particularly serene and unusually warm October Saturday morning. "We're going out to the parking lot to get some fresh air," I told the inquiring nurse as I wheeled down the hallway. I didn't tell her about the impromptu sign hung on the door of my room: Gone Flying. Our supposed "parking lot" was a 300-foot grass strip behind a farmer's barn. There, resplendent with its rainbow-coloured wings, was Bob's gift of magic to me—his single-seat ultralight, fully gassed and ready to fly.

We had talked earlier about the possibility of me flying again. From my perspective, it wasn't a question of if I would fly, but rather when. It would probably happen next summer, I assumed, after I'd had a chance to master some of the more basic motor skills. I was still learning how to transfer from the wheelchair into bed by myself. Driving my car with hand controls was yet to come. A return to flight seemed an even more distant dream.

But here was my chance—months ahead of schedule—a perfect blue-sky, windless day, and a little help from my friends. The big question: Was I ready to spread my wings? Although I had learned to fly an ultralight the previous summer, I now faced two additional complications, balance and spasticity. I'd been told that days of horizontal confinement in the circle bed would seriously impair my balance. People had been known to take several weeks to fully re-establish their equilibrium. I resolved that question to my own satisfaction by learning how to do wheelies in my sports chair. Within one afternoon, I could balance on the rear wheels without creating additional cracks on the tiled floor with the back of my head. By the second day, I was racing down the hospital hallways, back wheels only, scattering able-bodied pedestrians in the process. Surely my balance was normal.

The spasticity was a different issue. Not uncommon to spinal cord injuries, my legs sometimes jerked out of their dormant state uncontrollably. That could be a problem in flight, since I would be both the passenger and the pilot. Even with a lap belt, I could see myself suddenly gyrating all over the sky in one of these involuntary spasms, with my friends below thinking I was attempting a radical interpretation of the "Lomcovak," a dazzling aerobatic manoeuvre. Perhaps I'd be invited to join all the major air shows. We finally solved the problem by lashing ropes around my legs and torso. Ready for takeoff, I looked like a mummy bound for eternity in 50 feet of yellow nylon rope. If I was going to spasm, I'd take the whole airplane with me.

Was I afraid? Absolutely, yes. But it was not a fear manifested in perspiring hands or self-doubt. My challenge was to understand my limitations and still learn how to fly safely in spite of them. This was not a flight to be rushed. Only after several high-speed taxi runs to re-orient myself in this gravity-defying machine did I finally shove full throttle. With heart-pounding anticipation, I pulled back on the stick and took off. I was in the air. I was flying!

I flew that day. And flew. And flew. As I buzzed the field and saw my empty wheelchair below, I was overcome by this serendipitous moment. Even if I couldn't walk, I could still fly! And I knew then that I would once again find meaning and excitement in my life. This was unquestionably the best therapy that anyone could give me. I was ecstatic. I could fly. I would fly.

Two and a half hours later, my mind swimming with images and my heart bathed in euphoria, I headed back to the farm. Banking into the wind, I lined up on that small patch of green, pulled the throttle, and glided down to a fresh earth and a renewed desire. It had been the most memorable flight of my life. What a fortuitous moment. The sight of my empty wheelchair brought with it a leap of hope. It was as though my road to recovery had suddenly been transformed from a rutted, muddy trail to a four-lane expressway. It could only get easier.

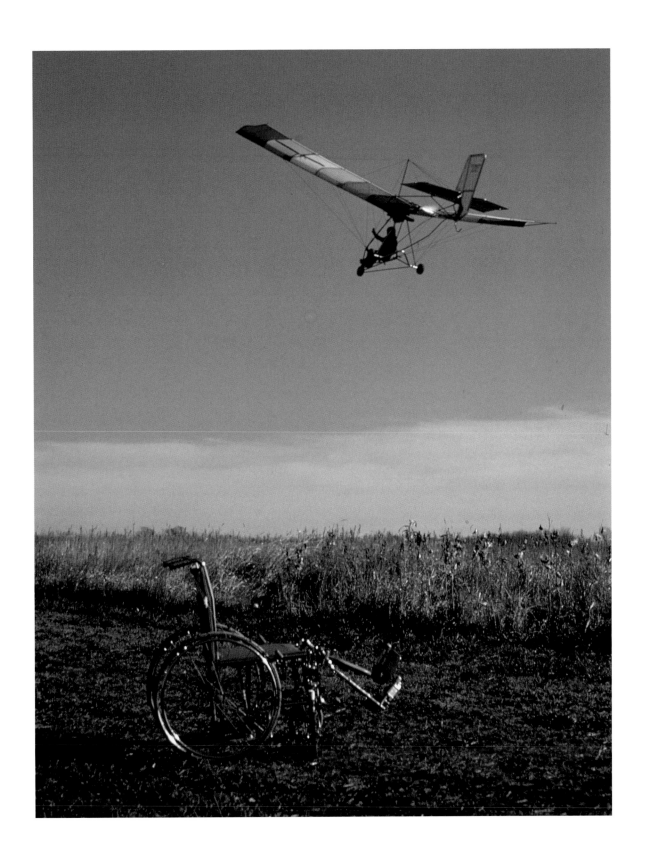

To my surprise, my enthusiasm for this flight was not contagious back at the hospital. Talk about being brought back to earth with a jolt. By now, of course, the Gone Flying sign had been discovered. "You what? Went flying? I don't believe it." That was just one of the nurses. The doctors were even less impressed. One of them, in an unusual twist of the Hippocratic Oath, was heard to say he was so upset he could kill me. To add even more drama to this controversial therapy, a short time later the local newspaper carried a front-page story. There was a colour photograph of my empty wheelchair, and flashing by overhead was me in my magnificent therapy machine. That photo-graph has remained the most emotionally charged picture of my life, vibrant in its tension between the empty chair and my wave of jubilation. A copy of it hangs beside my front door, a constant reminder of a momen-tous turning point in my healing.

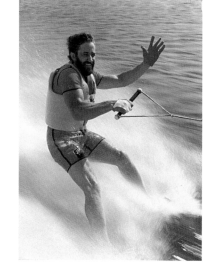

I realized that the medical staff were entrusted with my care and, given the nature of their work, may have erred on the side of caution. Yet, from my point of view, it was diffi-cult to understand why they felt threatened by this event. Nothing could have done more to awaken the inner healer. Like most other aspects of our lives, the road to recovery is largely a personal one. Flight had long been an integral part of my life. Should it have been a surprise that it also became my gift of healing? My rehabilitation period was projected to take three or four months. In actual fact, the discharge meeting occurred just three weeks into my program—a record for that hospital.

Upon in returning home for the first time, with a recently acquired day pass, I found myself back in familiar territory but seeing it through refocused eyes. All around me were reminders of my "playground" of the past: my motorcycle, hang-glid-ing equipment, scuba gear, hiking boots, climbing belt, cross-country skis. Each carried its own stories, memories of what my life had been.

My hospital stay had not prepared me for this. The medical mandate was to heal bodies, not minds or spirits. Left alone for a moment in my kitchen, I was suddenly engulfed by tears.

A few months after I finished my rehabilitation and moved back home, it became obvious to me that I would have to either sell or give away my much-loved sports equipment. I was in a wheel-chair now and could never use these items again. My activity-filled weekends were over. As each piece of gear left the house, it carried part of my past with it. The process was painful and left me with a big ache. How could I even begin to replace this void with equally meaning-ful activity?

In just a few weeks, the toys were gone, except for one—my special competition slalom water ski. Whenever I would run my hand over its concave bottom, my mind would flash back to those perfect sunset ski runs on Conestoga Lake. The rhythmic weave through a slalom course is the finest of dances. But the dance was over now. And so, the ski sat for seven years, stored in a closet, before I finally gave it to friend. Symbolically, it seemed I had to stretch this last goodbye as long as I could, hanging on to it but my fingers finally slipping away as my life moved on in a different direction.

Fortunately, I was still able to fly, and it was in flight that I found my therapy. I no longer needed to live in a world of confinement. I could once again move as effortlessly as my TAB (temporarily able-bodied) friends. In the wheelchair, facing a 6-inch curb was like facing a brick wall, an impossible barrier. In my sweet flying machine, a slight pull on the control stick sailed me with graceful ease over a row of pine trees or a river. It felt like a magical defiance of gravity.

My romance with flight continued. Within eight months of my accident I was teaching eager students to fly in a new two-seat ultralight. By the following summer I had an opportunity to open my own flight school. Over twenty ultralights were sold that season, and in the process I realized that there were options in life other than just being an incessant adventurer. My wheelchair forced the transition from a predominately physical world to one much more cerebral. Without the accident, it is not unlikely that I would have risked a major business undertaking. Flight had handed me a tragedy and then the means to re-establish my existence. I had been given my "open door."

<center>—————⊰⊙⊱—————</center>

It was in the beginning days of ultralights that my friend Alex and I set out on our first "cross-country" flight. We were fledglings who had just left our nest and had rarely flown out of sight of home base. It was now time to explore, and our goal was a 12-mile flight. This required serious preparation. We had road maps, air charts, compasses, and even a ground crew. Nothing would be left to chance. While cruising at 35 miles per hour over autumn-brown cornfields, an idea suddenly came to mind. It was as though some voice outside of myself asked: "Why not fly one of these machines across the country? If you can go 12 miles, why not 5,000?" In that simple question, the dream was born.

I lay awake that night, fascinated by this amazing idea. Finally, at 1 A.M., I got up to call Alex. "We could do it, right across Canada!" He simply told me I was crazy and I should get some sleep. But I didn't sleep. The dream was here to stay. I wrestled with it for most of the night.

As the months slipped by, this fantasy took root in my subconscious and laboriously transformed into a clear conviction. It was no longer just a crazy idea. I had to do this flight. But trying to piece together the details of this challenge was a lengthy and awkward process. No one had ever flown an ultralight across Canada. How would I do it? Who would be involved? What about financing? Was it really possible? My friends became sounding boards for ideas and more questions. Why not complete this flight on behalf of the Canadian Paraplegic Association, as a fundraising venture? Why not tie it in to Expo '86, the World's Fair in Vancouver, whose theme was Transportation and Communications? The ideas made sense and provided the corner-stones to begin building this project.

Since this was an aviation first, there were no precedents for me to draw from. Putting all the details into place became a full-time commitment. I worked mornings at my corporate marketing job, then spent the afternoons and most evenings at home with my "real" task. Before one To Do list was completed, another was drawn up. The biggest challenge was to convince people this flight was possible, that this was a sane project. I spoke to several conventional pilots who had much more flying experience than me. The message seemed clear: "Forget it, Carl. This has never been done before with an ultralight." Not stated, but sometimes implied, was the balance of the reply,"...let alone by someone in a wheelchair."

Obtaining financial backing was another matter. The cost of the equipment and services required for this trip would total over $100,000, and it was my task to find that support. At one point, I contacted the ten largest companies in my home cities of

*To love what you do and feel that it matters— how could anything be more fun?*

Katherine Graham

Kitchener–Waterloo—without raising a dollar. There was obviously some bliss in ignorance. Had I known in advance how difficult this project was going to be, I might never had undertaken it.

What started as a simple dream soon became an integral part of my life. I breathed, tasted, and lived it every day. If I hadn't, I would never have found the energy and commitment to overcome the frustrations and roadblocks along the way. In the end, the perseverance paid off. One of my first sponsors was a local Rotary club. A friend invited me to speak at the club's Friday lunch and make a proposal. Their answer arrived just a few days later: They would make a cash contribution. I was elated. Then my employer and fellow workers at Rogers Cable TV raised several thousand dollars. Gradually the sponsor list grew. Two developments gave the project tremendous support and credibility: Air Canada committed itself as a major financial sponsor, and Expo '86 endorsed my flight as an official part of the World's Fair.

A s individual parts of the puzzle came together, my conviction and confidence grew. Yes, the trip was going to happen and it was going to happen because of one simple dream. Because one innocent question had drifted down leaflike before me that day: "Why not fly an ultralight across Canada?" The question had carried with it the sense that it belonged to me. It was mine, and I needed to take care of it. I had no idea, of course, how the trip would be made possible. It took the next five years for those details to emerge. There are no calendars to determine the gestation period of dreams. The journey from the beginning of a

dream to its eventual realization is often an agonizing lesson in patience.

Within a few weeks of my accident, several people had tried to define the limitations of my wheelchair world: "You should apply for a permanent disability pension...You'll have to realize that your activity is going to be pretty much limited to the wheelchair, so you had better become used to it...You're certainly not going to fly again. You're paralyzed. You'd be crazy to try that." Had I listened to the doubters, I would still only be wishing for flight and the freedom of living an independent life. My challenge was to free my mind of these restrictive thoughts and let my imagination wander creatively. It was the dreaming that gave me both direction and hope.

As the funding and organizational pieces fell into place, I began to think about the flight itself and what I was up against. A year before Expo opened, I took a commercial flight to Vancouver to arrange for the building of the ultralights I would use. (They were being supplied by a west coast manufacturer.) On the flight home, I wrote these notes in my journal:

*Oct 28/1985  2:35 P.M.*
*Homeward bound on Air Canada #148*

*It's comfortable here. Fruit juice. A new novel. Classical music on the headset. But just two inches away, through the double pressure-sealed windows, a minus-40-degree wind screams by at 560 mph. Below me, 31,000 feet below me, the Rocky Mountains bare their menacing faces yet slide smoothly by. It seems surrealistic and impossible to reconcile these two worlds. This is jet-magic at its very best.*

*Just 50 minutes after blasting down the Vancouver*

*runway, the last of these white-capped peaks will smooth out into the prairies' flat expanse. Fifty minutes! I try to imagine next summer's ultralight flight over this same route. At 40 mph, bundled in a down vest and leather flight jacket, it will likely take me a week to travel the same distance. There will be no jet-magic distance from the elements then. Massive rock faces will tower above my fragile wings and disappear up into towering cumulous clouds. How closely I'll watch the changing sky, the fickle winds and the shifting terrain.*

*As ultralight pilots, ours is a different kind of magic. It is the magic of being wonderstruck by the closeness, the intimacy, the intensity of the earth and sky and flying within that delicate realm where they seem to reach out to touch each other.*

*I glance down again at the mountains, the rare pencil-thin roads, the miles of incredibly hostile terrain. It produces a lump in my throat, a fear based on respect and awe. In just nine months from now, I hope to be the first person ever to fly through here in an ultralight aircraft. Will I have planned thoroughly enough? Will Mother Nature listen to my "fair-weather" requests? Will my little two-stroke engine switch to "automatic rough" as soon as the last available landing strip slips too far behind?*

*The questions and doubts are real, but even stronger, more immediate, is the fascination with the challenge of this flight—of stretching comfort zones and exploring fresh territory. And there is the growing sense this dream will become a reality.*

⇒•⇐

The planning for the trip seemed endless. Never before had I been confronted with so many logistical details. Two ultralights had to be built, test flown, disassembled, shipped to Halifax and reassembled. I would fly one while the second would be flown by different pilots and would serve as the backup chase plane. We needed to acquire a motor home. My ground crew and pilots

would have to be co-ordinated for each of the five sections of the trip. In total, eighteen people had generously volunteered their summer holidays to make this endeavour possible. Press kits had to be sent out to almost five hundred media contacts and then followed up with phone calls. The list went on and on.

My days became increasingly hectic. Phone calls, letters, proposals, meetings. Then, to add to it all, an unexpected phenomenon occurred just a few months before my scheduled departure: I began to doubt myself and the viability of my dream. I was surrounded by questions that threatened to undermine my commitment—What if I can't find sponsors? What if the fundraising falls flat? What if I can't find enough team volunteers? What if I crash? The most persistent doubt of all questioned my very core: I'm just a Mennonite farm boy. What am I doing taking on a project that's much too big for me? Suddenly I began to hear all the "failure tapes" and view the negative self-images I had collected over the years. If there had been a way to bow out of the project gracefully at that point, I might have done so. It would have been easy to justify my decision. Why take a chance? There's no financial gain involved. If the project fails halfway through, I'll look like a fool. What if the experts are right and this isn't possible in an ultralight? Why bother?

It became a classic confrontation between the programmed need for security and the conscious decision to risk. Though the desire for security was understandable, more important was the need to explore the untried, the next challenge in my life. I recognized I couldn't have it both ways. It was impossible to steal second base and still keep my foot on first.

Until now, I'd been carried along by the energy of the dream itself. Now I was up against the reality of making it happen. Without the deliberate decision to risk, the dream might have died at this point.

⇒•⇐

Helen Keller once said that life is either a daring adventure or nothing. Why do some people live life to its fullest and others drearily repeat the same routines day after day, year after year? The answer, I suspect, lies in the decision to risk. Although Webster's dictionary defines risk-taking as a negative, "to expose to the chance of injury, damage, or loss," there is a flip side to risk-taking, a side that is a vital ingredient in success. In fact, success and the willingness to risk go hand in hand, and the rewards of risks usually outweigh the dangers.

Risk-taking is simply the willingness to explore the unknown even when we don't have all the answers. It's the trapeze artist who lets go and swings out into space before finding a sure handhold. Letting go of what we feel to be safe is never easy. Rarely do we see the heavens open and hear a deep voice rumble, "This way, my child." Learning to risk involves lessons in faith, but we are always the better for these lessons.

I once interviewed a man in his early seventies who had switched jobs an average of once every five years throughout his entire working life. He had raised a wonderful family of four and lived all across Canada. His prolific job-switching had been intentional, for he saw each new position as an opportunity to learn and to make a contribution. He claimed each move had been an act of courage, that it would have been so much easier to have stayed where he was. Sometimes he left a job not knowing where he was going to next. But his decision to take risks had given him a life rich in experience and adventure. He said he wouldn't have had it any other way.

Most of us are not natural risk-takers, and even when we do understand the importance of risk-taking, we are often ambivalent about doing so. Typically, we try to make our lives as convenient and as safe as possible. When the secure life becomes too boring, we look for excitement without taking the risks ourselves. We watch others take the chances for us in movies and car races. Unfortunately, vicarious risks are ultimately unsatisfying, for the stakes are not ours. There is a need to resolve this inherent struggle. I find I must remind myself periodically that the same security blanket that provides me with a cocoon of warmth and comfort is also the very one that can smother me. The adventure in life happens only when I break away from routine and explore the untried. Only in the success of having risked and triumphed can we build our security from within. It is the only security that can never be taken away.

Perhaps we sometimes limit ourselves because of a misunderstanding of failure. We see not completing something or not "pulling it off" as a step backward. Nothing could be further from the truth. Failure is an important part of the learning process. Henry Ford once said that failure was the opportunity to begin again more intelligently. Unfortunately, we easily forget the lessons we've learned in the past. We fell many times before we learned to walk, and we missed the ball often before we made our first base hit. The greatest of the heavy hitters, Babe Ruth, struck out 1,330 times—but he also hit 714 home runs!

Not only is it okay to fail, it is good to fail. Failure is a sure sign we are still experimenting and taking creative risks. In fact, we usually learn more from our mistakes than our successes. We should never worry about failure, only the chances we'll miss if we never try in the first place.

---

In the final months of organizing my flight, Murphy's Law (If anything can go wrong, it will) prevailed. It was amazing how many good intentions went awry. At one point, a $10,000 shipment of goods from Vancouver to Halifax disappeared mysteriously en route. Technical glitches with an innovative amphibious landing gear delayed our aircraft construction deadline to the proverbial

eleventh hour. My checkout ride on floats took place less than an hour before sunset on the evening prior to our departure. Time and again, I was moved by the dedication and perseverance of my crew. The trip would not have happened without them.

But my day finally arrived. I was in my ultralight, bobbing gently in the Atlantic Ocean just outside Halifax harbour. With the engine warmed for take-off, I waved goodbye once more to the well-wishers on the shore, added a touch of power and turned downwind. The aircraft started rocking uncomfortably as I taxied away from the protective breakwall and headed out to the open sea. A few minutes later, I glanced back at the shoreline, now about a 1,000 feet away. This should be far enough, I thought. Left foot on the rudder, a quick blast of power, and the nose swung into the wind. If there was ever a spellbinding moment in my life, this was it. I took a deep breath, exhaled with deliberation, and shoved the throttle full forward.

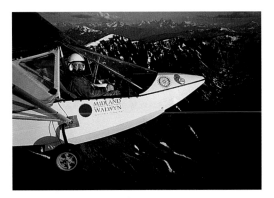

*Bam. Bam. Bam.* The floats of my RX 550 Beaver ultralight pounded hard against the tops of the waves. The winds had picked up and the sky was already starting to cloud over. These were not great weather conditions, and I wondered if they were a sign of things to come. *Bam*—a big one, and suddenly the ultralight broke free. I was airborne! I climbed laboriously into the turbulent air and at 300 feet banked right and circled back toward the crowd. A final wave, a dip of the wings, then I pointed the nose west to Expo, 5,000 long miles away.

I watched long, featherlike fingers fanning toward me across the water in the harbour below. Headwinds. Canada's prevailing winds blew from the northwest, almost directly on my nose. I would wrestle with these westerlies for 49 days out of my 58-day trip, with my ground speed reduced to an average of only 35 miles per hour. It was not going to be a warp-speed flight. I hoped the World's Fair would still be there when I arrived.

Three weeks later, my backup plane and I were still adjusting to these winds. On that particular morning, they reduced our ground speed to only 10 miles per hour as we flew into Toronto's Pearson Airport. The control tower radioed to say, "Ultralights, just want you to know, you've got the record for the slowest arrival ever." (I imagined the controllers' concern as two little green dots appeared not to be moving on their radar screen!) On another occasion, the winds were so strong I flew backward relative to the ground. That seemed like a great idea if you wanted to see where you had been, but a time-consuming way to cross Canada.

Of all the adventures during that summer, one of the most terrifying happened near Parry Sound, in the middle of Ontario's cottage country. Just after takeoff, a strong down-draft forced my light plane to less than a hundred feet. Then a severe rotor—a swirling air mass—flipped me nose down and sideways. Even with full power and full opposite controls, a crash appeared inevitable. As the pine trees rushed toward me I had a clear image of my aircraft wreckage scattered on the rocks. Amazingly, the thought of death—which was a real possibility—never once occurred to me. It was the fear of failure that frightened me, the likelihood that the Gift of Wings dream had ended.

My friends estimated that the floats of my ultralight cleared the treetops by a matter of inches. You could not stare disaster any closer in the face than

this and still survive. I landed uneventfully, crawled out onto the dock, laid face down, and did not move for an hour. The near accident had drained me, and it wasn't until the next morning that I felt sufficiently rejuvenated to carry on.

As if that experience wasn't enough to make me think about wheeling to Expo instead of flying, Old Man Murphy and his law scheduled another visit. This time, it was near Dryden, in Northern Ontario.

It was late afternoon, and I was the first in line for takeoff. By now, the cockpit felt more familiar than my wheelchair, and I had no reason to doubt this would be just another routine departure. Full power, touch of left rudder, stick back, lift off. The ultralight strained for altitude as I headed over the pine trees. Suddenly, the engine gasped, and in just three seconds the propeller clunked to a halt. The only sound was the wind rushing through the open cockpit. I jammed the control stick forward to keep up my air speed. Altitude—not even 200 feet! My only landing option was the Trans-Canada Highway, directly ahead. My mind raced. Watch the curve in the road. Watch the road sign. Watch the car coming towards you! I could almost see the driver's startled look of disbelief.

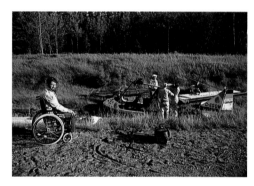

It was over in less than 20 seconds. Fortunately, I missed the obstacles, but just after touchdown, the aircraft wheels caught a soft roadside shoulder and pulled me into the huge ditch at about 20 miles per hour. *Thunk!* There I sat, at a bizarre angle with a damaged aircraft, gasoline pouring down my back. Fortunately, I was not hurt. The initial shock wore off quickly and was replaced with frustration and disappointment. We had just lost several days because of thunderstorms and now this. Of the entire trip, this was the most discouraging moment. It became a

time of reaching inward for strength and courage, of reminding myself why I was attempting this flight in the first place. I realized I could not let circumstances control my reaction. I was still responsible for my attitude, and I needed to see this as a challenge, not a failure. We began the recovery. The ultralight would have to be disassembled and shipped to Winnipeg to await repairs. In the meantime, I would fly the backup aircraft, which was there for such an eventuality. Because of this contingency plan, within a week we were once again on schedule.

———— >•<— ————

The accident brought to mind another aspect of risk-taking—fear. I thought of it again during my flight through the Rockies. At 8,000 feet in the Yellowhead Pass, I was buffeted by winds I couldn't understand. I felt crushingly insignificant in that cavernous rockscape. Without doubt, it was fear that occupied the ultralight's rear seat that day. Had I chosen to remain focused on the fear, the flight might have ended there. My choice, however, was to focus my thoughts on the goal— Vancouver and Expo '86. By holding that image in front of me, I found the courage to note the next checkpoint on the map, radio my ground crew that all was well, and to continue on.

Those of us who are seen as risk-takers are often labelled as Evel Knievel types who are fearless in our intent. Nothing could be further from the truth. Fear is a part of any risk-taker's agenda. It might leave one feeling vulnerable, but also very much alive. What perhaps separates risk-takers from those who hold back is the decision to focus on the goal and not on the fear. We can run from fear or

choose to meet it head on. It is a matter of personal choice, and each of us is ultimately responsible for our own decision.

Prior to my accident, most of my risks had been physical in nature. In our society, these are the risks that are usually revered and attract media attention. They are often the easiest to take. Much more difficult are the personal, the emotional, and the spiritual risks. By an interesting coincidence, when I was 26 years old I embarked on four significant risks: I bought my first house, took up sky-diving, developed a relationship with a woman who had a child from an prior marriage, and I left behind my formal church membership—a risk-taking exercise in the financial, physical, emotional and spiritual arenas. All of them carried attendant fears, yet my biggest fear was not jumping out of a Cessna aircraft at 5,000 feet. It was of the inner journey that came with relinquishing my church membership. Much of my spiritual definition had been enmeshed in a cultural tradition, but a strong inner voice said I needed to leave some of this behind and, for the moment, pursue my own spiritual journey outside of the formal church structure. In hindsight, it was the beginning of a much more committed faith. At the time, however, making this decision was an agonizing process.

<div align="center">⟹⟶●⟵⟸</div>

In this country of opportunity it is amazing how many people still tiptoe cautiously through life, hoping to make it safely to death. They fail to recognize that life's value is not measured in its duration but in the quality of the time spent. I think it's unfortunate when people spend 20 or 30 years at jobs they are unhappy with, when, by deciding to risk, they might have freed themselves to pursue other options. People sometimes hang in there for questionable reasons—the security of a great benefit package or dreams of a perfect retirement. Perhaps no one ever told them that you can't pack a lifetime into a retirement.

I think the greatest quality one can display in this life is not genius or creativity. It is courage, the willingness to take risks, whether in our personal relationships or in starting a business. It is the power to risk that allows us to soar on the wings of our conquering spirit.

The value of risk-taking is that each time we successfully push back the boundaries of fear, we enhance our capacity for enjoying life's experiences. It is immensely satisfying for me to introduce people to their first-ever flight. After one such occasion, I received a letter from a 52-year-old passenger who said, "It's been a long time since I've stood on the edge of fear. Years ago I learned to live safe. Not well, but safe. I decided there should be no big challenges in life because then I could not lose. But on that flight with you I had no place to run to. And as I slowly pushed my fears aside I could see how beautiful this was. Suddenly I realized how important this was in allowing me, in the future, to stand a little closer to the edge and not die inside."

The willingness to risk becomes the tightrope that can carry us to discovery, fulfilment and success. We are all capable of doing more and of being greater than we are. But these discoveries will never happen unless we put ourselves to the test. It is easy to live, as Thoreau once said, "lives of quiet desperation" and to go to our graves with our music still in us. But to turn our dreams into reality and to discover our inherent God-given abilities, we must learn to risk.

Risk-taking offers no guarantees. During my flight, for example, I experienced a major disappointment with our fundraising. At an altitude of a thousand feet, it was awkward to lower a bucket and collect donations en route. Inclement weather made it impossible to predict our arrival times at airports, further limiting our chances for donations. But in the end, the flight and my subsequent public presentations raised over $100,000 for the Paraplegic Association. These funds were directed to research

*Fear of danger is ten thousand times more terrifying than danger itself.*

Daniel Dafoe, *Robinson Crusoe*

efforts and the hope of one day finding a cure for the spinal cord injured.

What was exciting and rewarding was the successful media campaign. We often received front page news coverage as we passed through both rural towns and provincial capitals. CTV produced a one-hour documentary for national television. There was an intrigue to this story with its Wright brothers flavour. The idea of an open-cockpit, slow-flying machine winging its way across the country had a grass-roots appeal. Most important to me was that the media attention allowed me to make a public statement on behalf of the "physically challenged" community, a statement that said, "Hey, we are not disabled. We're just challenged in a different way than you are. You wear glasses to drive your car. I use a wheelchair to get to mine. It's simply a matter that we use different tools to get the job done. We need to recognize that you and I have much more in common than we have as differences."

Perhaps the best part of my flight was the extraordinary photo opportunities. Often, my heart raced in the course of trying to photograph such unexpected images. It was hard to believe this country could offer such a diverse visual experience. The more I discover and photograph these unusual scenes, the more I realize they often echo one of my fundamental philosophies: How we look at things makes all the difference. The importance of perspective was never so clear as it was at the moment of my accident. The instant my glider crashed into the hill on that fateful day, I was presented with a choice. An uncanny clarity of mind allowed me to see that the real issue was not my broken back but rather my attitude: I could be devastated by this or see it as my personal challenge.

The fact that I was able to rise to this challenge almost immediately is tribute to the values I was given as a child. I had a strong sense of being a survivor and knew that I was cared for. I felt I belonged both in my family and in my church community. Out of that acceptance had grown a generally optimistic and healthy attitude toward life. As Dr. Hans Selye once said, "If you are desired, if you feel necessary, then you are safe." I had been blessed with a supportive childhood. The core values that we learn in those first few formative years are of utmost importance as we become adults and play out our life's drama. A Carnegie Institute study of successful people found these people attributed 85 percent of their success to their mental attitude. Their education or expertise was seen as much less important. We are not born equal in terms of ability, but we have equal opportunity in our choice of attitude. It is easy for us to attribute someone else's success, or our own failures, to "circumstances," as though these circumstances exist beyond our control. But we are largely responsible for our own destiny, for our choice of attitude often shapes our circumstances. In my days as a marketing projects co-ordinator, I once approached my manager and said, "Listen, Bob, the engineering staff have run into some technical difficulties and we're going to be three weeks behind our schedule. We've got a serious problem here." I will never forget his response: "Carl, you don't have a problem. You have a creative opportunity." It was a radical shift in perspective for me, and a lesson that stuck.

We cannot control the cards we are dealt in this life, but we have a choice as to how we play them out. My wheelchair brings with it many restrictions and limitations—including most of the sports I relished in the past. Focusing on these limitations is a guaranteed exercise in frustration. The alternate perspective is that my accident and this wheelchair have given me an even richer life in many respects. Although I spend less time on self-fulfilling physical activities, my work as a presenter and photographer has given me new purpose. Whether we rise to the challenge of adversity or are devastated by it is largely a matter of choice. Ultimately, we are responsible for that choice. Ernest Hemingway once said, "The world breaks everyone, then some become strong at the broken places."

Many of us grew up with an inherited sense that life should be fair, that a fundamental justice permeates this world. It's perhaps easy to believe this until we are confronted with a personal tragedy, when we often lash out—"Why me? This isn't fair. God, why are you doing this? I don't deserve this." Our questions are understandable, but perhaps our premise is flawed. I don't think God goes around placing his fingers on triggers and his hands on steering wheels. Life is not fair. We live in a world of happenstance, randomness, viruses, and cars that go crunch in the night.

Each day of my life begins in pain—chronic, frustrating, relentless pain that has no logical medical explanation. It is somewhat equivalent to an amputee's phantom itch. It is my biggest cross to bear and makes being in the wheelchair pale in comparison. How I long to awaken just one day and be free of pain. There appear to be no solutions, however, so the issue once again becomes one of choice. Do I focus on the pain and the outrageous injustice of it all, or do I focus on the opportunities that are still there despite the hurt? It is only with the daily raw resolve to push past the pain (which never becomes easier, despite all the practice) that

I open myself up and am able to extract the most from the day's potential. One of our major challenges in life is the need to move past the questions that have no answers and realize we are still responsible for our journey. It is possibly one of the most perplexing, fundamental, and difficult challenges most of us will ever face.

—————————

If there was a moment of pure joy on this flight, it happened in the middle of the Rocky Mountains, mid-afternoon, August 21, at 5,000 feet. I was about to begin my descent for another refuelling stop, when suddenly the right wing of ultralight flipped upward. A thermal.

Somewhere, far below, the sun had heated a rock face, which in turn had warmed the air above it. Warm air rises, and this towering air mass now twisted upward, a long finger jabbing at my wingtip as it passed by. My reactions as an old hang-glider pilot were instinctive and I quickly banked the aircraft to find the centre of the thermal.

*Wham.* There it was again. The aircraft pitched upward in the turbulent air—a sure sign I'd found my flying carpet. I began to circle, each spiral 200 feet higher than the last. The mountaintops slid beneath me and still I climbed higher. I lost track how many times a prominent peak in the distance circled past. I pulled the zipper on my leather flight jacket even tighter, for the air was now becoming shivering cold. The small, fat hand of my altimeter gradually edged past the 11,000-foot mark. And then the magic.

A brown blur suddenly caught my eye, just off to the left. A bald eagle, less than a 100 feet away, drifted peacefully past my wing, silent as a shadow. His flight seemed effortless, wings outstretched, intuitively sensing this air better than I could ever hope to. For one brief moment, he turned toward me and our eyes locked. Time was suspended as this master of flight and I shared an almost sacred encounter.

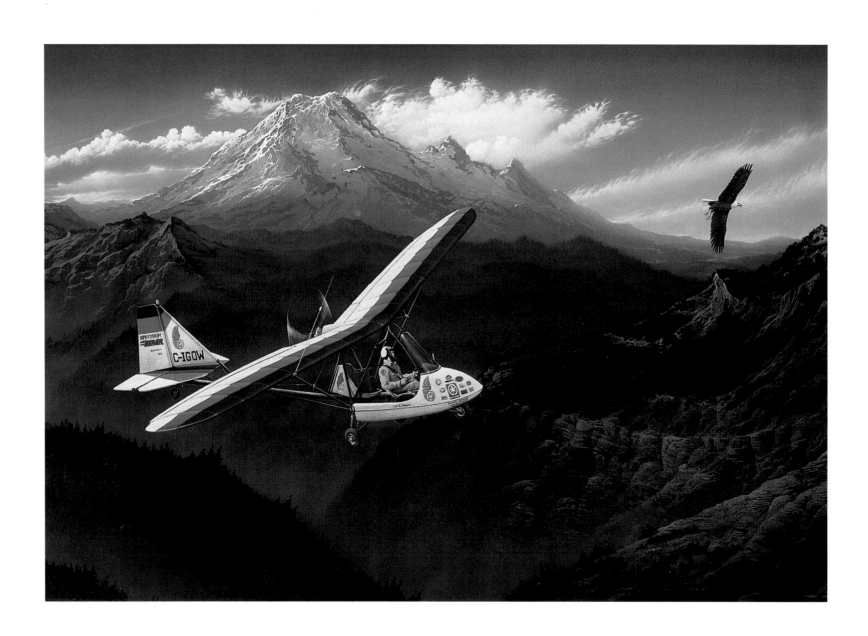

For me, this moment contained all of the dreams man has ever entertained of flight, of being one with the birds, from the mythological Daedalus to Leonado da Vinci's obsession with the ethereal air, to the first faltering flight by the Wright brothers. And in one revered instant, this gift was mine. There, alone above the mountains, shivering in rarefied air, I found myself embodied in the ultimate dream of flight.

Then the spell broke just as quickly. The eagle dipped a wing, veered gracefully, and disappeared into the mottled landscape below. I grabbed my camera, but even as the motor drive spun the film past the shutter, I knew it was too late. Even if he had remained in perfect formation flight, no film could have captured this moment.

I flew on alone, overcome with a sense of wonderment and oneness with the sky. Only once had I encountered words that came close to describing this feeling. They were the last few lines of John Magee's classic aviator poem, "High Flight":

*...or even eagle flew.*
*And, while with silent, lifting mind I've trod*
*The high untrespassed sanctity of space,*
*Put out my hand, and touched the face of God.*

A ugust 28, 1986. It had been 58 days and 5,000 miles, and this was the last leg of the flight. Just 30 more miles. Compared to the overall intensity of the last two months, this final stretch felt anti-climactic. My heart was full with emotion as the Pacific Ocean slid into view, then the city of Vancouver, and finally, Expo. As the pavilions of the World's Fair became visible, I was surprised by how familiar they looked. I had an uncanny sense that the buildings were exactly where they belonged, almost a déjà vu. Then it struck me. I had seen this view many times before through the process of visualization.

About a year before Expo opened, I had been given a promotional brochure containing an artist's conceptual view of the site. I had pasted a photograph of my ultralight in the sky just above the cluster of pavilions, and almost every day, for the next twelve months, I had spent a few minutes staring at that picture, imagining myself arriving safely at Expo. Visualizing my victorious arrival had become the proverbial carrot hung just beyond the doubts and difficulties. It had been the incentive I needed to stay with my commitment.

Visualization is the formation of mental images. Scientific studies have shown that our central nervous system does not know the difference between a real and an imagined experience. What we believe to be true can easily become so. The mechanics of visualization are simple enough. Fundamentally, the process involves the conscious mental repetition of what we wish to achieve. By imagining success, we subconsciously begin to believe that we are actually capable of accomplishing it. The key is to project ahead and see ourselves as having already achieved our goal—be it a sales target, a rekindled relationship or a perfect run down the ski slope. If we then couple that belief with the necessary effort, the seemingly impossible becomes possible.

"Gift of Wings, give us a smile on your left," my headset suddenly crackled. I jumped, startled by this intrusion. Off my left wingtip hung a huge helicopter with a photographer perched in its open door. A TV news crew were filming this last chapter of my journey. I waved back at them as we flew in formation over the city and toward the coast.

Special permission had been granted for an aerial tour of the Expo site, and I now began a wide circle over the pavilions. I snapped a few pictures, but to my surprise, my heart wasn't in it. It was gratifying to know that I had completed my goal, but I was also engulfed by a strange sadness.

Where was this coming from? I wondered. And

then I realized: This was the end of the dream. I was suddenly tempted to turn eastward and head back to the mountains. I wanted to keep flying. As many others before me had discovered, the joy was not in the destination, it was in the journey.

And so the dream came full circle—from a simple idea to months of planning, to the actual flight. A five-year journey. I pulled back the throttle for the last time and as the engine slowed to an idle, the altimeter needle began its counter-clockwise rotation. Five hundred feet. I banked left into the wind for my final approach. By now I could see small waves on the Pacific Ocean. Just off the beach of English Bay, the water looked relatively calm and I steered slightly to the right. The altimeter steadily reached for zero feet of altitude—precisely where it had begun this trip 5,000 miles ago. A hundred...fifty... twenty—at ten feet, I eased back on the control stick. Hold it off, hold it off...a light bounce...splashdown! A perfect landing. A perfect finale for the trip.

I smiled as once again the ultralight rocked gently in the ocean waves. Salt air tickled my nose. The Pacific Ocean. I had done it. A coast-to-coast flight in an ultralight aircraft. I had been given my gift of wings.

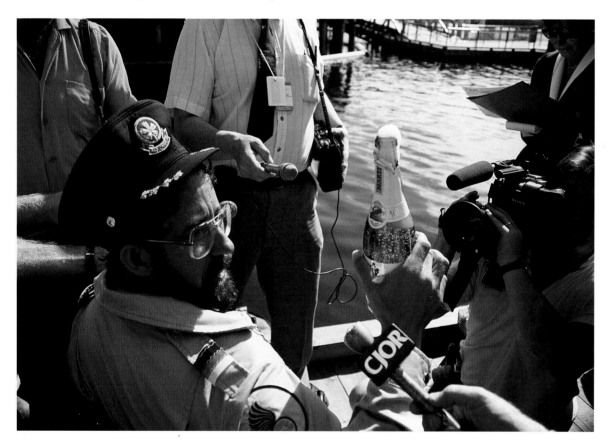

# POSTSCRIPT

It often seems the truths in life that are worth discovering are so simple we trip over them. We look for the grandiose, the profound, and miss the obvious. Perhaps no one understood this better than Nadine Stair. I came across her wisdom years ago in a simple one-page note that I've read many times since, and often use as a closing to my presentations as a speaker. It's become a bit of a touchstone, a favourite gem, rubbed smooth and comfortable in the hand, never farther away than a deep, warm pocket.

Nadine Stair was blind, 85 years old, and living alone in the Appalachian hills when she was asked what she would do if she could live her life over. You might argue that her response is somewhat simplistic. I think it is profound:

"If I had to live my life over, I'd dare to make more mistakes next time. I'd relax, I'd limber up. I would be sillier than I've been this trip. I would take fewer things seriously.

"I would take more chances. I would take more trips. I would climb more mountains and swim more rivers. I would eat more ice cream and less beans. I would have more actual troubles but fewer imaginary ones.

You see, I am one of those people who has lived sensibly and sanely, hour after hour, day after day. Oh, I've had my moments, and if I had it to do over again, I'd have many more of them. In fact, I would try to have nothing else. Just moments, one after another, instead of living so many years ahead of each day.

"I've been one of those persons who has never gone anywhere without a thermometer, a hot water bottle, a raincoat and a parachute. If I had my life to live over, I would start barefoot earlier in the spring and stay that way later in the fall. I would go to more dances. I would ride more merry-go-rounds, and I would pick more daisies."

I wish you a wonderful barefoot journey as you wander through this book and toward your own dreams.

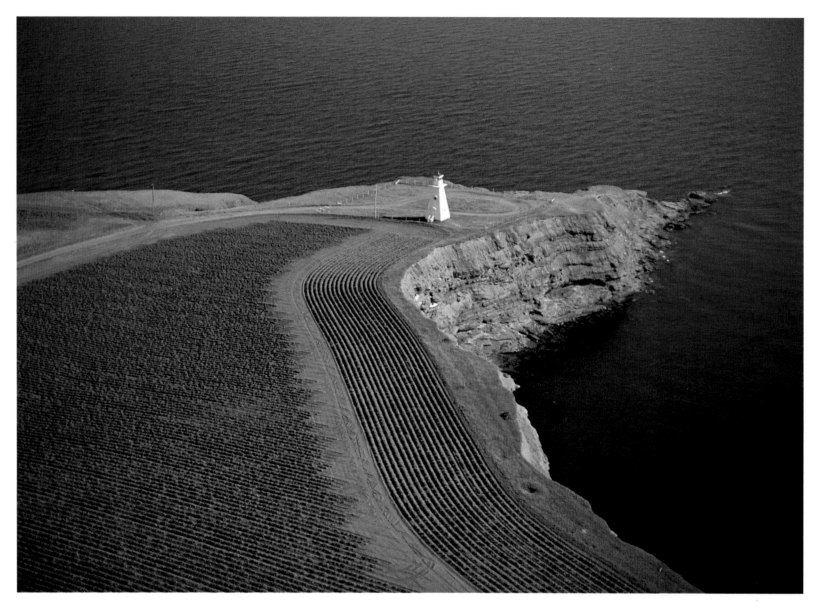

Established in 1905 to warn the sailors of sudden cliffs, this lighthouse now faces a future with an ironic twist.

The danger of the sea is still there, but this time it is the sea itself that has come to claim the lighthouse.

A century ago, no one could have anticipated the erosive power of relentless pounding waves.

Will the engineers return in time to build a protective sea wall around the base of

this beacon, or will this popular tourist site be returned to the ocean?

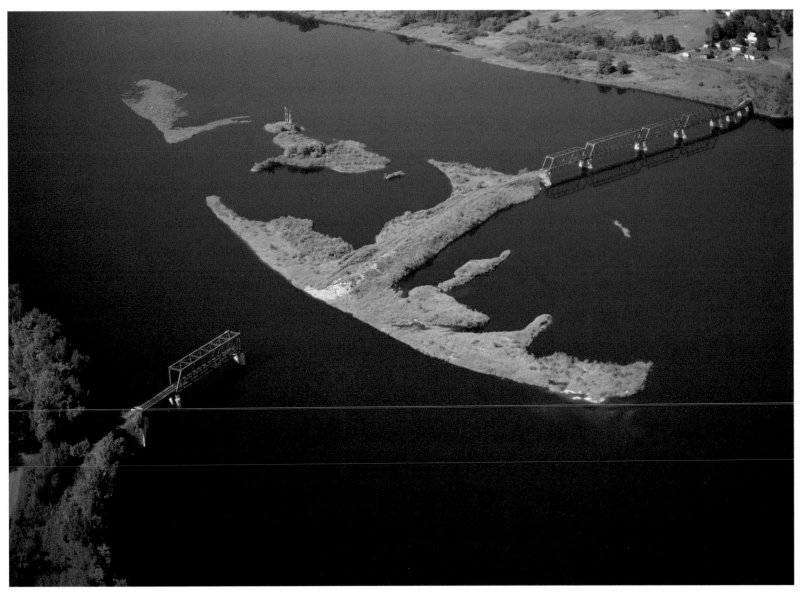

Shortly after this picture was taken, I attended a Gordon Lightfoot concert and heard him introduce a song
that he said was a proven crowd-pleaser around the world, "The Great Canadian Railroad Trilogy." Unfortunately,
hundreds of miles of rails are no longer in service. Here, where a former CP track crosses the St. John River,
spring floods have washed out a span and deposited it downstream. There seems limited justification
for its replacement and the gaping hole is a sad reminder of the men and the vision
that once linked this country together with a ribbon of steel.

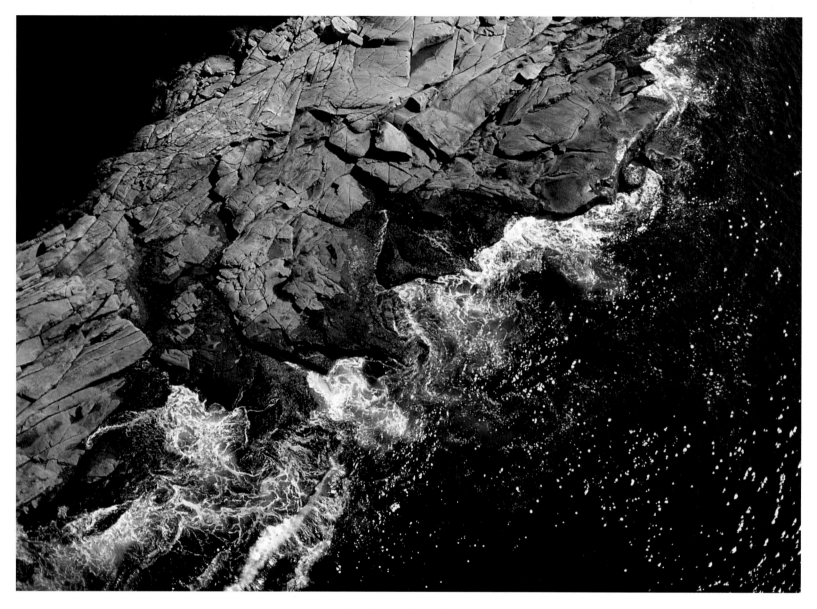

CAPE NORTH, NOVA SCOTIA

Looking down on this coastline, I felt I had a privileged view into the inner workings of nature's
definitive timepiece. Surely this was the ultimate measure of time—great, white, surging
hands sweeping across rock shores and marking this endless ebb and flow.

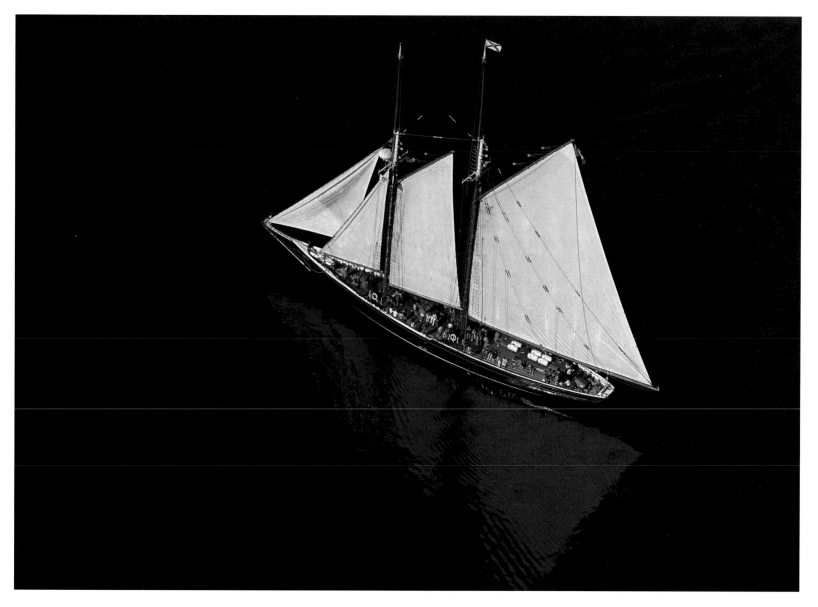

HALIFAX, NOVA SCOTIA

There is a stateliness about the *Bluenose II*, and rightly so. She possesses the spirit of
dedicated seamanship and the love of adventure from those early years of iron men and wooden ships.
The original *Bluenose*, a long, lean schooner and every bit a Lunenburg saltbanker, was launched in 1921.
She had a touch of magic built into her hull, and not only won the first International Trophy sailing competition
she entered, but held that prize against all comers for the next twenty years. She became a legend
among seafaring people and still sails today on the back of our ten-cent piece.

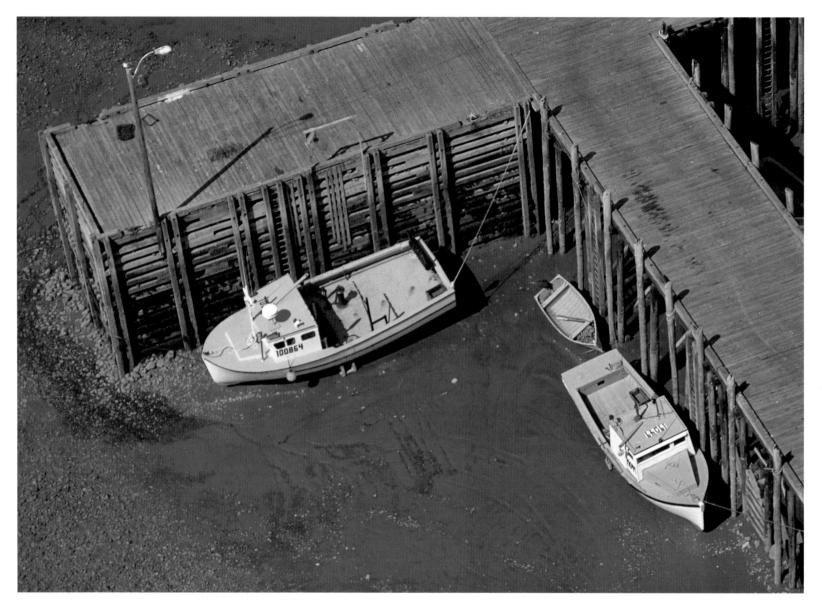

PARKERS COVE, NOVA SCOTIA

When the moon and sun combine their cosmic powers to massage the Earth's oceans, they do their best work
in the Bay of Fundy. Record-breaking tides of 54 feet have been set here as the Atlantic is drawn into this narrowing
bay. Seagulls wait patiently for the waters to recede and leave behind a fresh feed, and woe betide the fisherman
who disregards this immutable timetable and arrives too late for his morning expedition. Twice a day,
these coastal harbours are emptied and then refilled in this eternal cycle of the heavens.

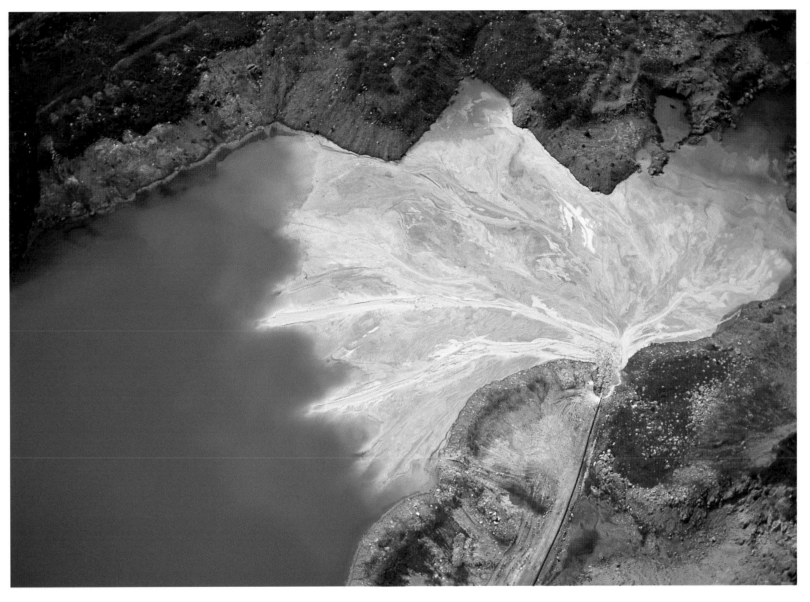

WINDSOR, NOVA SCOTIA

This moonscape is the result of gypsum mining. After it is quarried and crushed, the rock
is washed free of impurities and the resultant tailings pumped back into the quarry. I prefer to see it as
an artistic technique, where an abstract expressionist has splattered blobs of paint on canvas. Here, the space
has been filled from a central point to create this uncontrived but striking maple leaf. The lime green
is caused by light refracted on finely suspended particles of gypsum and anhydrite.

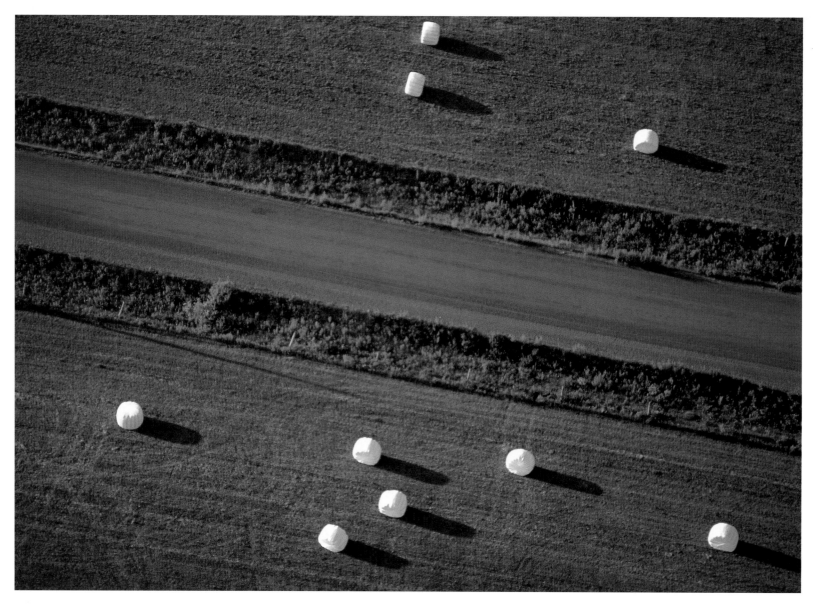

Children instinctively cry out "marshmallows" when they see these. They are equally appealing to cattle,
for just one round hay bale will keep a cow happy for a month. Technology has given the farmer a small edge on
unpredictable weather. He can now wrap his half-ton food canisters in white plastic, which greatly
reduces spoilage. A good year will yield six to seven bales per acre with the first cutting.

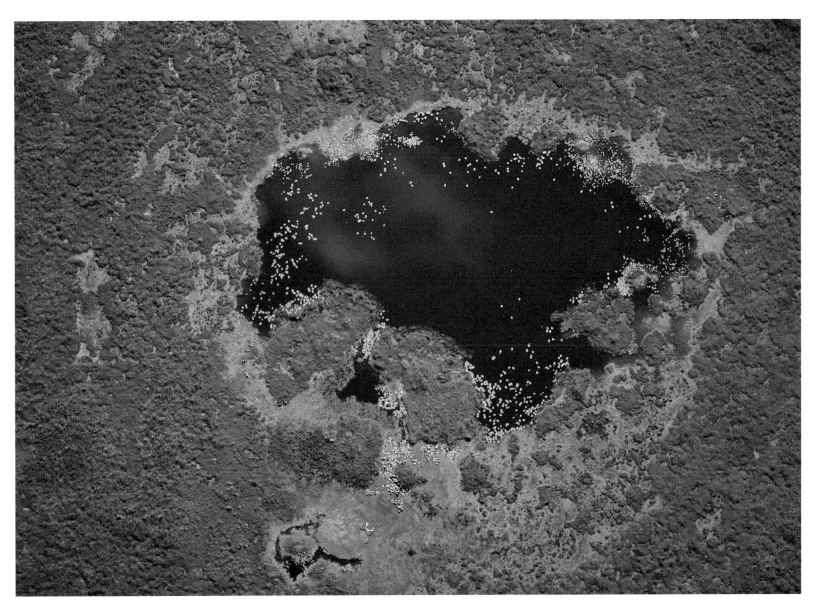

POINTE-SAPIN, NEW BRUNSWICK

The iguana's eye stared unblinkingly into my lens, curious as to my intrusion. So convincing is this interpretation,
I almost had to remind myself I was still flying an airplane, 100 feet above the lowlands of the east shore.
The rich colours are a combination of thick sphagnum moss and evergreen heaths. Underlying this
is a root system that can vary up to 20 feet in thickness. To give you a sense of perspective,
the small green-white dots on the pond's surface are lily pads.

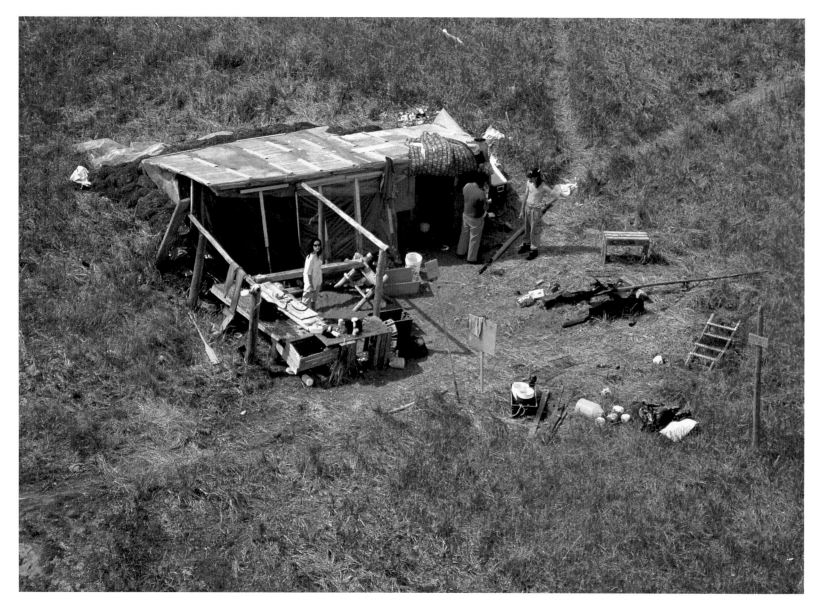

KOUCHIBOUGUAC NATIONAL PARK, NEW BRUNSWICK

This is the house that Jack built. When the government expropriated coastal land for this national park,
Jackie Vautour, an original landowner, decided he'd rather stay. His ongoing battle with the bureaucrats to remain
in this modest abode has involved several cash settlements, heated discussions, lots of press, and even the exchange
of bullets. After twenty-six years, Jackie is not only still a periodic park resident but has also become
somewhat of a folk hero to his fellow Maritimers, who have come to admire his incorrigible spirit.

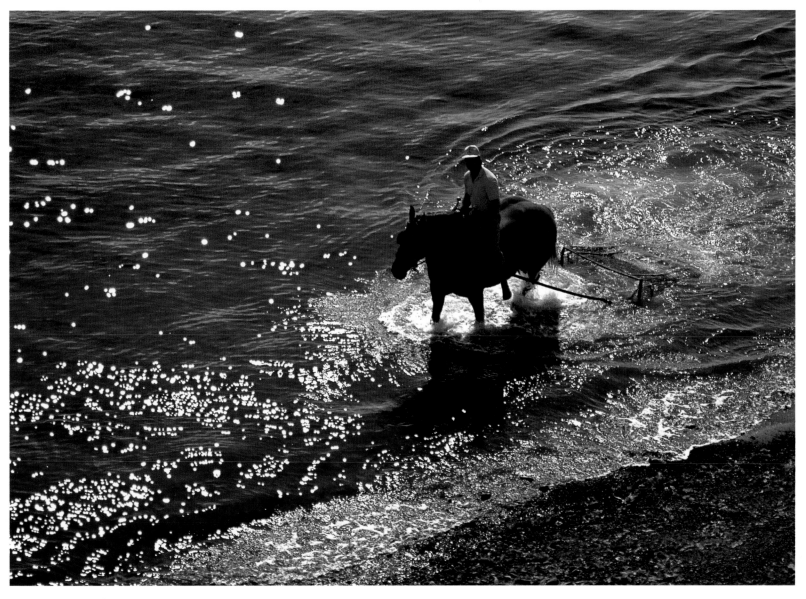

"It's hard work," says Floyd Ellsworth, "and I hope my boy doesn't have to do it." Floyd is of the third generation in his family to farm the sea, raking in Irish moss, a purplish seaweed, along PEI's northwest shore. A good week for him and horse, Prince, could net up to $500. Unfortunately, the most productive time for raking, the hours immediately following a storm, is also the most dangerous, and men have drowned on the job. The seaweed yields carrageen, used in the manufacture of medicines, cosmetics and many foods.

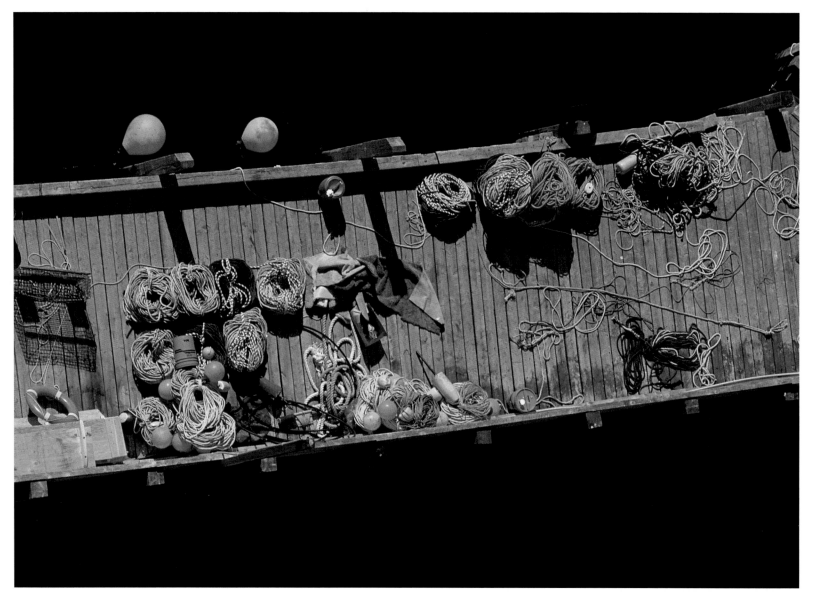

SOUTH SHORE, NOVA SCOTIA

There is something instantly captivating about this fisherman's dock, with its joyous vitality.
Nothing is lacking in his unintentional sense of colour and composition. Perhaps it is an awareness
of the dark side of fishing—the terrors of storms and the bleak realities of declining
fish stocks—that makes this work station appear all the more flamboyant.

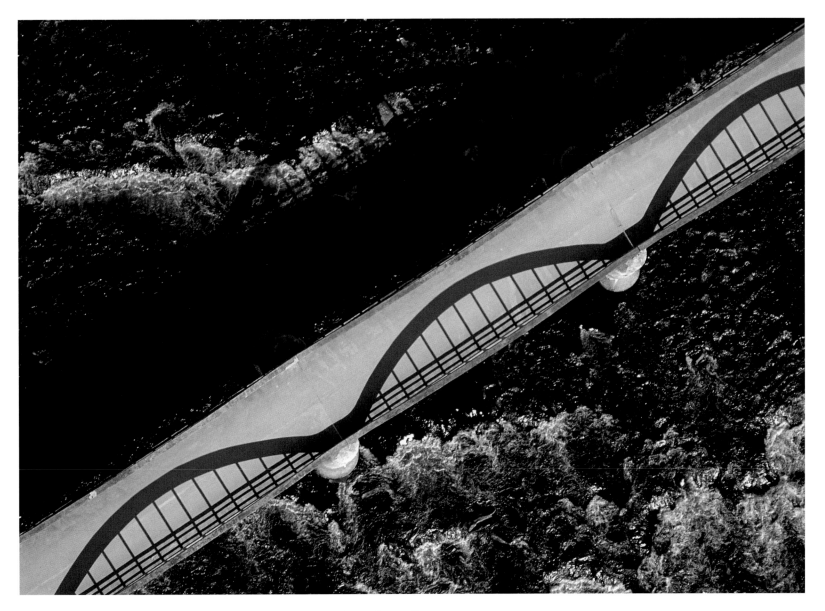

I'd flown for almost two hours and nothing had particularly caught my eye. In some respects,
central Newfoundland reminded me of Northern Ontario—seemingly endless miles of bush and lakes—and I'd
become lazy in my photographic search. Then, just a few miles before landing at Deer Lake, the elegant arches
of the Humber River bridge dazzled me back to awareness. A hard right turn, three shots straight down,
and one picture captured the intrigue of this simple but poetically designed structure.

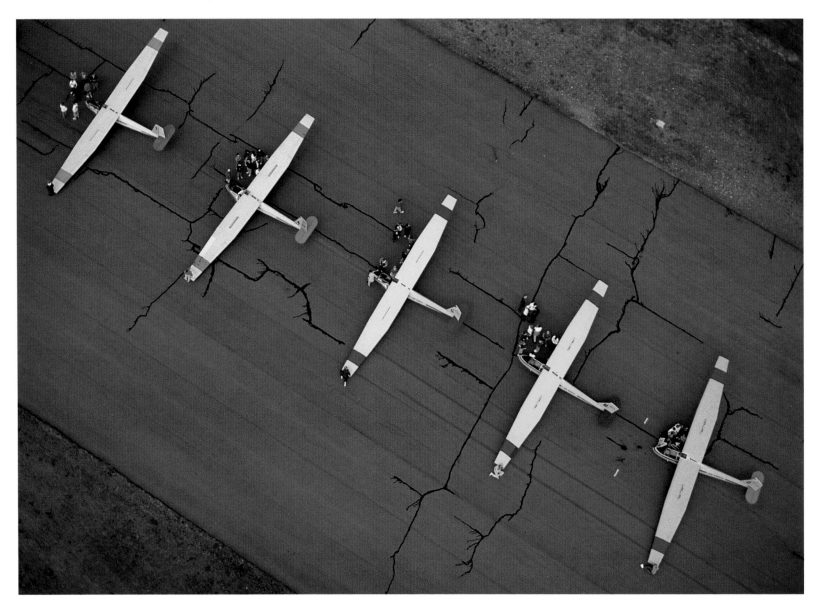

DEBERT, NOVA SCOTIA

In the words of the students, "It's awesome." Every summer, approximately 320 young men
and women (the top one percent) of Canada's Air Cadets head off for the skies with the glider training program.
Most are sixteen years old, don't even have a driver's license, and yet will qualify as pilots in command by
the summer's end. In the words of one instructor, "My throat still gets tight when I see these young people receive
their wings. The years of preparation and dedication have pulled out the best in them. They are bright,
highly motivated, and outstanding Canadians." Here, at 8 A.M., eager for another day of magic,
the students line up their Schweizer gliders at the old military base of Debert.

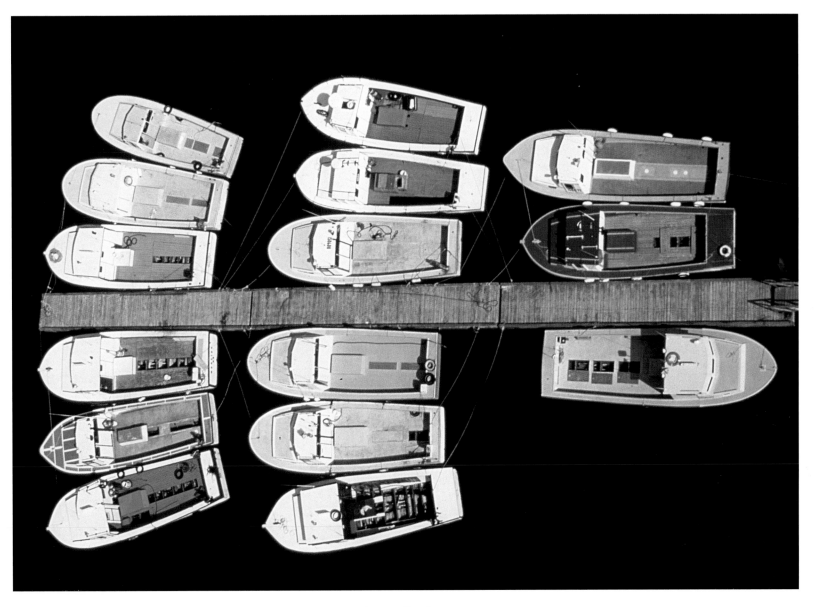

EAST SHORE, NEW BRUNSWICK

Another harbour, another cluster of lobster boats on New Brunswick's east shore. But this one made me wonder.

Who owned the boat in the lower right-hand corner? Why did he point his boat in the opposite direction?

Was he a south paw? Had he always listened to the beat of a different drummer or was he just having a bad day?

Most likely, the skipper had arrived for just a quick stop and tied up his boat in the easiest way.

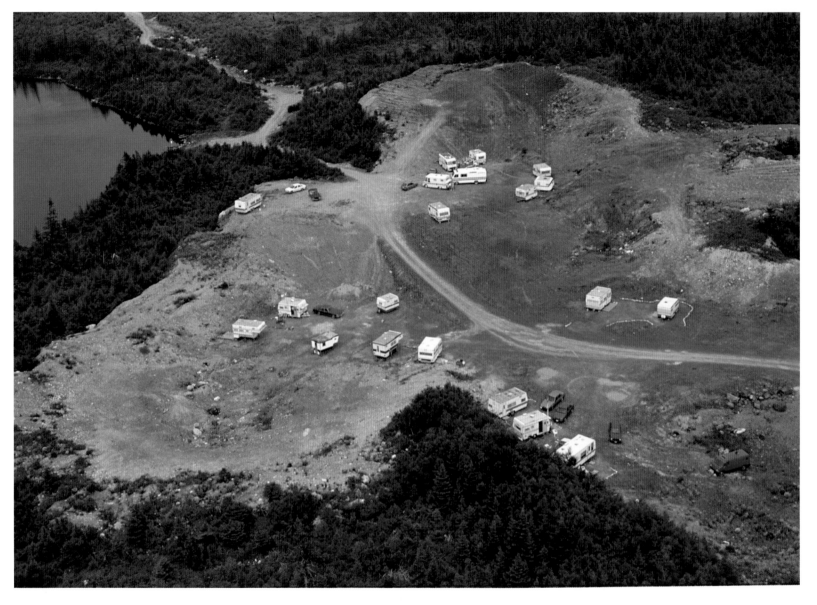

EASTERN NEWFOUNDLAND

At first sight, it seems illogical—camper trailers in a gravel pit just off the Trans-Canada Highway. But, no, this is one of numerous such weekend retreats scattered across Newfoundland. So time-honoured is this tradition of family camping at the pit, it has even been immortalized in a local folk song ("The Pits") by Buddy Wasisname and the Other Fellers. It speaks of polishing off a bottle and a pot of moose stew, flying a Newfie flag, telling stories and having just a lovely time. The chorus goes:

*It's the twenty-fourth of May and we like to get away*
*Up in the woods or going out the bay.*
*There's all kind of places but the place I like to get*
*Is up on the highway to the gravel pit.*

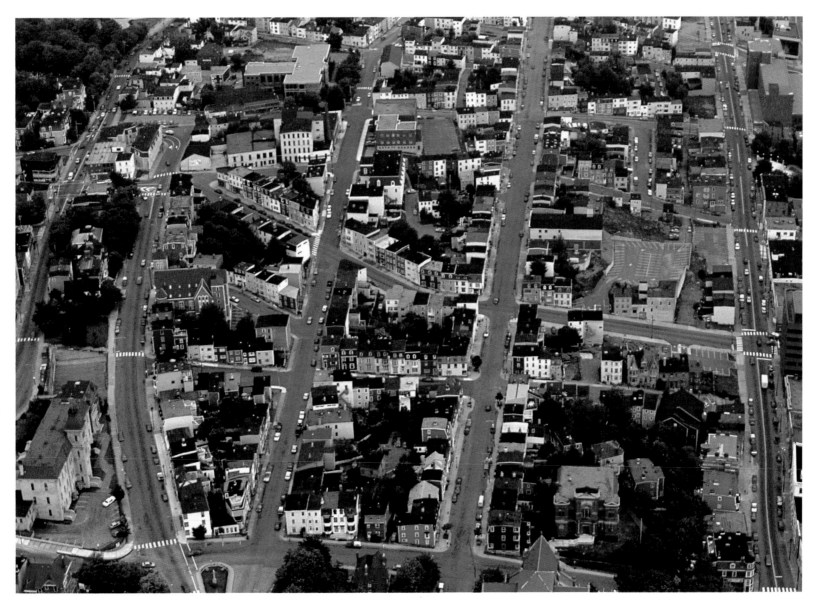

ST. JOHN'S, NEWFOUNDLAND

The old east end of St. John's is rich in history and culture. Most of these pastel wooden buildings were constructed after
the great fire of 1892 that wiped out much of the city. Today, the neighbourhood is populated by a mix of artists, downtown
yuppies and working-class families. A quaint story also lies in the curious and unexpected diagonal streets. They date from years
gone by when horse and cart dominated transportation. A kind-hearted clergyman wanted to make the horses' lives easier and
suggested that streets cross the hill diagonally, rather than at a steeper angle. One very early street was called Burst-Heart Hill.

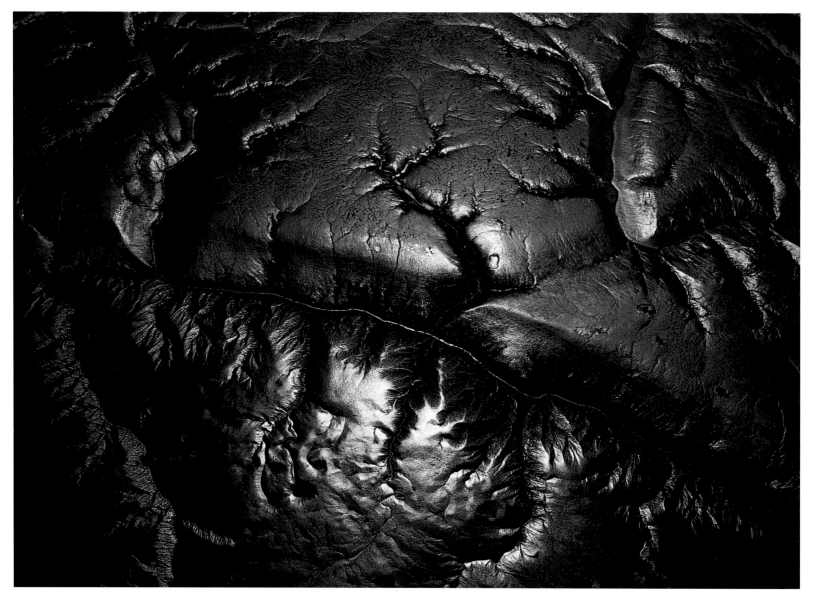

MUD FLATS, NOVA SCOTIA

The humour may be twisted, but I laughed when I saw this picture. It made me think I was peering into
a hospital operating room and viewing the explicit details of a liver operation. Nature is often astonishingly original
in its visual offerings. Seen here from 200 feet above are the tidal flats of the Bay of Fundy. The tide has receded
and left exposed miles of mud, mud, glorious mud, its luscious surface carved by rivulets of run-off tidewater.

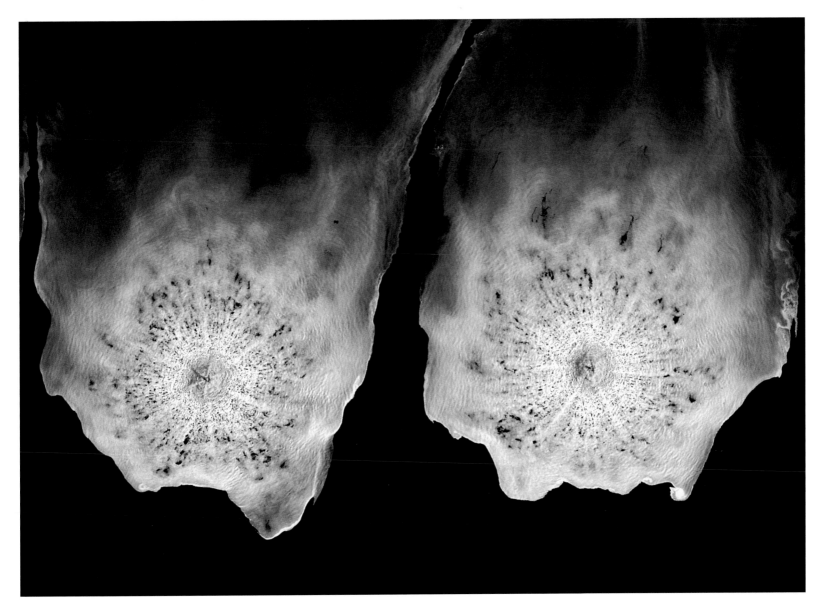

This photograph illustrates my basic philosophy that our perspective, how we look at things, makes all the difference. From the ground, this scene probably wouldn't receive a second glance. Yet from directly overhead, it is perplexing. It is nothing more than the aeration pond of a pulp-and-paper mill. As the effluent is sprayed up the centre pipes, it mixes with the air and changes from a yellow to a white froth. A north wind reaches down and gently sweeps it to one side of the pond. By isolating just two of these patterns from a much larger number, one's mind entertains thoughts of fried eggs or more evocative images.

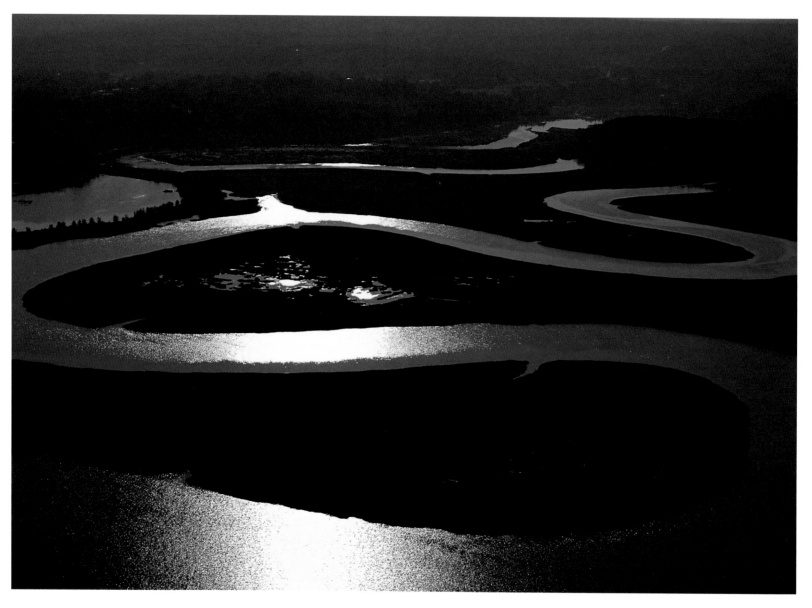

ANNAPOLIS RIVER, NOVA SCOTIA

An ultralight flight across Canada is an exceptional geography lesson. A few thousand years ago,
this river was much more directed in its course. By continuously transporting and depositing sediment, it began
to wander, and slowly built up the entire valley floor. It will eventually erode through the downstream banks of these
meanders, cut through the loops to form oxbow lakes, and once again flow in a much straighter course.
In my overhead flight, I was able to see and appreciate just one instant of this lengthy process.

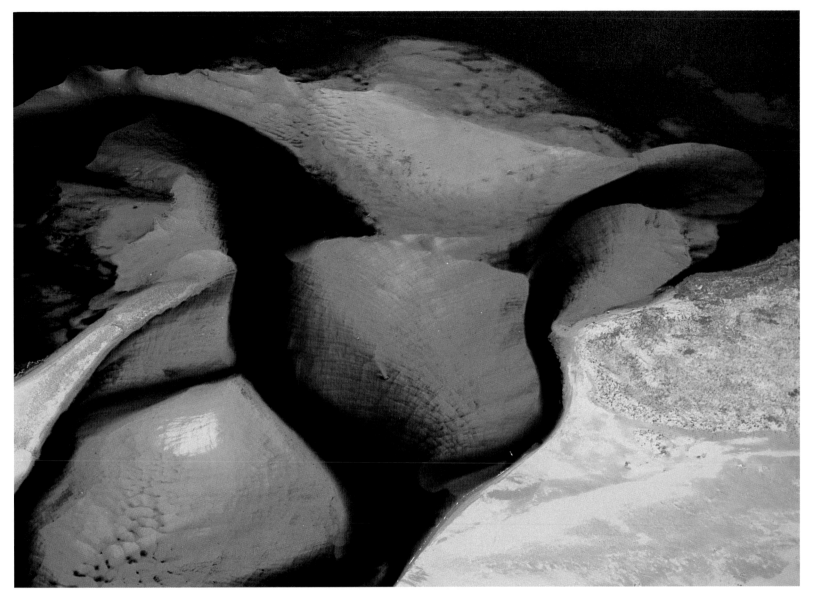

NORTH SHORE, PRINCE EDWARD ISLAND

Old sailors speak of the lure of the sea. I sometimes feel that same siren call when I explore
the edges of her frontier. As the sea communes with the shore in infinite conversations, she reveals
her more subtle moods. Much of her beauty is reserved for the aerial view—ebbing tides, shifting sands,
dancing light. Several illusions wait to be discovered in these shallow-water sandbar formations.
Is that a tiger's face, jowls full, staring towards the lower right corner of the photograph?

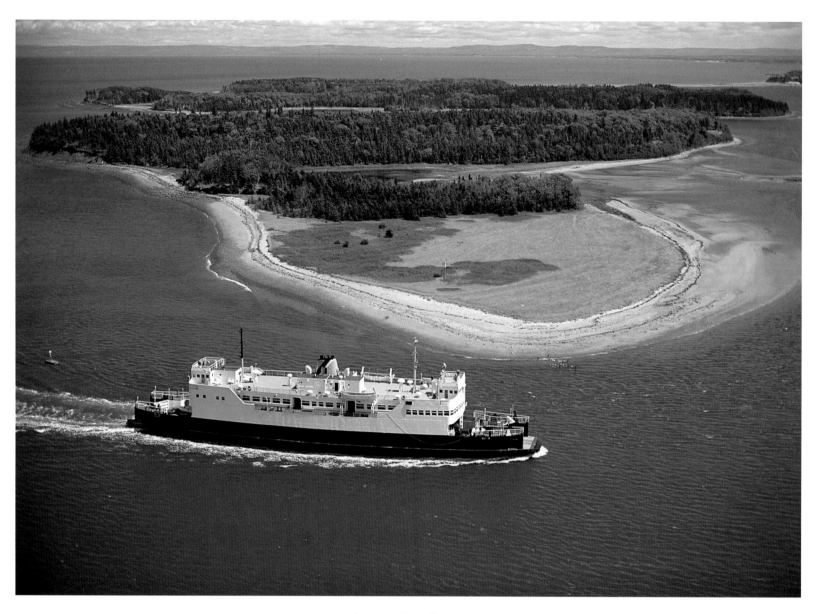

CARIBOU, NOVA SCOTIA

On a fair day such as this, the captain has little worry as he guides his ferry into Caribou Harbour. But add a strong nor'wester and he'll have his hands full. With a sandbar on the left side, Munroes Island on the right, and only 20 feet of depth even at high water, "He'll be smellin' the bottom at times." Fortunately, the PEI ferries have a flawless record and safely carry approximately two million passengers annually. They hope to continue operating even after the proposed fixed link, connecting the two provinces, is completed in 1997.

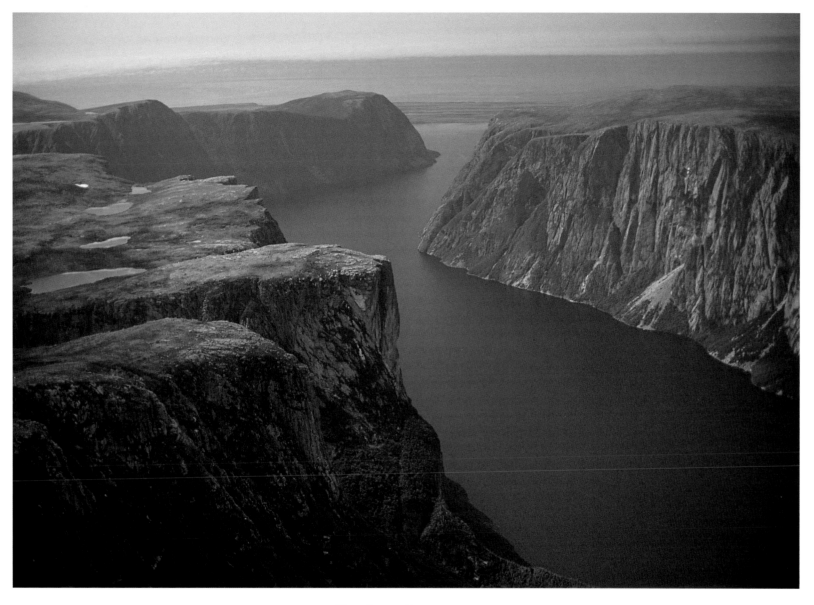

WEST COAST, NEWFOUNDLAND

It seems one of the best-kept Canadian secrets is the rich diversity of our landscape. I, for one,
had no idea that stunning fiords sliced into the west coast of Newfoundland's Gros Morne National Park. So unique are the
geographical features of this park, the United Nations has designated it a World Heritage Site. These cliffs soar over 2,100 feet
above the cold Atlantic and plunge another 500 feet below the surface. I had to sympathize with those dedicated purists
who spent four hours hiking up the back side of this summit. I had the luxury of merely shoving
the throttle forward and six minutes later was granted this inspirational view.

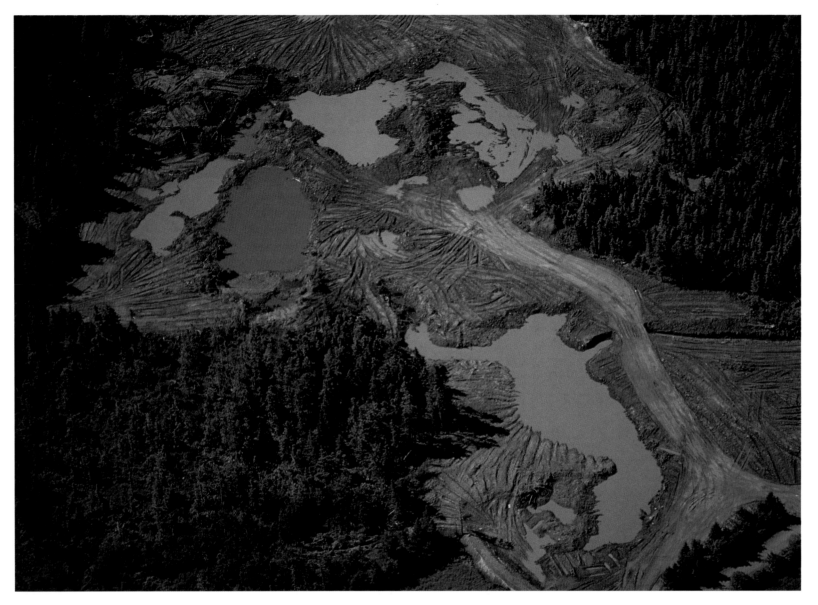

Most of the landscape of Prince Edward Island lies soothing to the eye, acres of brilliant green perfection.

Then, the unexpected—an explosion of chaos and savagery. Stripped of its trees by the butchering hand of progress,

this site now bleeds profusely from the iron-rich soil beneath. Yesterday a forest, today a clear cut, tomorrow a gravel quarry.

My flight continues, but I am left disturbed. How can we justify this Earth wound exacted by our consumer lifestyle?

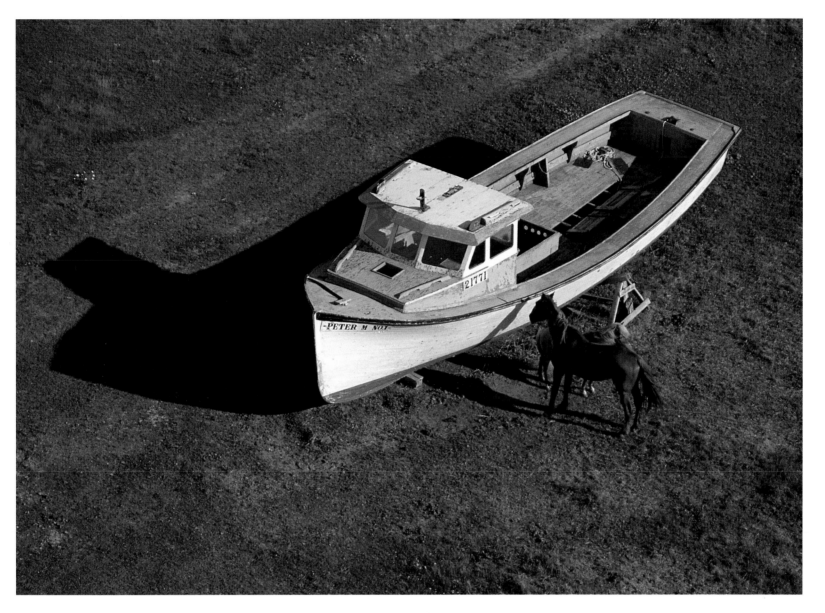

The *Peter M No. 1* reflects a good part of one man's working years. This boat was purchased in 1965
for $2,400, and for the next twenty-five years was used for fishing lobster off the North Shore of PEI. They
were long days, leaving the harbour at 5 A.M., but the work was enjoyable—each trap held new expectations.
Some years the owner barely made expenses, while others, he had an easy winter. But for those who
grew up on the boats, it was hard to imagine doing anything else. Today, the *Peter M* is retired and
serves as a pasture centrepiece, attracting only the odd inquisitive visitor such as this horse and foal.

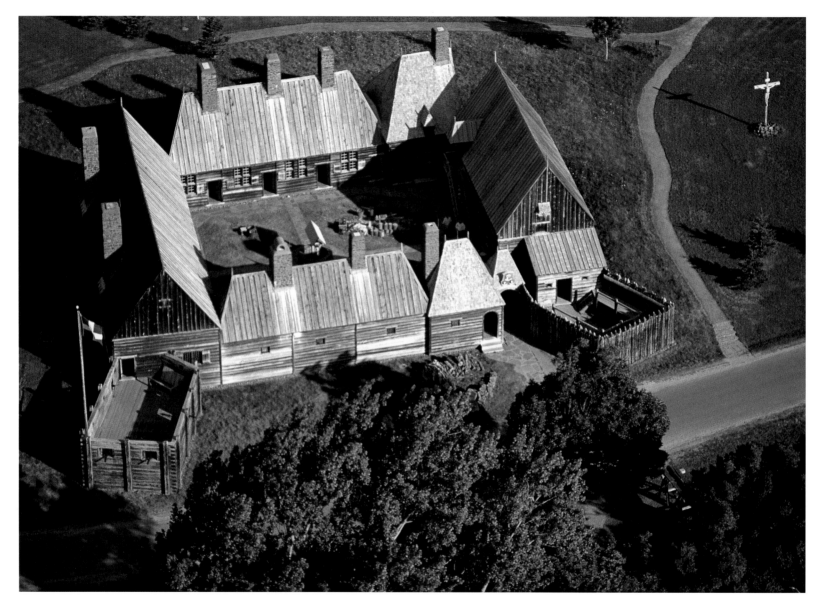

ANNAPOLIS ROYAL, NOVA SCOTIA

We sometimes have a strange propensity in this country for learning more about American history than
our own. The story of the Pilgrims landing at Plymouth Rock, for example, is known to most Canadians. How
many realize that, fifteen years before that event, a small party of French explorers established Port-Royal, the first
European settlement in North America north of Florida? The year was 1605 when Samuel de Champlain
and Sieur de Monts built this fur-trading post. It was also home to one of North America's first
social clubs, L'Ordre de Bon Temps—the Order of Good Cheer—founded by de Champlain.

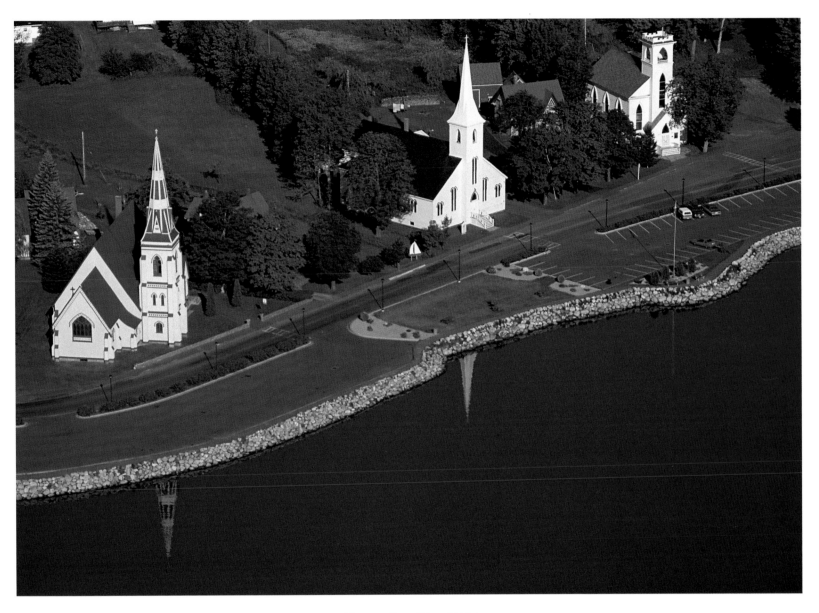

MAHONE BAY, NOVA SCOTIA

The residents of Mahone Bay may just qualify as the most ecumenically minded Canadians.
Members of these three churches (left to right: St. James Anglican, St. John's Lutheran, Trinity United), along
with the other two denominations in the bay, the Baptists and Pentecostals, often have special services together.
The Anglican church is original to the site, while the other two relocated here, on the town's main thoroughfare
and closer to the water. The flagpole reflection seems a ghostly substitute for Trinity United's missing steeple,
which was destroyed by lightning in the 1920s. A new steeple could have been erected, but it has now
become a part of that church's tradition not to have one. Tourists from around
the world regularly come to visit this scene of ecumenical tranquility.

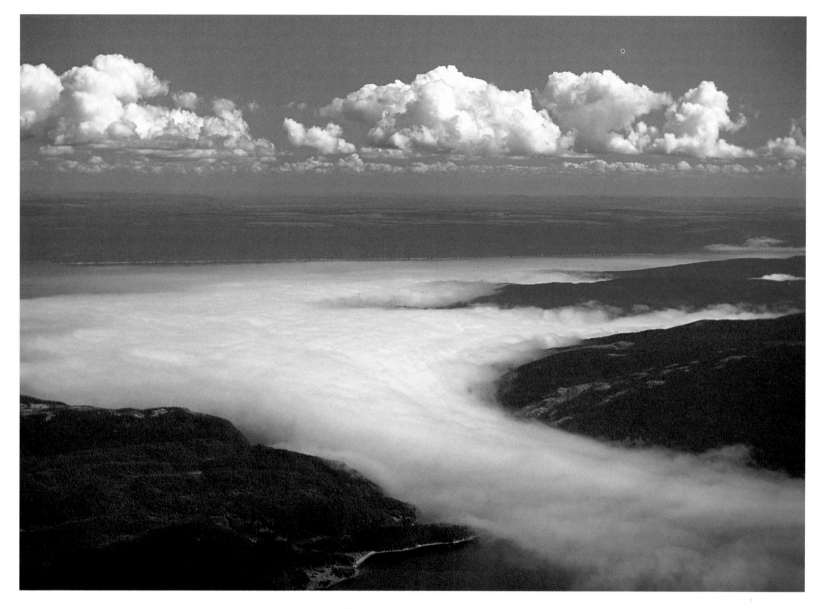

WHITE BAY, NEWFOUNDLAND

It's arguable that the weather of Newfoundland is the most unpredictable in Canada, for it is here that the
southern Gulf Stream meets the Labrador Current. Accurate weather forecasting is an oxymoron, so fishermen
and pilots learn to err on the side of caution. One St. John's pilot told me of numerous encounters with
"high-speed fog." The fog would rush in from the coastline, moving as fast as 40 mph, he said,
making it a nerve-wracking race to arrive before a grey blanket obliterated the airport.

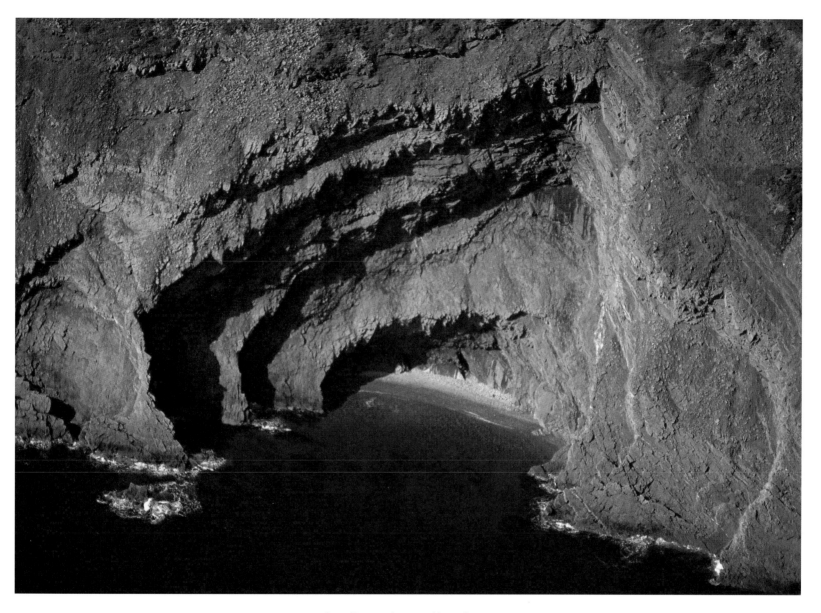

CAPE BRETON ISLAND, NOVA SCOTIA

"I have travelled around the globe. I have seen the Canadian and American Rockies, the Andes and the Alps and

the Highlands of Scotland; but for simple beauty, Cape Breton outrivals them all," said Alexander Graham Bell,

who lived much of his life in Baddeck, Cape Breton Island. Bell was also the visionary and driving force behind

the flight of the *Silver Dart*—the first manned flight in Canada. As I flew by this sea cave on

the Island's north shore, I wondered how more much eloquently Bell might have waxed

had he witnessed this stunning sea cave from the cockpit of an ultralight.

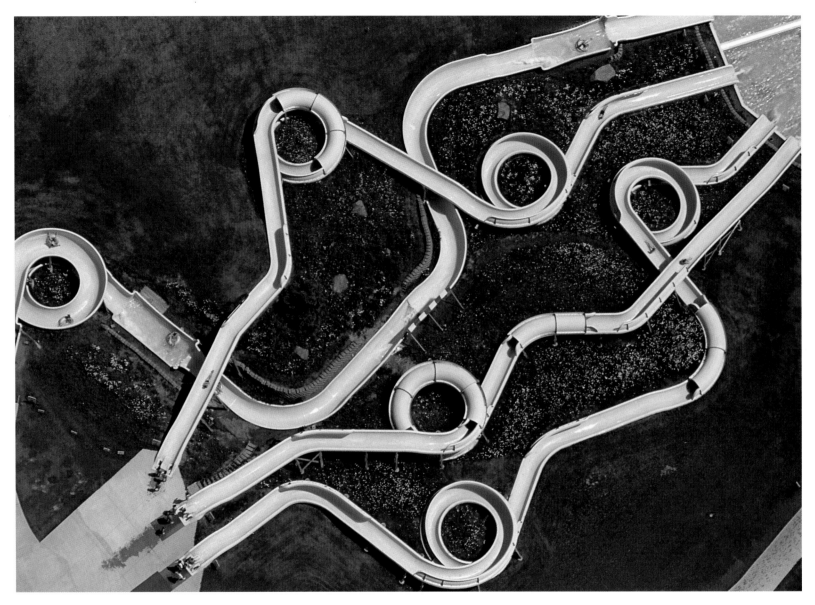

MONCTON, NEW BRUNSWICK

It is called the "Kamikaze," and for good reason. Fun-seekers accelerate to speeds of 40 mph on this
waterslide; they scream blue murder all the way down, and then buy "I've Done It" T-shirts just to prove it.
The most memorable day for the owner was the day a visiting women's troupe of young Czechoslovakian
dancers lost their bikini tops on this wild ride. "They just laughed about it, forgot about their tops,
and went up again. I lost the use of my male employees for the rest of the afternoon!"

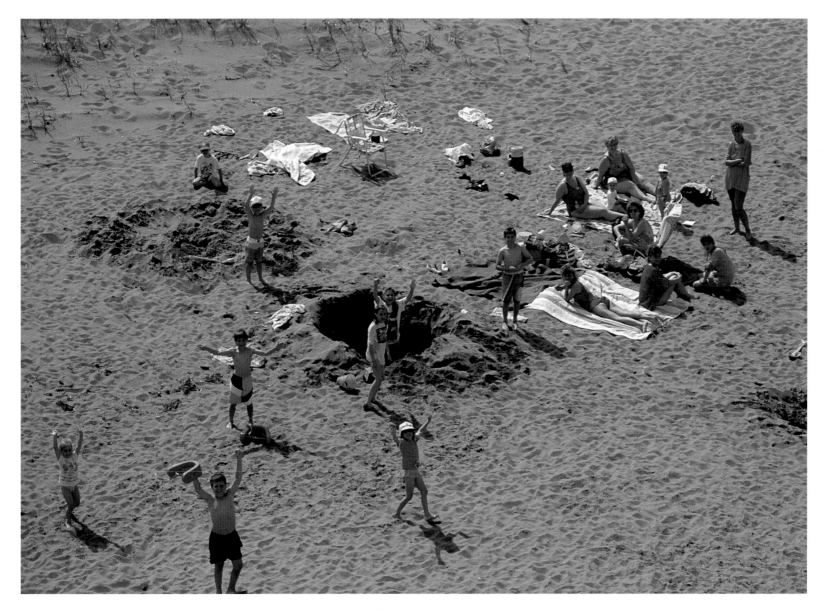

KOUCHIBOUGUAC NATIONAL PARK, NEW BRUNSWICK

I once visited an Inuit family on Baffin Island, and my host described their weather as nine months
of winter and three months of bad snowmobiling. Although many of us bemoan our extended winters,
they do give us a heightened anticipation and appreciation of summer. The exuberance
of these children reflects the child within us all, ready to embrace life to its fullest.

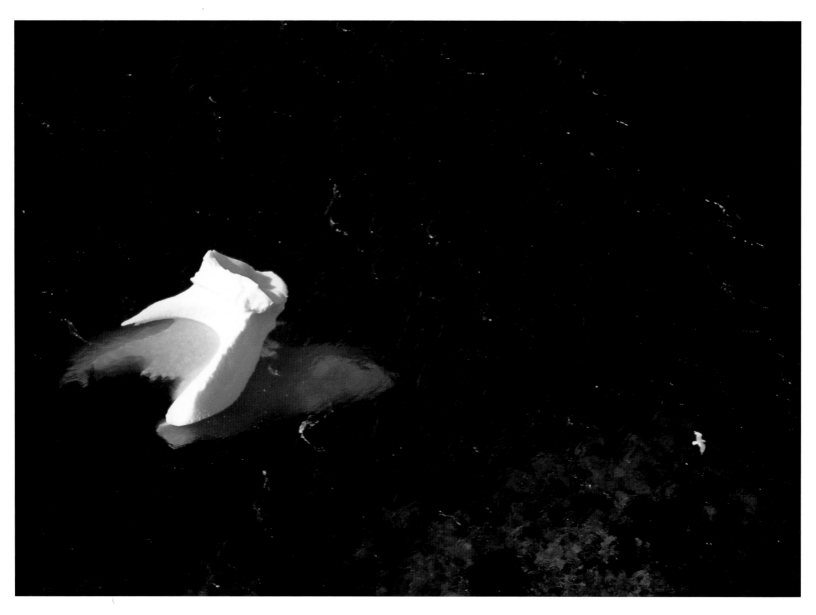

WHITE BAY, NEWFOUNDLAND

Each spring, Newfoundlanders brace themselves for the invasion of icebergs, swept down from
the Arctic glaciers. Hundreds of these sometimes immense sculptures are deposited along the ragged coastline.
As is the case with this look-alike Tyrannosaurus Rex molar, they often become grounded in shallow bays.
Despite their size, their existence is precarious and, like pats of butter in a bowl
of hot soup, they quietly and slowly melt into summer's waters.

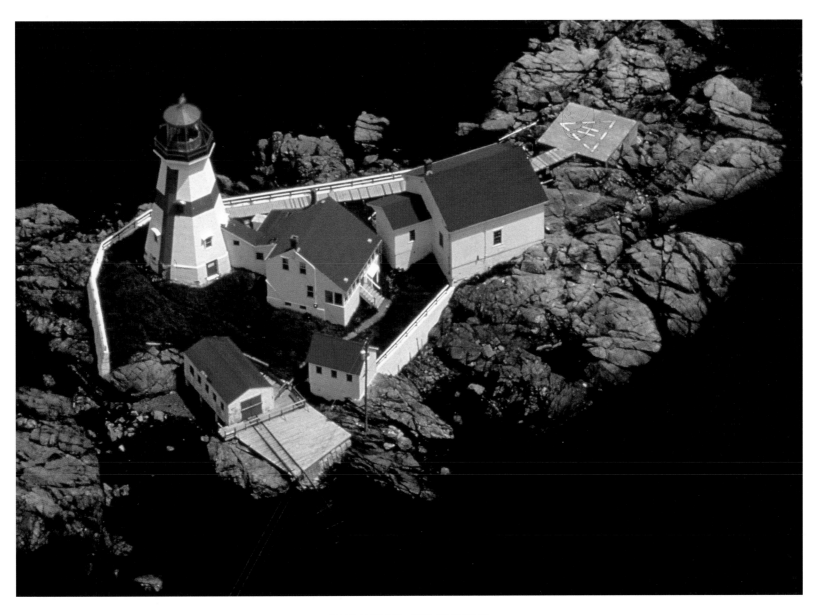

HEAD HARBOUR, NEW BRUNSWICK.

It seemed the perfect welcome mat: a large "H"—for Hiebert, of course—thrown
down at the end of the boardwalk. The sign, in fact, pinpoints a helicopter landing pad.
For all its well-kept appearance and orderliness, this lighthouse on Campobello Island,
over 160 years old, is now completely automated. The only human voices
heard here are those of an occasional maintenance crew.

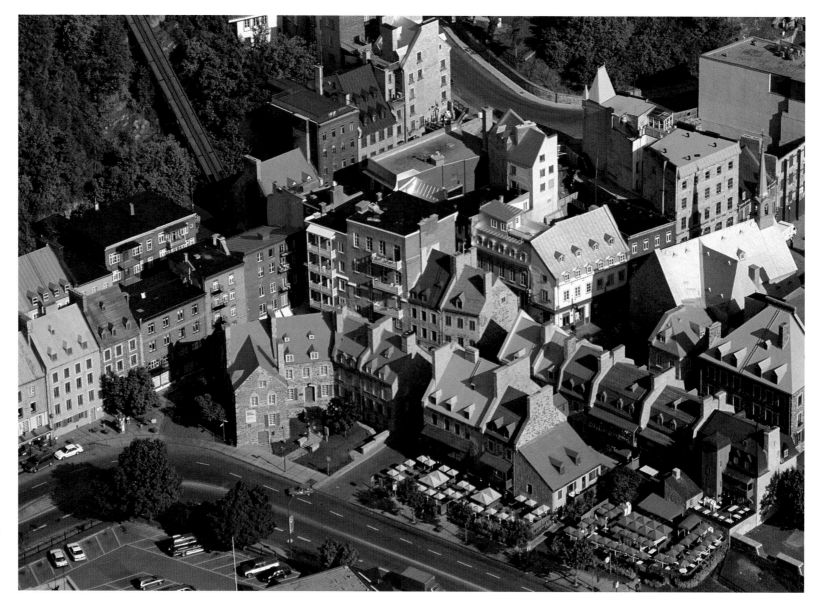

QUEBEC CITY, QUEBEC

Not only is this part of Quebec City one of the oldest districts on the continent, it has possibly the richest
architecture and heritage. Many of these buildings date back to the late 1600s, and it is only through
ongoing, patient restoration work that they retain their charm and elegance. For the most part,
small businesses such as cafés and souvenir shops occupy the ground floors, while
the upper levels house tenants fortunate to live in such historic apartments.

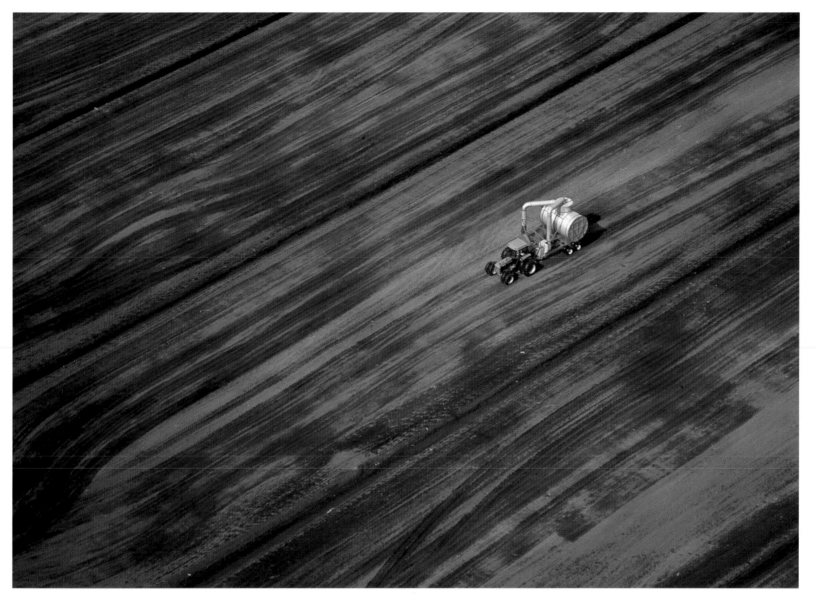

RIVIERE-DU-LOUP, QUEBEC

After days at sea, it has been said, a ship seems stationary and it is the island that seems to move toward
the vessel. In this photograph of a peat moss farm on the south shore of the St. Lawrence, the tracks give
the odd impression that the land is moving steadily by, while the tractor and huge vacuum cleaner rest calmly,
sucking up a thin layer of porous moss. The aerial perspective dramatically challenges our sense of motion.
Pedestrians are immobile, birds fly backward or sideways, and clouds always rush toward us.

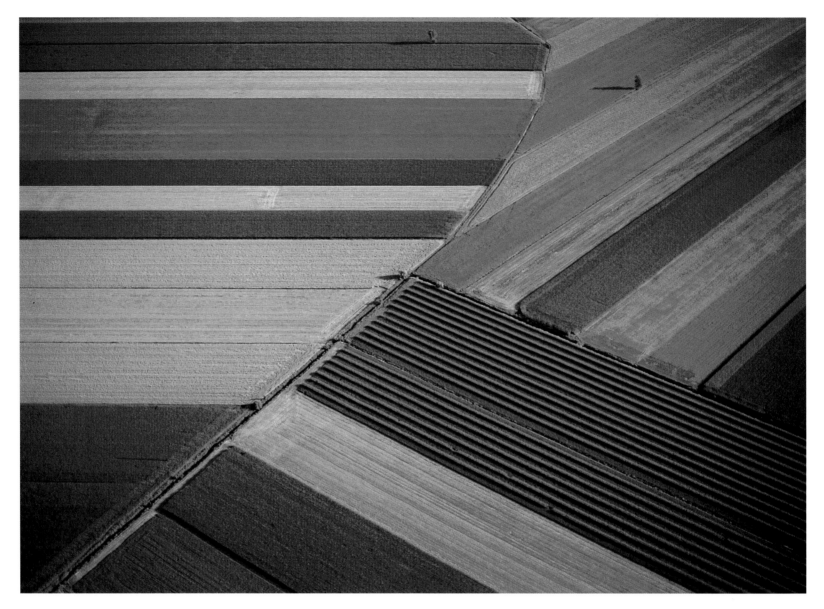

It is the distinctive seigneury farms that define the shoreline of most major rivers in southern
Quebec. Called "rangs," these long, narrow lots are an inheritance from the French feudal system.
Although the system was abolished in 1854, the farms are still the heart of Quebec's agriculture, and their
distinctive structure will remain for years to come. To the pilot on a coast-to-coast flight, these
patterns reassuringly confirm one's proximity to Quebec City or Montreal.

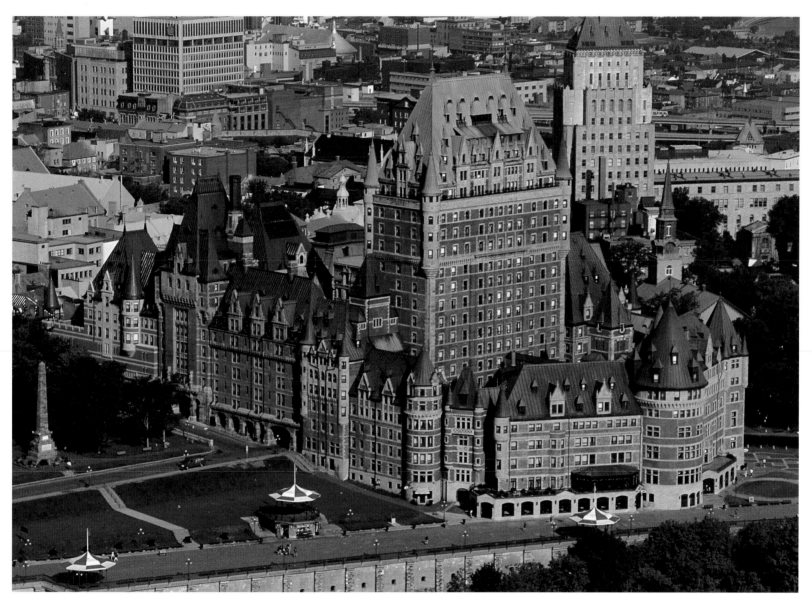

QUEBEC CITY, QUEBEC

In my flight over Quebec City, I felt dwarfed by this giant of a Canadian landmark, the Chateau Frontenac.
Designed to immortalize the history of the two great powers who once occupied the highest cape in Quebec City,
this castlelike building is no less majestic today than it was when it was built over a hundred years ago. Churchill
and Roosevelt met for historic conferences at this world-renowned hotel, and kings, queens
and celebrities from around the world have enjoyed its elegance.

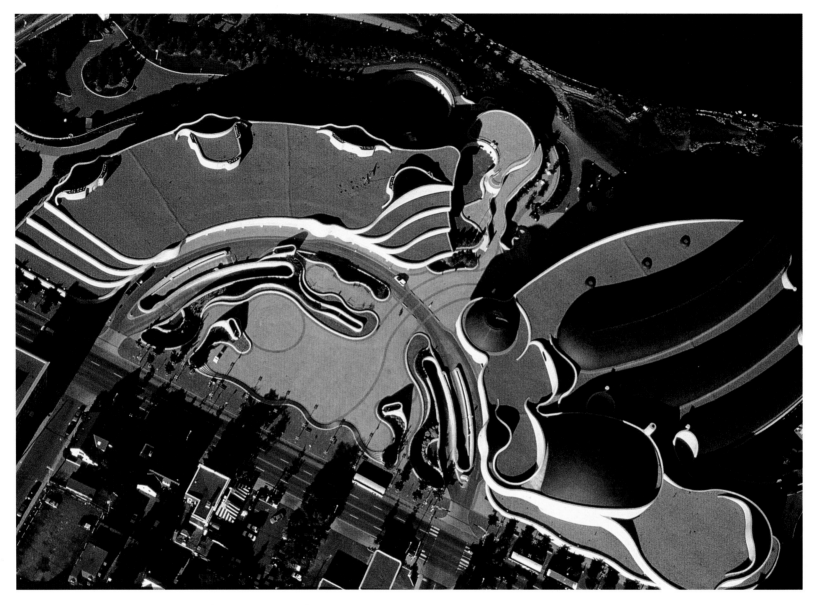

HULL, QUEBEC

Wandering through the rooms of the eye-catching Canadian Museum of Civilization, it's easy to miss
the novelty of its design. From overhead, it appears as though the architect has indulged in child's play, rearranging
his brown-and-white sculptured building blocks this way and that until a sense of rhythm and balance has
fallen into place. In fact the museum's shape is symbolic and speaks of the emergence
of this continent, its form sculptured by the winds, rivers and glaciers.

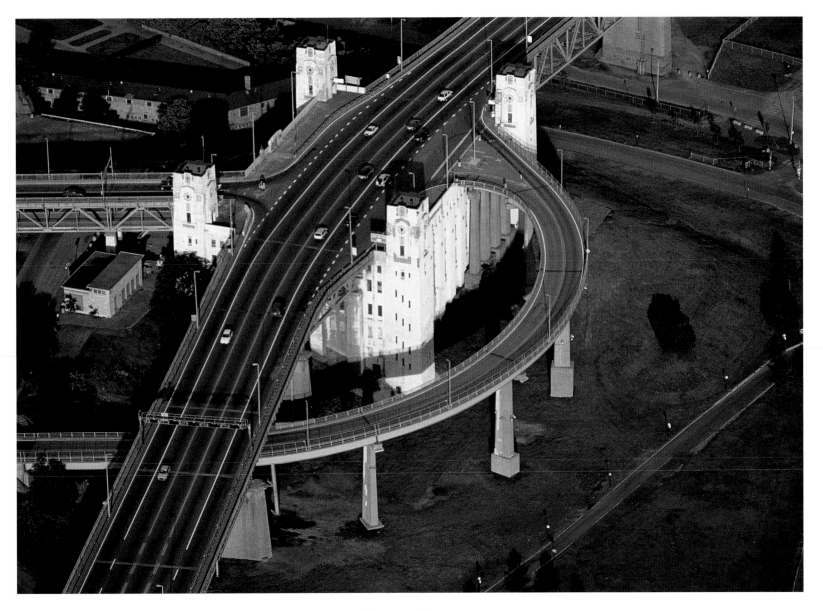

One can only shake one's head, smile, and wonder who arrived at this site first, the bridge engineer
or the building architect. There is a delightful irrationality here, as disbelief meets reality where the Jacques-Cartier
Bridge meets "le pavillion du pont" (the bridge building). For many years, the building was used both for storage and
offices. Perhaps the complaints of shaking walls and falling plaster were too numerous, for now the
structure is empty except for the lowest floor, used to store salt for the roadway above.

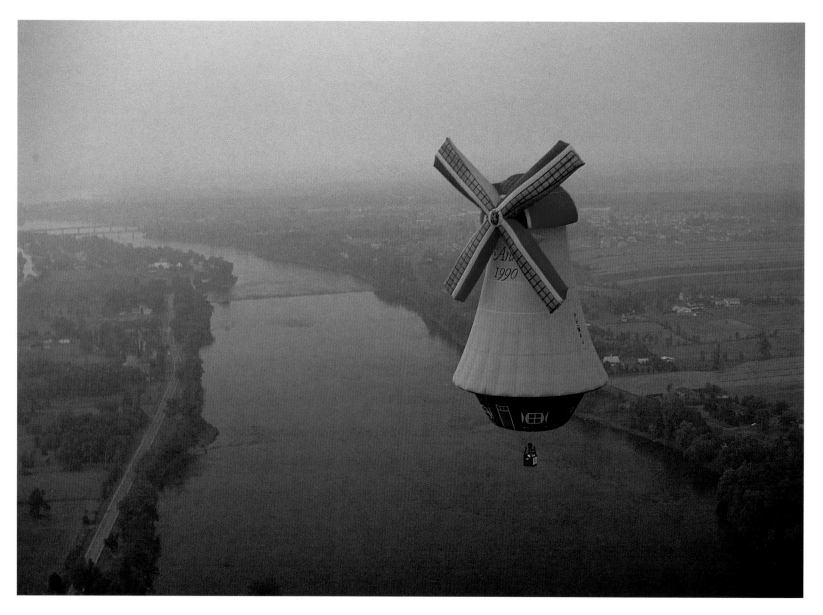

It was the opening day of the annual Festival de Montgolfier (balloon rally). Out of the early morning haze emerged this seeming apparition. Not surprisingly, the pilots were Dutch, and they had brought their 114-foot-high trademark all the way from Holland. A careful look reveals small green windows at the bottom of the balloon envelope, leading us to wonder who might be peering out from behind the curtains.

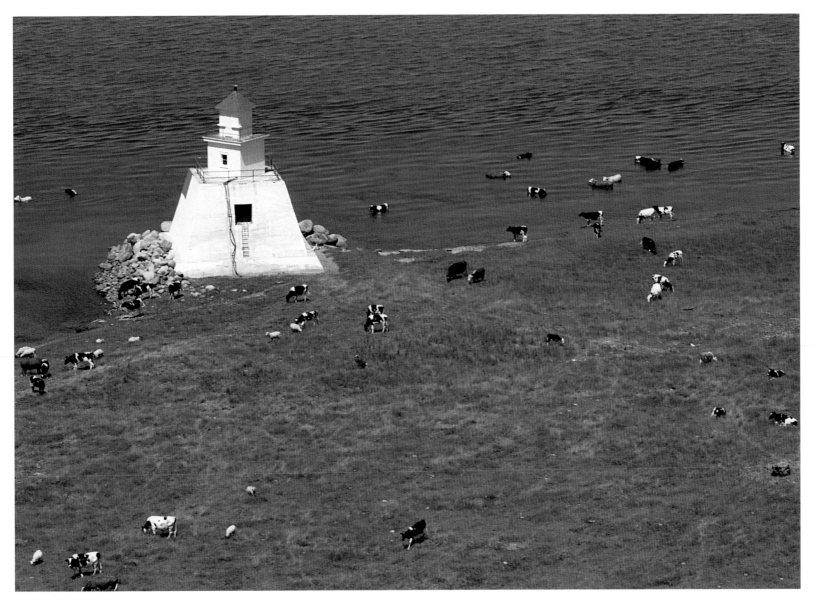

I did a double-take when I saw these cows. Didn't they notice the lighthouse that reminds them this is where the land ends and water begins? Perhaps there is a logical explanation for this bizarre scene. Perhaps a novel farming technique has been devised whereby the longer the cows spend in the water, the greater the farmer's chances of obtaining skim milk. The scene looks as though it belongs in a Gary Larson collection, with at least one Holstein equipped with snorkel and diving mask.

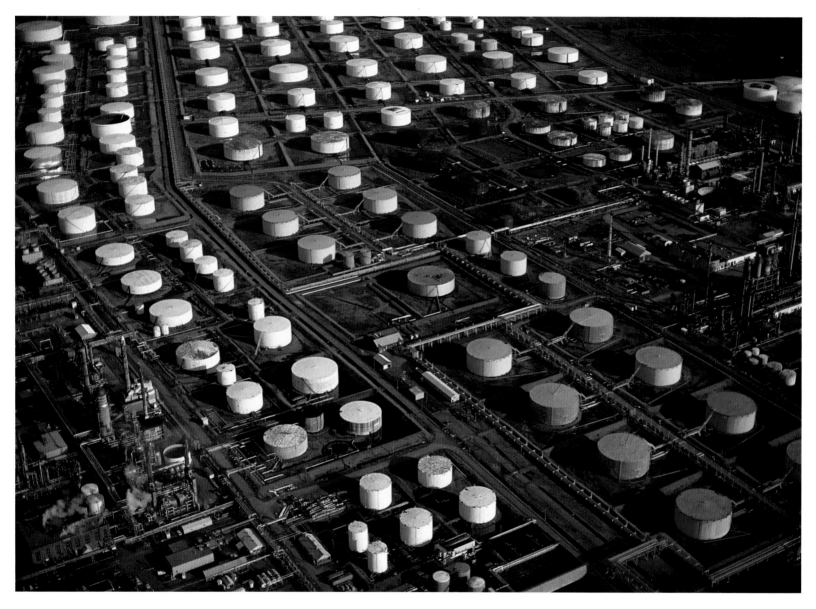

MONTREAL, QUEBEC

Looking like the production lines of a pill factory, this east-end refinery and storage facility in Montreal is
an important element of the Quebec economy. Its daily production generates home-heating oil, gasoline, aviation
fuel and chemical products. Even though Canada is self-sufficient in oil production, the complexities of transportation
and the competitiveness of today's global market mean that this operation uses only imported crude.

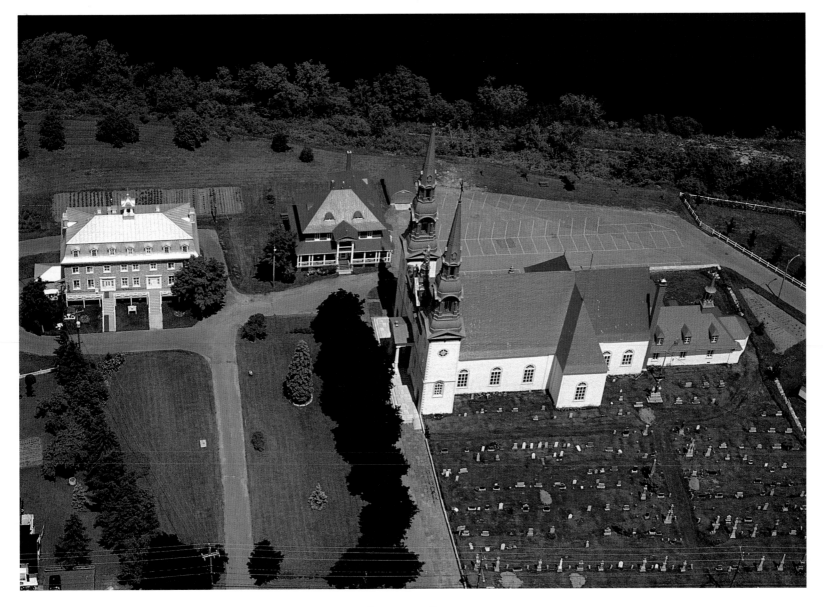

LOTBINIERE, QUEBEC

When the saints go marching in, they will most likely do so first in Quebec. In all of Canada, there is no greater
proliferation of saints immortalized by church names than in this Catholic-dominated province. This is the church of
Saint-Louis-de-Lotbiniere, nestled on the south shore of the St. Lawrence. It is named after King Louis, who ruled
France in the 1200s with a kind and gentle hand, and converted his people to Catholicism by example.

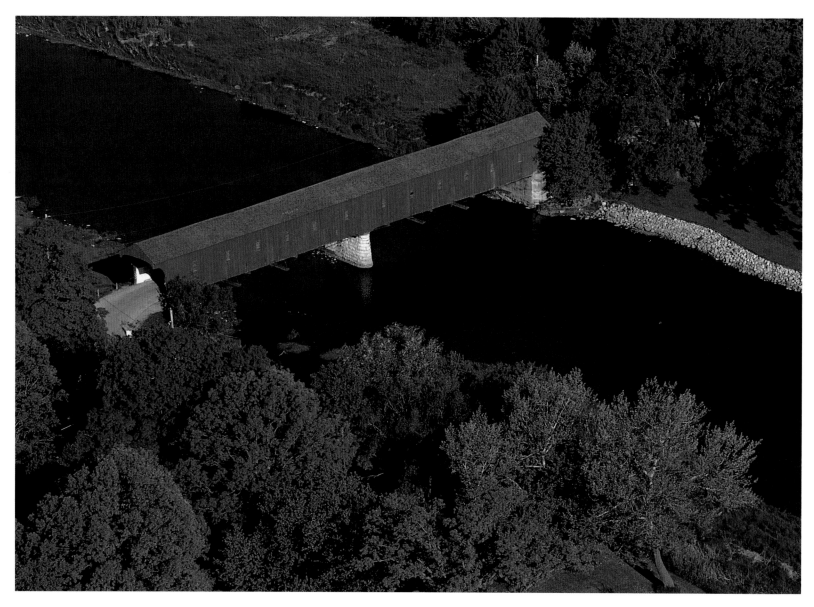

WEST MONTROSE, ONTARIO

This 198-foot covered bridge over the Grand River just gains character with age.

The only such bridge remaining in Southern Ontario, its roof was designed to protect the timbers from the

elements. Yet before the first winter was over, its engineers realized they had an ironic design problem on their hands—

they had to shovel snow inside so that the sleighs could pass through smoothly. Life was slower in that construction

year of 1881, and the signs at each end of the bridge warned, "Any person driving faster than a walk will be prosecuted."

There are no signs, however, to prohibit kissing under its roof. Occasionally, a car will emerge from

this charming tunnel with the occupants smiling, having affirmed the bridge's alter ego, "The Kissing Bridge."

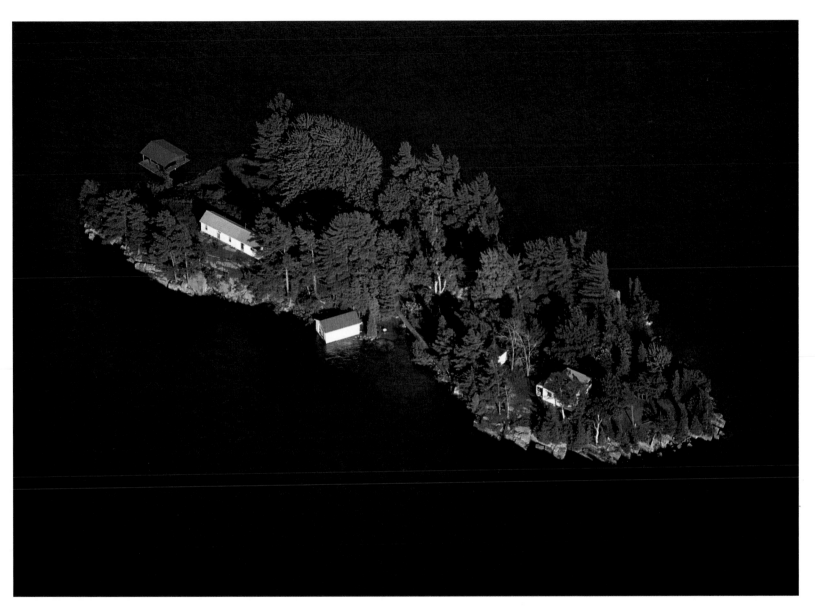

GANANOQUE, ONTARIO

It's a moot point perhaps, but there aren't 1,000 islands in the Thousand Islands. The count is only 997,
unless you wait for a season of low water. Formed about 8,000 years ago as a result of the last receding glacier,
these islands now serve as the playground of the upper St. Lawrence River. They are considered
a "must-see" for any tourist visiting the highlights of Canada.

TORONTO, ONTARIO

For all the cliche superlatives hung on the CN Tower, it is still an amazing structure. Since its opening in 1976,
more than 30 million people have visited the world's tallest freestanding tower, 1,815 feet 5 inches high. Not all
visits have been by conventional means, however. A rock climber scaled the outside glass windows twice in one day.
Two hang-glider pilots sailed off the SkyPod, and a stuntman set a world's record by bungee-jumping from
this giddy height. More philanthropic is the annual United Way fundraising race up the tower's 1,760 steps.
Regardless of how one arrives at the top, the view is always breathtaking.

THUNDER BAY, ONTARIO

By sheer coincidence, I happened to fly by Terry Fox's memorial on the day of his birthday, July 28.
I was humbled and touched by his legacy. Here was an unassuming Canadian who had the courage to believe in his
dream, and in so doing, touched the hearts of millions and changed a country. Terry ran over 3,000 miles before cancer
forced him to stop just outside Thunder Bay. But his dream lives on. His annual runs have raised over $144 million,
making it the single largest one-day fundraising event for cancer research in the world. A truly great
Canadian hero, he challenged all of us to take responsibility for our lives.

This truly blasted patch of land, the colossal steel mills of Hamilton, come complete with fire and brimstone.

Yet this same crucible is essential for the production of many of the necessities of twentieth-century life,

from cars to fridges. As a major supplier of steel products to the North American marketplace,

this facility alone produces approximately two and a half million tons annually.

This scene conjures up images of a nineteenth-century northern English coal town— air pungent with smoke,
buildings layered in soot, workmen's eyes staring white from blackened faces. Fortunately, we live in a more
environmentally aware age. The white plumes from the city's paper mills, dramatized by the early morning sun,
are mostly steam and dissipate quickly. For all the industry, the people here breathe clean air and
are proud of their city, whose adopted slogan is "Superior by Nature," reflecting the wealth
of nature right next door and the city's location on beautiful Lake Superior.

It is called "lodging" and does not make for happy grain farmers. As wheat ripens it becomes
increasingly vulnerable to the elements. Straining with the increased weight of their golden kernels,
the once resilient stems become stiff and brittle with age. A serious mid-afternoon thunderstorm
played havoc here. Depending how and when the lodging occurs, the farmer might lose
as little as 10 percent of his anticipated harvest or almost all of it.

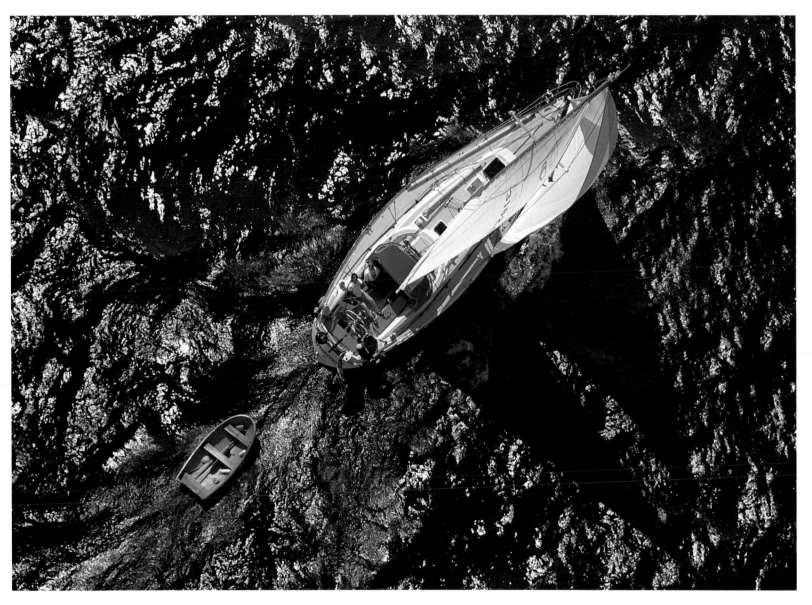

LAKE HURON, ONTARIO

The two sailors glanced upward, surprised to see a lone ultralight, probably looking somewhat lost in the
wide expanse. If they could only see what I see, I thought, they would be equally amazed by my unusual view
of them—the arrested motion, an impregnable surface, and confused waves of crumpled tin foil.
With its many protected anchorages, uninhabited islands and spectacular scenery, the north shore
of Lake Huron is said to offer some of the best freshwater sailing in the world.

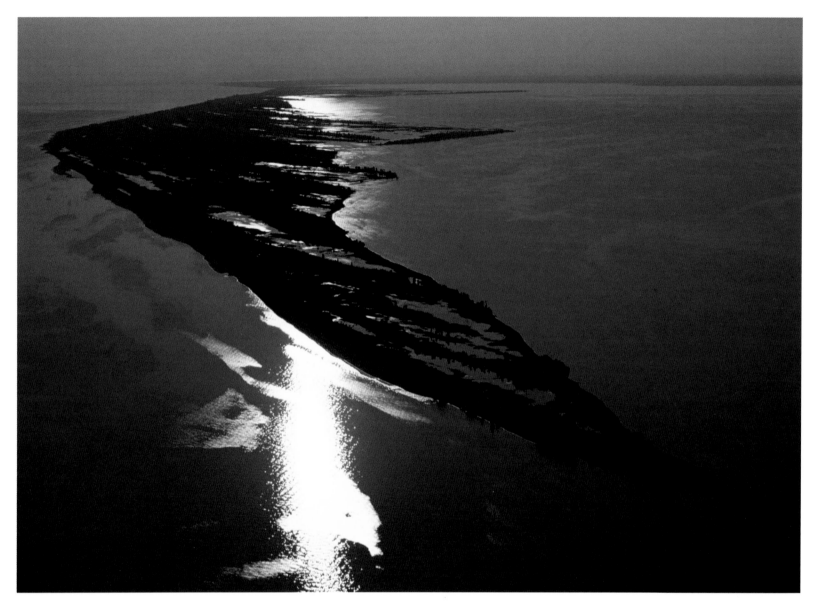

LONG POINT, ONTARIO

It stretches 24 miles into Lake Erie, and from its tip, one can easily see the night lights of Pennsylvania.

For its small size and fragility, it is one of the more intriguing areas of Canada. The history of Long Point is rich

with shipwrecks (nearly 200), heroic rescues, bootlegging ventures, and illegal prize-fighting. Today, it is

better known for its diverse blend of habitats and as one of the most popular waterfowl staging areas

in the province. In 1986 the United Nations designated this area as a World Biosphere Reserve.

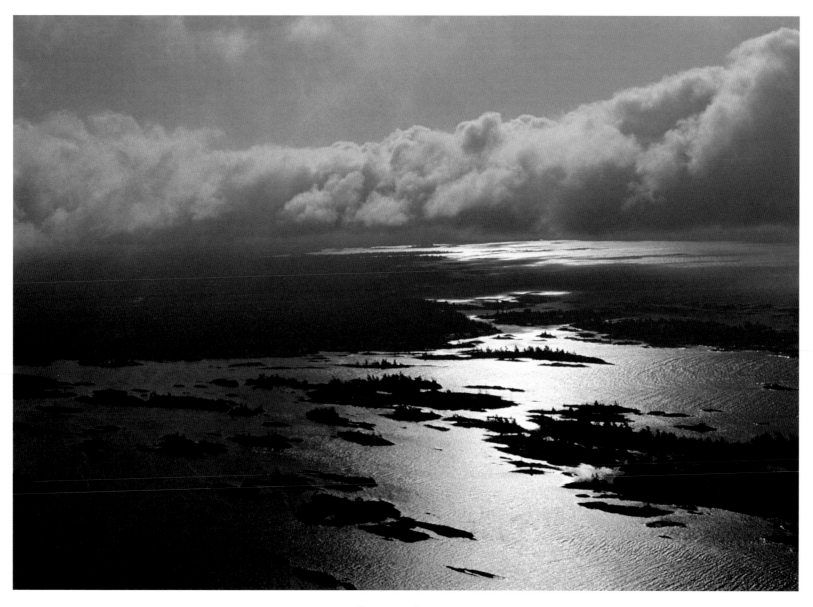

KILLARNEY, ONTARIO

Learning the actual "how-to" of flying is easy enough; some of my students have soloed in less than five hours.
It takes a lifetime of learning, however, to judge weather, and whether or not to fly. On my flight from Killarney
to Parry Sound I was confronted with a classic pilot's problem—unforecasted changing conditions. The cloud ceiling
moved steadily lower, squeezing me underneath. Tight ripples and whitecaps began to form on the water below,
denoting an alarming wind speed. A forced landing would have been precarious, and there were no airports
along this shoreline. Sunlight momentarily broke through the clouds and interrupted
my anxiety. I took it as a good omen. An hour later, I landed safely.

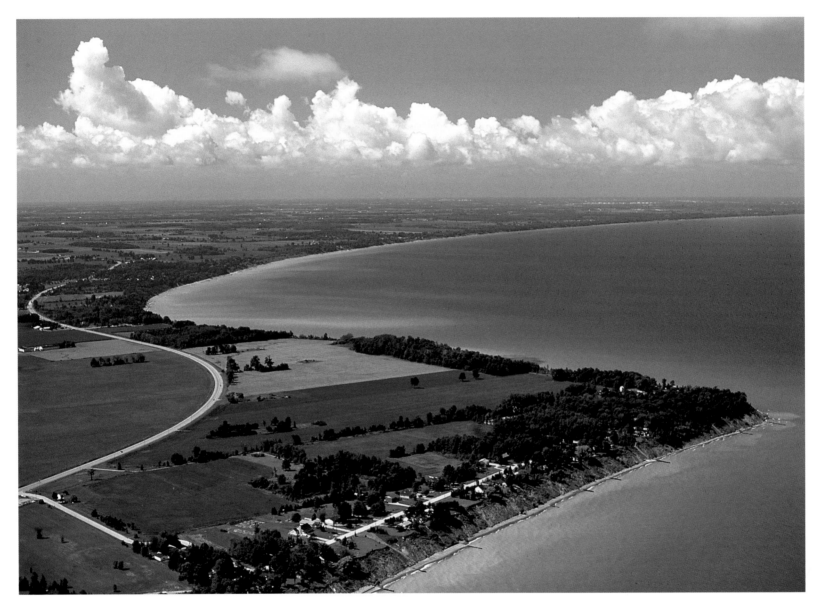

LAKE HURON, ONTARIO

It was a perfect "God's in His heaven, all's right with the world" kind of day. As I flew south along the shoreline,
I saw the potential for a postcard-perfect photograph within these shifting compositional lines. The peninsula became
more prominent as I continued, while the bay's smooth inland sweep, by virtue of its negative space, demanded
increasing focus. A sense of both tension and harmony lay between the man-made highway and nature's
more irregular shoreline. The pieces kept changing, and I wondered, where was the precise
moment of balance that would capture the peacefulness of this day?

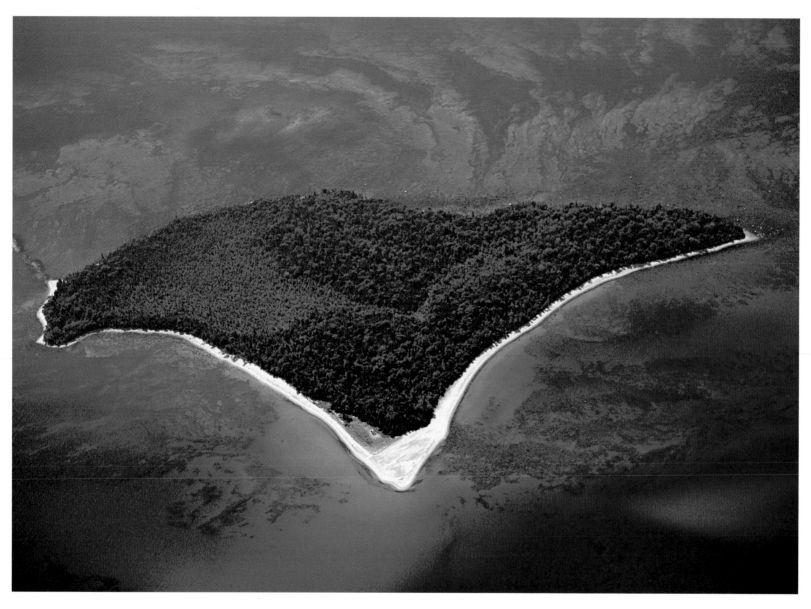

NORTH CHANNEL, LAKE HURON, ONTARIO

Once, while I was scuba-diving in the Caribbean, a giant manta ray glided past just a few feet away.

Twenty years later, I thought it had returned—a close encounter for the second time—disguised

in its island form. There is a sense that one should be able to peel back this island

and look underneath, exposing its green-light mystery.

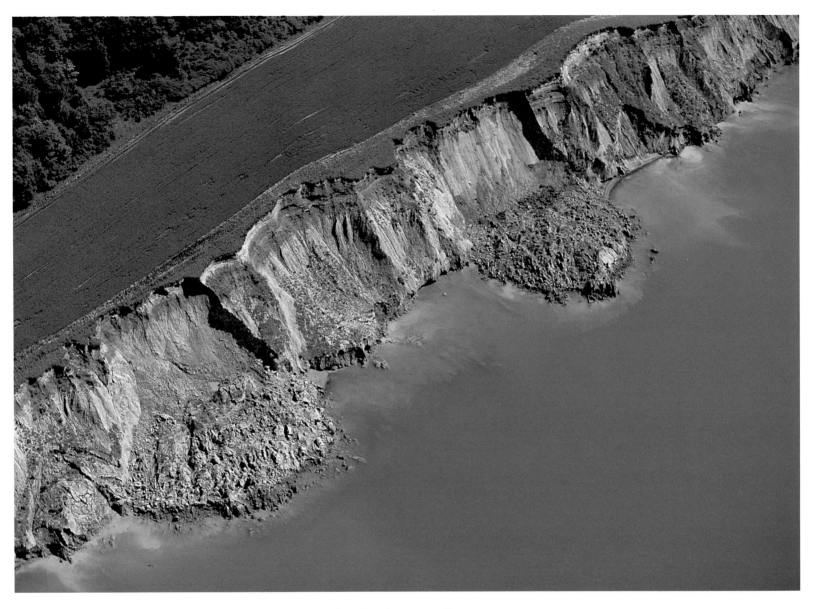

LAKE ERIE SHORELINE, ONTARIO

Behind the tranquillity of this day lies a sad truth. High water levels cover the beach, eliminating a natural
buffer for waves. Some of this irreplaceable farmland has eroded at a rate of up to 15 feet a year.
One storm alone caused an estimated $11 million in erosion damage. The landowners are frustrated,
the government says nothing can be done, and the waves' voracious appetite is never satisfied.

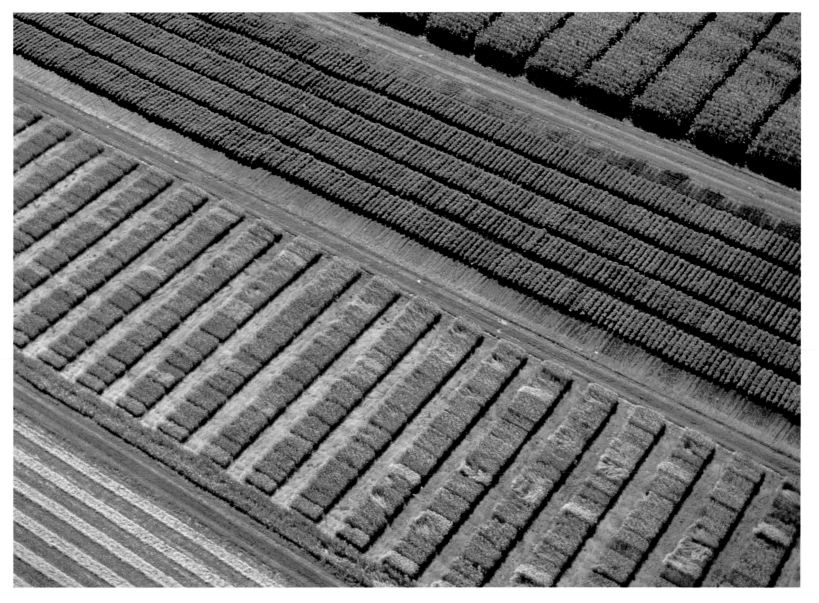

MORPETH, ONTARIO

Today's crop yields are dramatically higher than those of just fifty years ago. Then, wheat and corn might have produced 40 and 60 bushels per acre respectively. Yields today could be as much as 80 and 130 bushels. In addition to the increased use of fertilizer and pesticides, genetically engineered seeds are behind much of this gain. Millions of dollars are spent annually on researching new varieties. At this privately owned research farm, multiple plots of alfalfa, wheat, soybeans and corn (left to right) grow alongside each other for easy comparison.

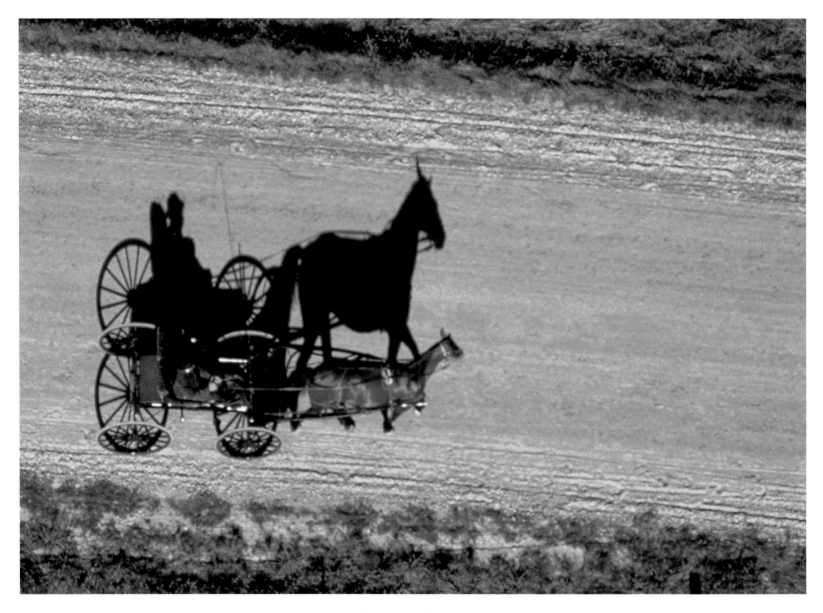

HAWKESVILLE, ONTARIO

One of the distinctive aspects of Waterloo County is the community of Old Order Mennonites, about 4,000 strong. My own Mennonite roots are in a much more progressive group, but I feel fortunate to count some of these people as friends. Visiting tourists often feel they have taken a trip back in time as they watch horse-and-buggy travel on country roads. Based on what these people have taught me about values, integrity, and a truly functional understanding of community, I think they are, in many respects, eons ahead of the rest of us.

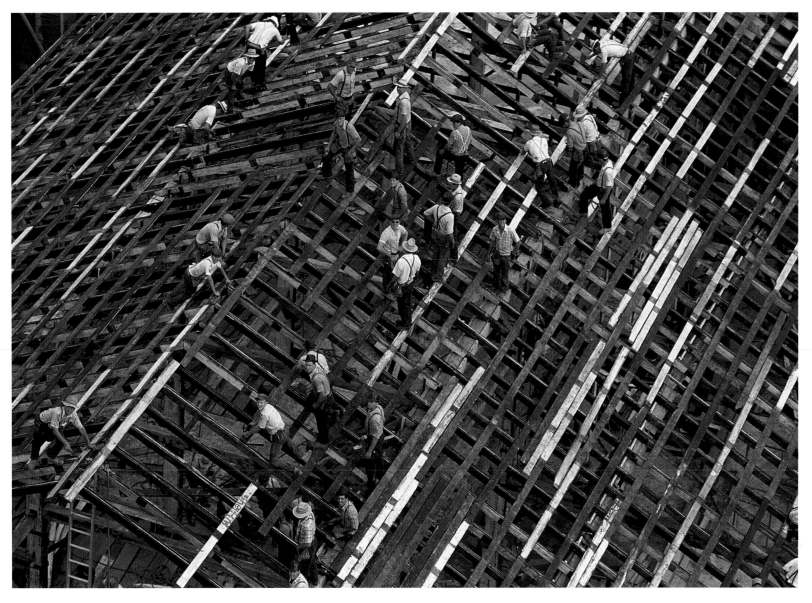

DORKING, ONTARIO

There is no finer or more graphic example of community than a Mennonite barnraising. On this day, 218 men pooled

their muscle power in a statement of caring. At noon hour, they sat down to a lunch of scalloped potatoes, baloney, fruit,

and the finest selection of pies found anywhere. Families caught up on local news; young men tried

to outwork each other; and the rate of construction boggled the mind. By sundown, the roof

was completed, and I had witnessed another superb demonstration of brotherhood.

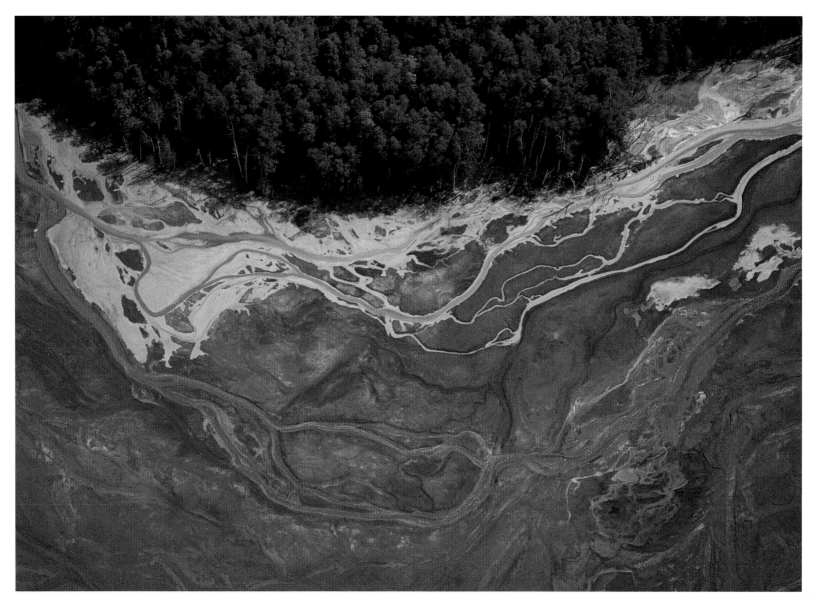

The iron ore mine of Wawa was the first in Ontario and is the only one remaining. This amber necklace
is part of the settling system. As the miners bore ever deeper, the rain, snow and seepage water must be pumped out
of the mine. It flows out in this natural drainage pattern, forming small pools on the undulating rock surface.
The deposits of iron left behind after evaporation will be collected and recycled back into production.

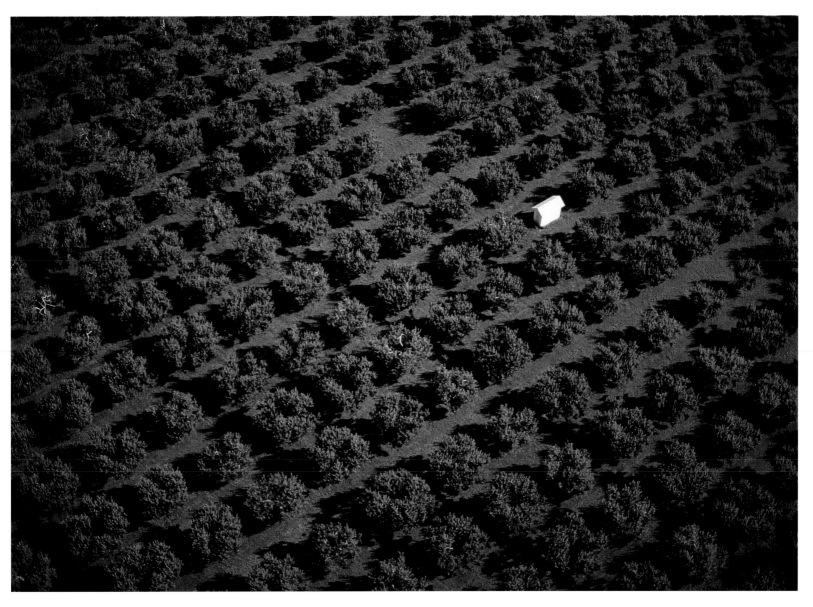

Our obsession with precision and uniformity generates an unavoidable dance of the eyes. We are instantly drawn
to the white storage shed in the middle of this apple orchard, but then almost as quickly, we have a need to explore.
We skip erratically through the conflicting lines, the complexity heightened even further by diagonal shadows.
Having satisfied their urge to wander, our eyes come back to a certain comfort this unchanging building
offers. They rest only momentarily before leaving once again on another visual cycle.

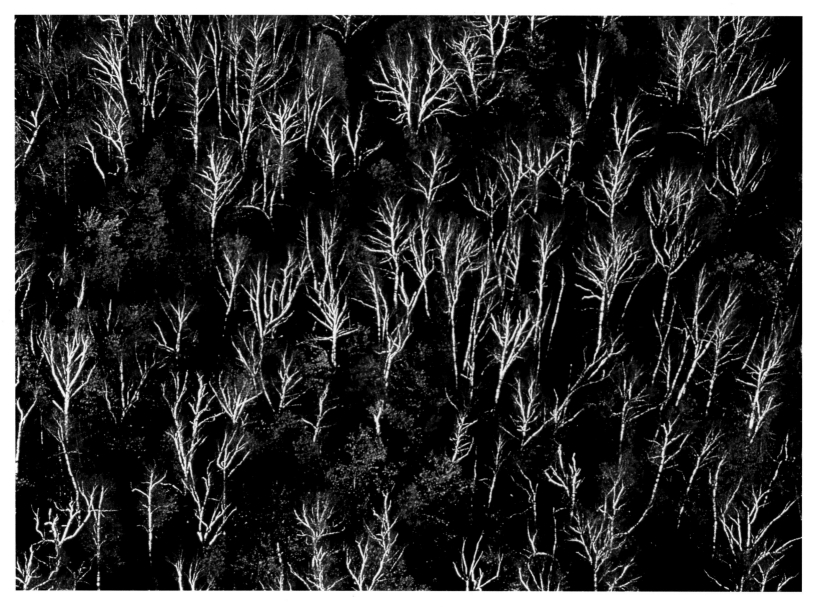

FERGUS, ONTARIO

Photography and fine art can easily overlap. There is a technique in watercolour painting whereby
one can scratch the pigment out of a dark wash with a pointed tool to simulate white etchings. It looks as though
a similar procedure has been used in this graphic display of native paper birch (often called canoe birch) that have
characteristically dropped their leaves early. Bathed in the evening sun, the trees are a true abstract—one can
easily imagine frost patterns, electrical charges, or an annual caribou convention.

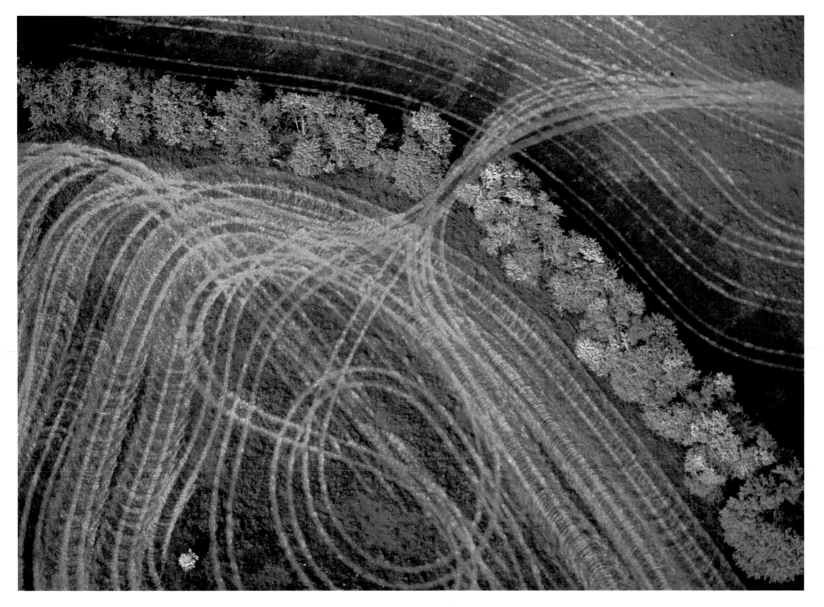

WALLENSTEIN, ONTARIO

When I showed this photo to the farmer who owns the field, even he was amazed. It took some time
before he was able to explain his own chaotic artwork. He had just spread liquid chicken manure on his pasture,
and the heavy nitrogen content had temporarily stunted the growth. The effect was particularly evident where his tires
had flattened the grass. After a couple of warm spring rains, he said, the grass would not only revive itself but would
continue to flourish and could produce a yield up to 20 percent higher because of this natural fertilizer.

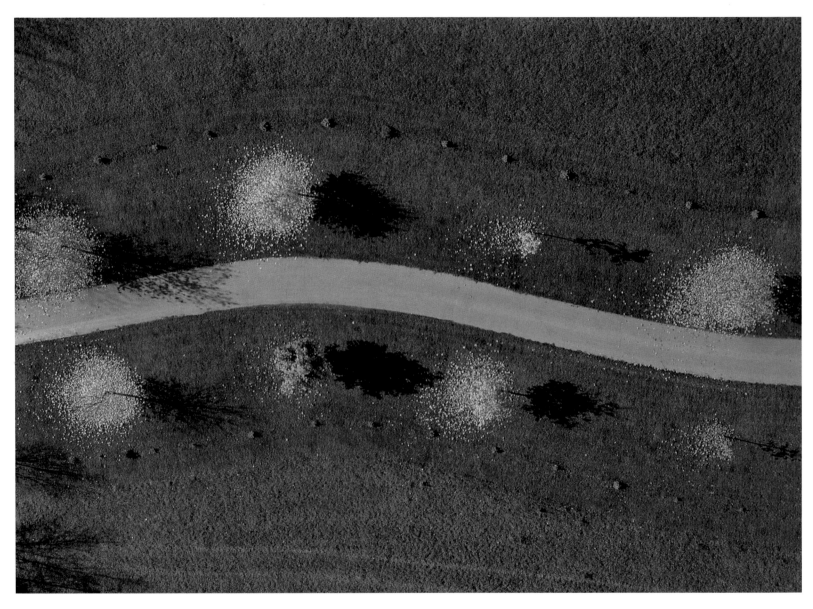

MARDEN, ONTARIO

This scene would be impossible to appreciate either on the ground or in a Cessna at 2,000 feet.

It is the ultralight's low-and-slow perspective that allows this privileged view of young maple trees.

You can almost feel the breath-holding stillness that has allowed thousands of leaves to fall straight down.

Yet a few have remained and give the trees concurrent shadow definition.

They make me think of starbursts at a fireworks display.

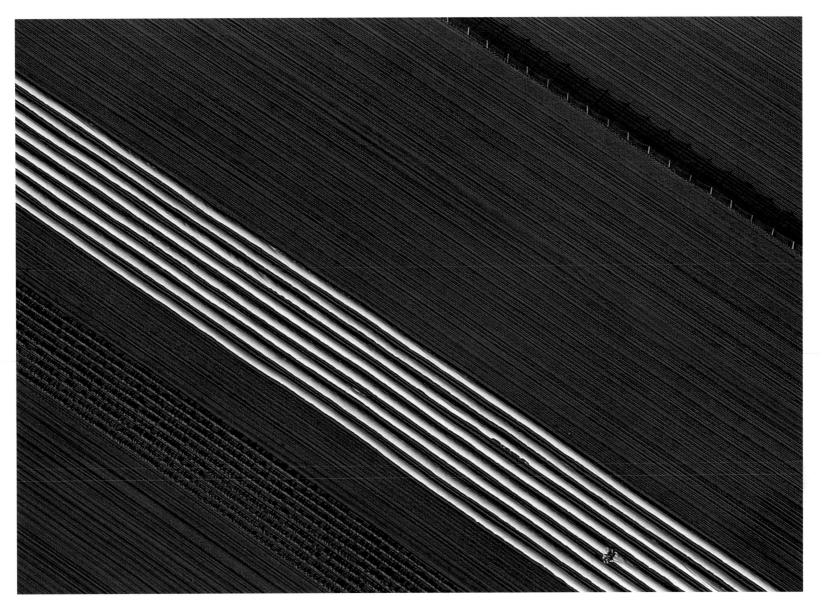

DELHI, ONTARIO

I often wonder, as I fly overhead, whether farmers have any sense of their art. These rows are textbook straight, the colours and texture are well contrasted, and the use of space is innovative. Only one slight hiccup interrupts this perfect composition, where a short section of the protective white vinyl has split open. The covering increases heat during the day and speeds up the ripening of this farmer's specialized crops—most likely strawberries or melons.

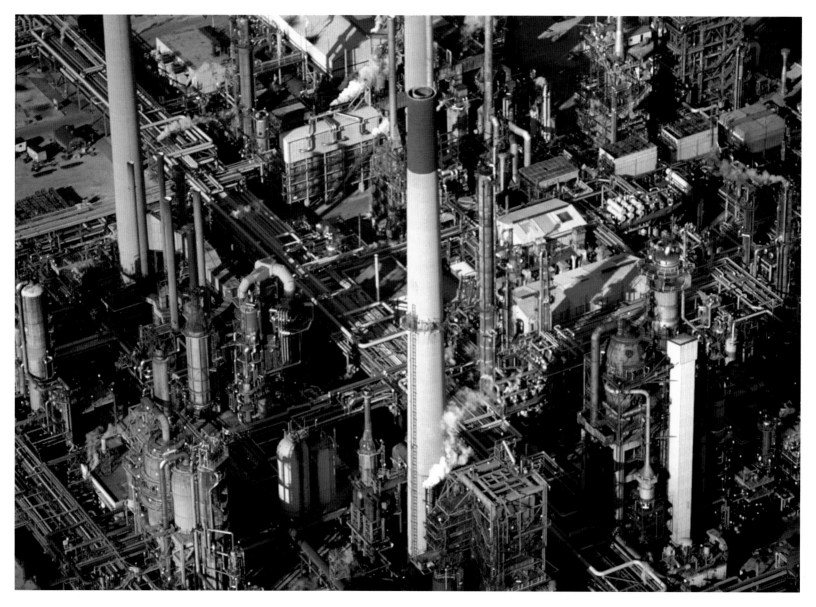

SARNIA, ONTARIO

Stretching southward from Sarnia along the St. Clair River is a vast network of petrochemical and refining
complexes—Canada's "Chemical Valley." Its roots lie in nearby oil fields and its branches are spread throughout
the world. Sixteen major companies are now concentrated in this area. Despite its vast size, this facility
is less environmentally threatening today than it was twenty years ago. Increased awareness and
government restrictions have led to the installation of elaborate pollution controls.

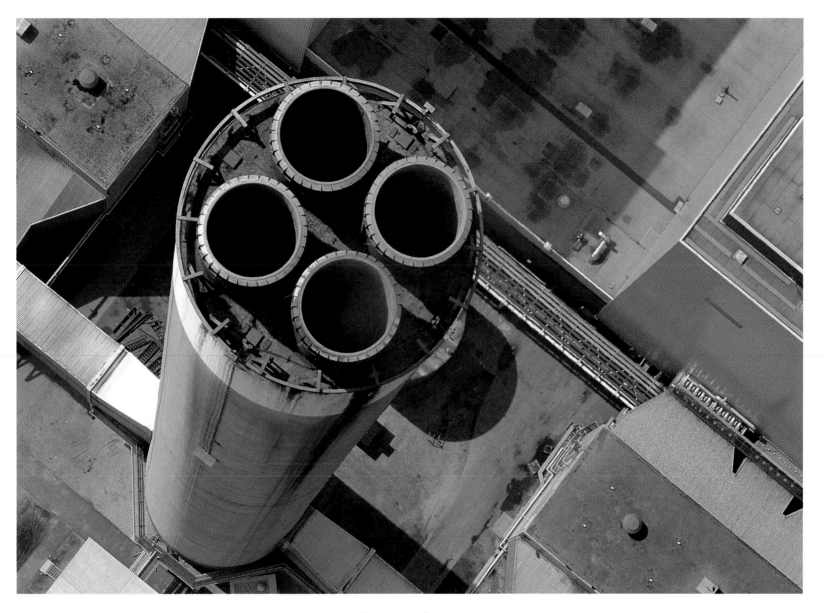

Could this be the calamitous result of a failed rocket launch? It is, in fact, a 650-foot smokestack of one of the world's largest coal-fired generating stations. Its nearly invisible fumes were so forceful they momentarily pitched my ultralight almost vertical, causing a few heart-wrenching seconds.

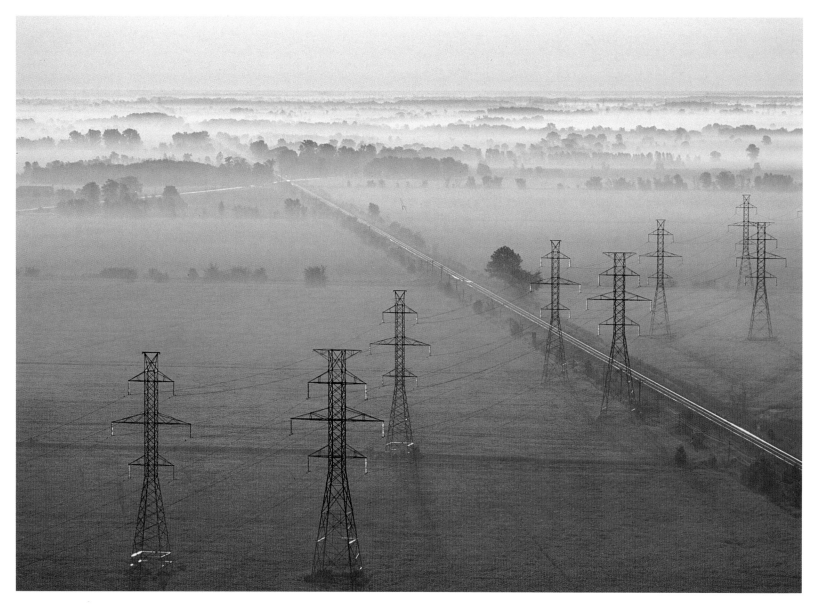

WINDSOR, ONTARIO

From the large perspective of the air, you can see the soft beauty of ground fog as it lies gently, and without distinction, both on pastoral fields and on the arrow-straight lines of technology. For me, it is a soothing symbol of the need to integrate our demands for progress and the preservation of nature.

COLLINGWOOD, ONTARIO

It caught me by surprise—manicured farmland and then, suddenly, a sparkling blue winter wonderland.
The dazzle originates from the manufacture of car windshields, a small part of which end up as trimmings
and imperfect plates. This glass is recycled for the fibreglass industry and for reflective beads.
These glass beads are mixed with paint to produce reflective surfaces, something we benefit from
each time we drive at night, following the highway stripes that warn us to stay in our lane.

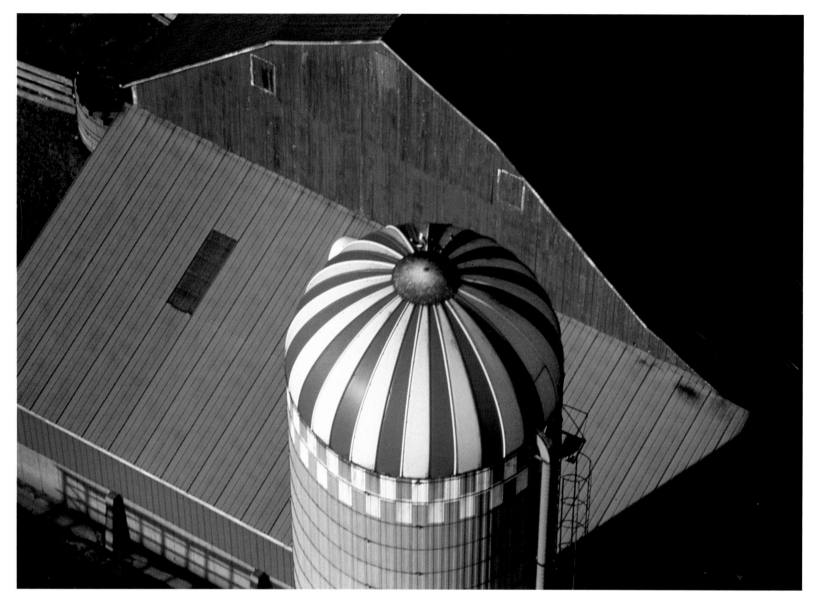

CROSSHILL, ONTARIO

The farmer is at once the tiller of soil, the philosopher, and the eternal optimist—often executing his roles with
a certain whimsical touch. The red barn is traditional enough—the idea possibly having originated in the mid-1800s,
when red paint was the cheapest to buy—but this exterior decorator has added a personal stroke with his
candy-caned silo roof. Patterned white tiles complete the top row of this three-dimensional work of art.

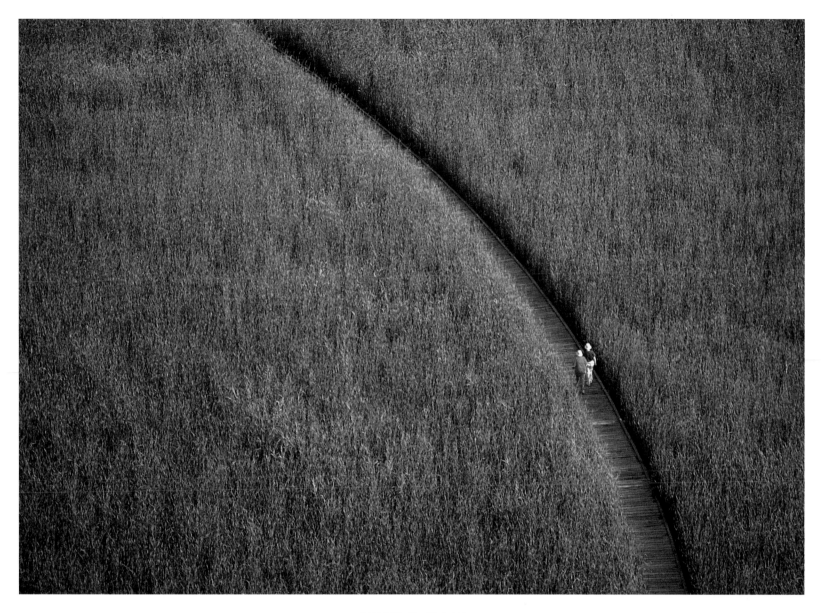

POINT PELEE, ONTARIO

Each spring, waves of migratory birds descend on this tiny oasis of green—and are greeted by human waves of birders.
People come from around the world to see some of the more than 350 different species that have been sighted here,
making it one of North America's best locations to observe the northward migration. Just after a 6 A.M. sunrise,
this couple head out on the boardwalk that loops into the largest protected freshwater marsh in Ontario.

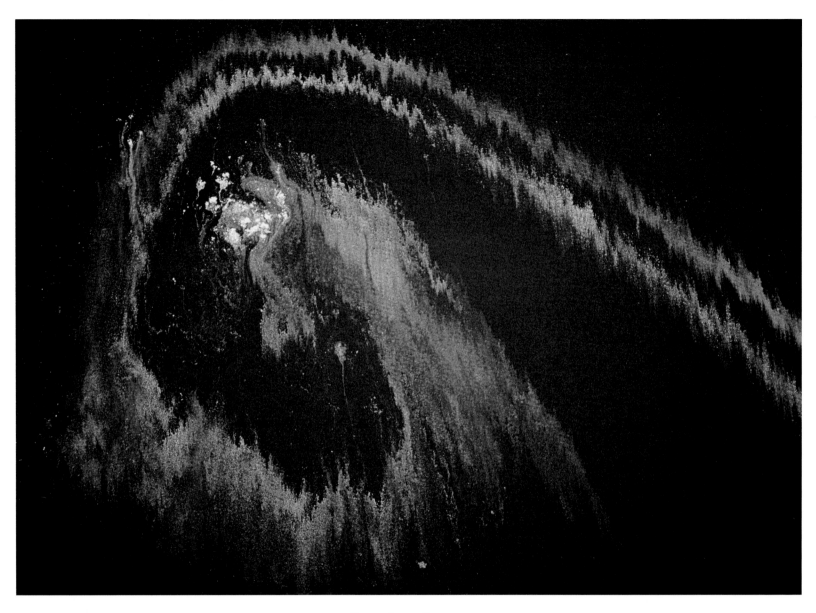

RIDEAU RIVER, ONTARIO

It always amazes me to discover the unexpected in the ordinary. This scene defies immediate explanation.
A cosmic swirl in a distant galaxy? The horrific explosion of a shuttle launch? It is, in fact, a swirl of algae growth.
The wind and current have gently conspired to give us a golden masterpiece. By underexposing
the photograph in the early morning light, the drama is enhanced even more.

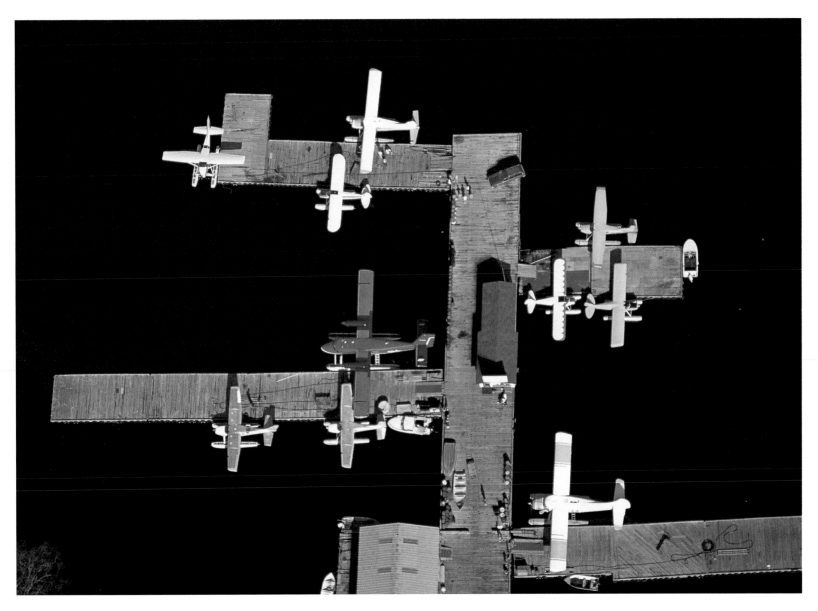

KENORA, ONTARIO

Who else but children playing with toys would create such a delightful and slightly skewed arrangement
of docks and planes? For all the whimsy implied here, bush plane operations are a serious business. Bush-flying
began in Canada, and more than any other country of the world, Canada was explored through this grassroots type
of aviation. Despite the limitations of no radios, proper maps, or reliable compasses, the best of these pilots
managed the near impossible. They completed flights hundreds of miles across the wilderness and,
in so doing, helped establish mining communities and develop regular passenger and mail routes.

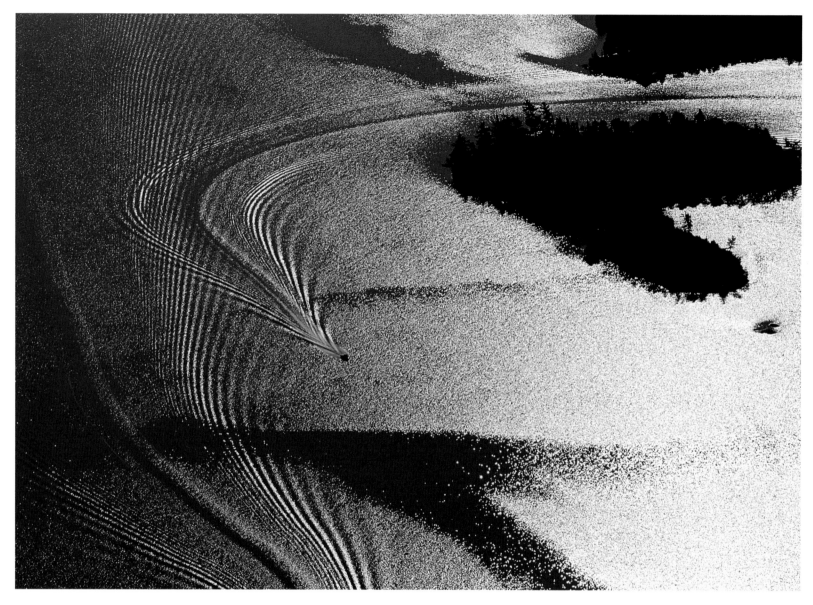

LAKE OF THE WOODS, ONTARIO

If one could imagine perfect cottage country, it would probably look a lot like this. With its
65,000 miles of shoreline and 14,500 islands, Lake of the Woods provides an abundance of recreational
opportunities. Here, two boaters race out on an early morning tour. I realized their low perspective would limit
their appreciation of this fanciful play of light, wind, and waves. From my vantage point, I was particularly amazed
by the illusory wind shadow mirroring the island above and winging its way westward across the waves.

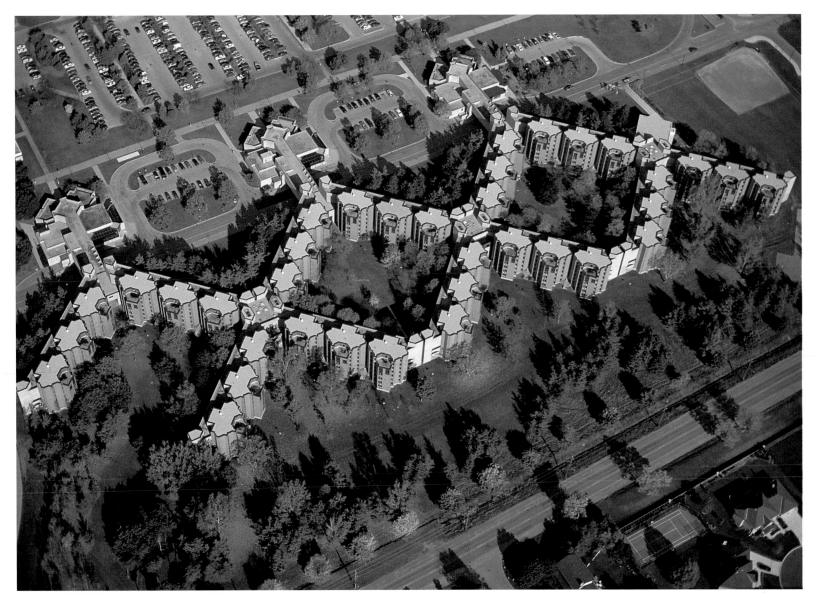

GUELPH, ONTARIO

At first glance, one wonders if this was intentional humour—a complete wing seemingly placed at the wrong end
of this building. Nicknamed "The Complex," this University of Guelph residence accommodates over 1,700 students
and is the single largest student residence in Canada. Its vertical house concept was designed to encourage
a sense of community. Initially, more modules were to be added, but a drop in housing demand
changed those plans. The result is this unintentionally whimsical creation.

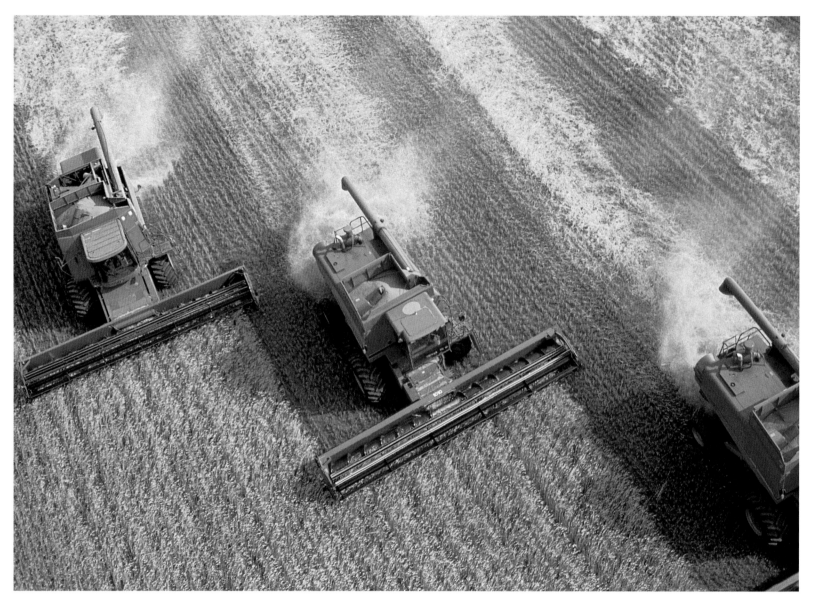

MAGRATH, ALBERTA

I was raised on a farm of only 70 acres and have never quite comprehended the size of prairie operations.
Harvesting our two small grainfields employed half of the family and involved much sweat and a week of our time.
On this day, twelve thundering combines voraciously attack a field of barley. By tomorrow, they may have harvested
upwards of 1,500 acres and 60,000 bushels. Ironically, the very efficiency of these machines has also driven
their price to $200,000 or higher, forcing more and more farmers to hire custom operators.

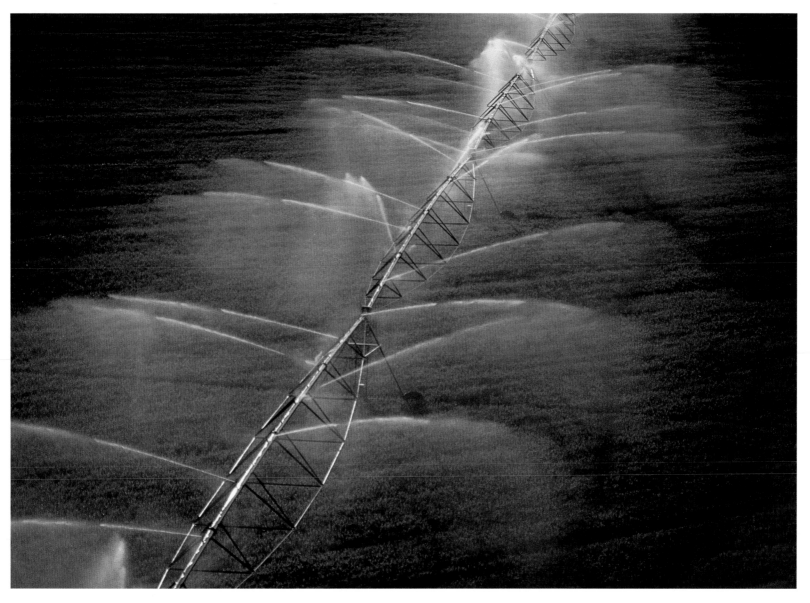

BOW ISLAND, ALBERTA

This pivotal irrigation system, with the appearance of a praying mantis, gently soaks the parched earth.
Anchored at one end, the huge, wheeled arms—up to a half-mile in length—slowly rotate about their pivot points.
During a dry season, they might operate continuously for up to ten days. The most sophisticated of these
systems are automated. Small computers determine water flow by regulating the rate
of rotation, giving the farmer peace of mind during long, dry, sunny days.

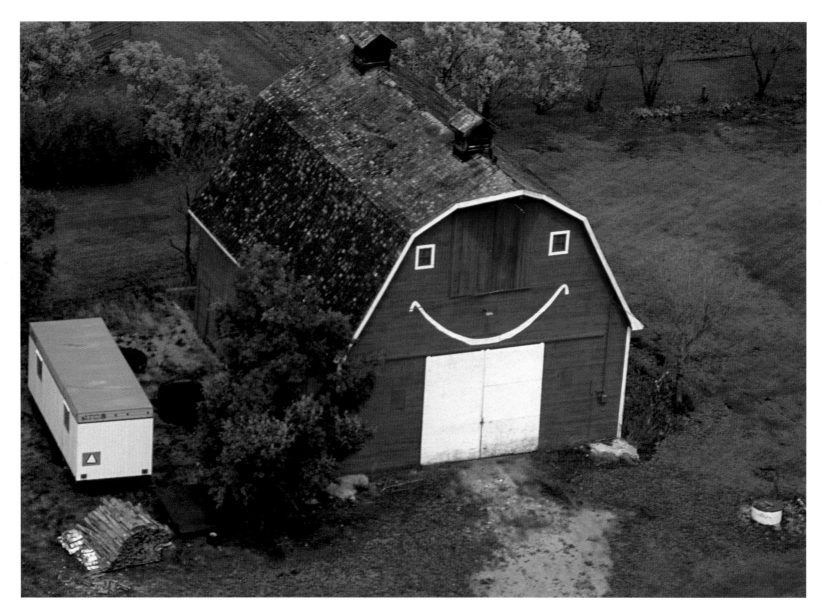

BEAUSEJOUR, MANITOBA

"We had just finished painting and were having a late afternoon beer," said Richard Kisiloski,
"when I thought, 'This barn needs some life. Why not a face?'" In less than an hour he transformed this 70-year-old
structure into a guaranteed smile-getter. "The kids really love it. As you drive into town, you can see it
from the main highway. It sort of hits you as it jumps out from between the trees."

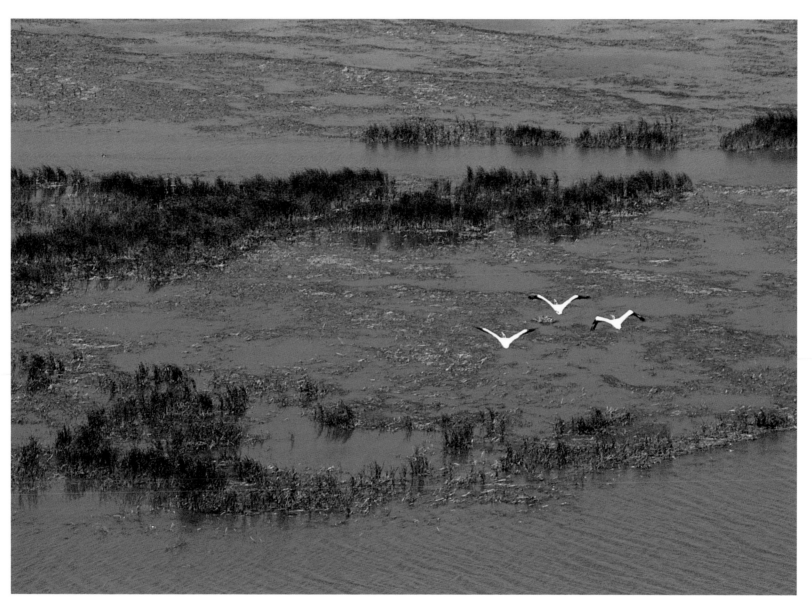

LAKE WINNIPEG, MANITOBA

I was surprised to discover that Central Manitoba contains some of the world's largest nesting colonies of the
American white pelican. Known locally as the "Icelandic Air Force" because of their great fishing ability,
these graceful birds are often seen flying in tightly choreographed formations. On several occasions
we circled together, and I was awed by their elegance and ease of flight.

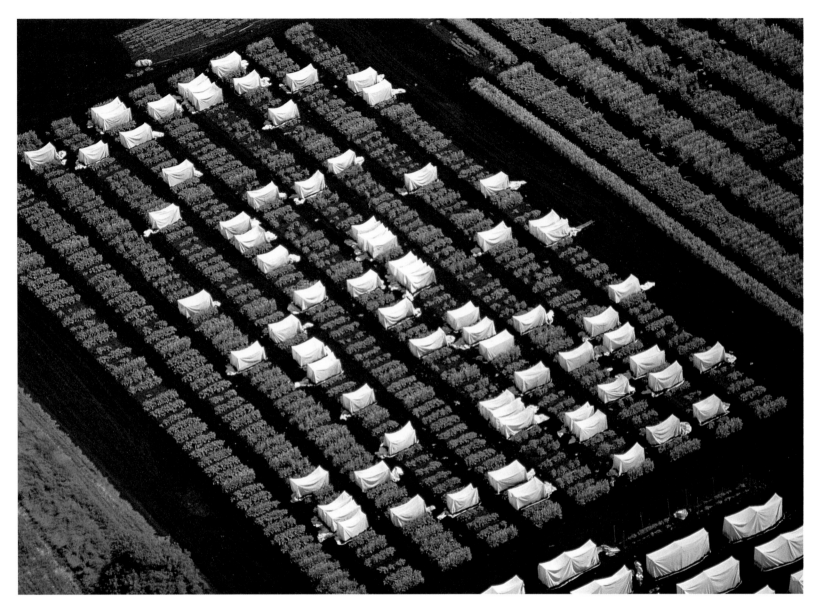

CARMAN, MANITOBA

The ongoing search for new seed varieties has become a finely tuned process. At this research station,
white shade blankets are used for pollination control during the flowering season. By prohibiting the entry of
pollen-bearing insects, researchers are able to ensure the plant's genetic purity. At summer's end, the various species
are compared for yield and for protein and oil content. The process is painstaking, and it typically takes eight
to ten years from the initial development of a new seed to its introduction to commercial agriculture.

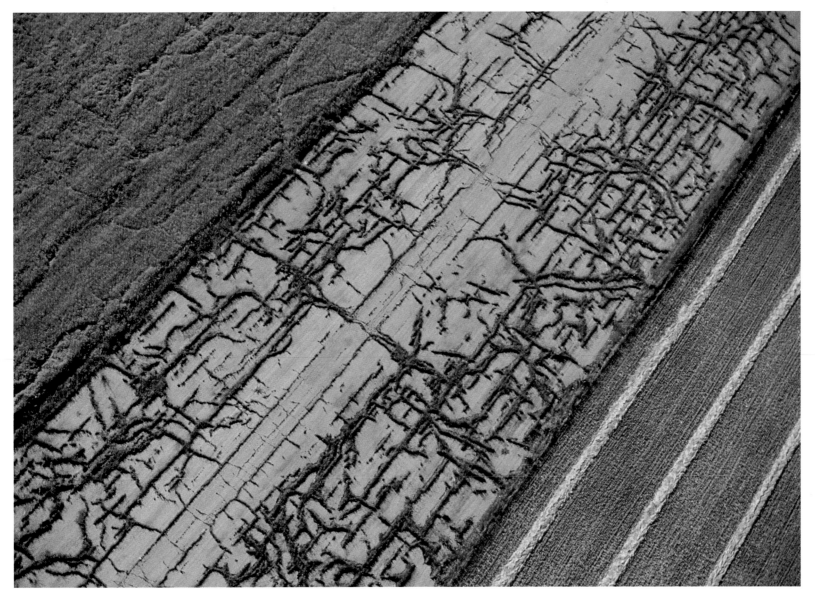

DEWINTON, ALBERTA

There is a chapter of Canadian history that stares up from the land. During the Second World War,
dozens of flight-training airports were hastily constructed, and the skies over these distinctive triangular runways
were soon alive with yellow trainers. With that war behind us, Nature has dutifully helped to cover the scars
of the past. In another fifty years, grass will have largely obscured these asphalt runways.

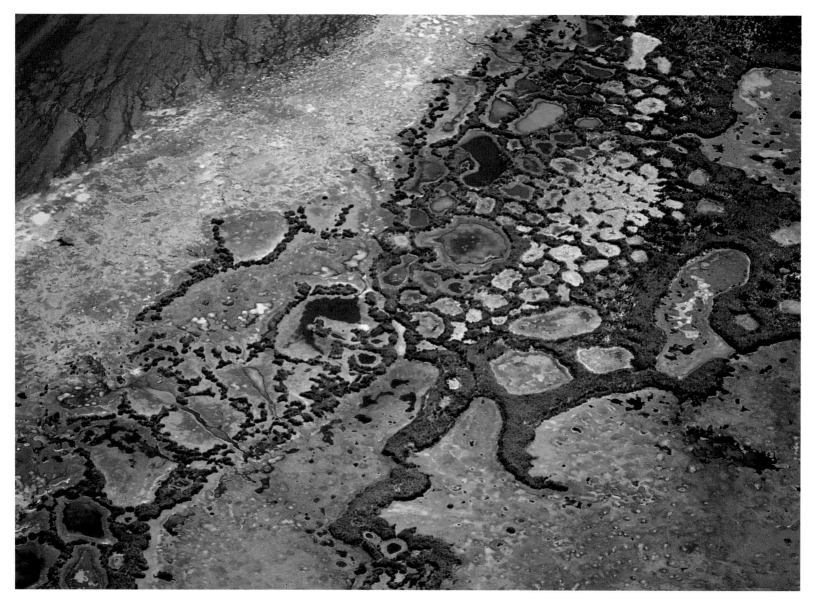

BIGGAR, SASKATCHEWAN

The variety of patterns on the surface of this salt lake was amazing. In fifteen minutes I shot three rolls of film. There was no end of surprises—an Arctic icescape, an acid-etched copper plate, a flayed alligator skin deteriorating in the sun. The patterns are an unusual combination of stagnant yellow pools of brackish water, high in minerals; small dark-blue spring-fed ponds; green salt grasses; and a white crust of dried salt. During a dry summer, most of this shallow lake (6–8 inches deep) will evaporate, leaving behind a sweeping white blanket of salt.

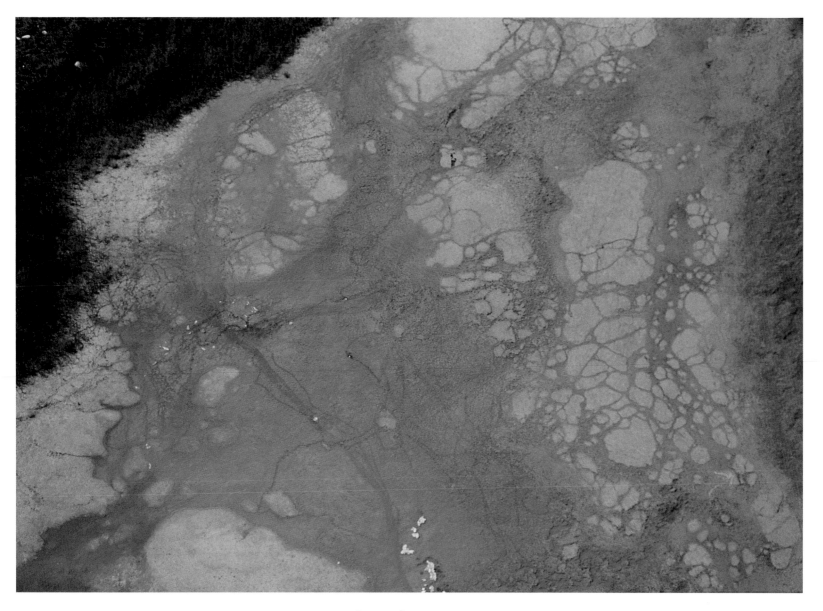

BIGGAR, SASKATCHEWAN

How easily our eyes are deceived. This could suggest a microscopic culture, an insidious virus permeating its host's body. Fortunately, it is much more benign than it appears. Photographed vertically from about 100 feet, a rare occurrence of red samphire has formed in a dry saline slough. It is a salt-tolerant plant with no true leaves, but rather scales at the nodes of its stems. At maturity, it turns a bright crimson.

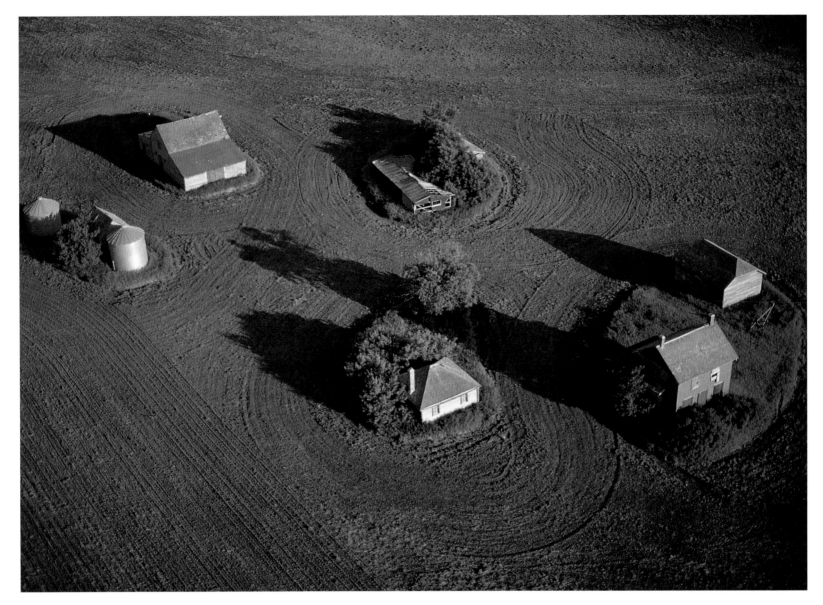

ESTERHAZY, SASKATCHEWAN

I felt a curiosity about this place. Wouldn't it have been sensible to touch a match to these buildings—

aside from the steel granaries—bulldoze the remains aside and get on with more efficient use of the land?

Although the prairie farmer is by necessity pragmatic, he often exhibits a strong sense of history and sentimentality.

Perhaps his grandfather built and toiled in these buildings. In any case, they are deserving of respect, and so

the farmer deliberately weaves his spring cultivator around these islands of memories.

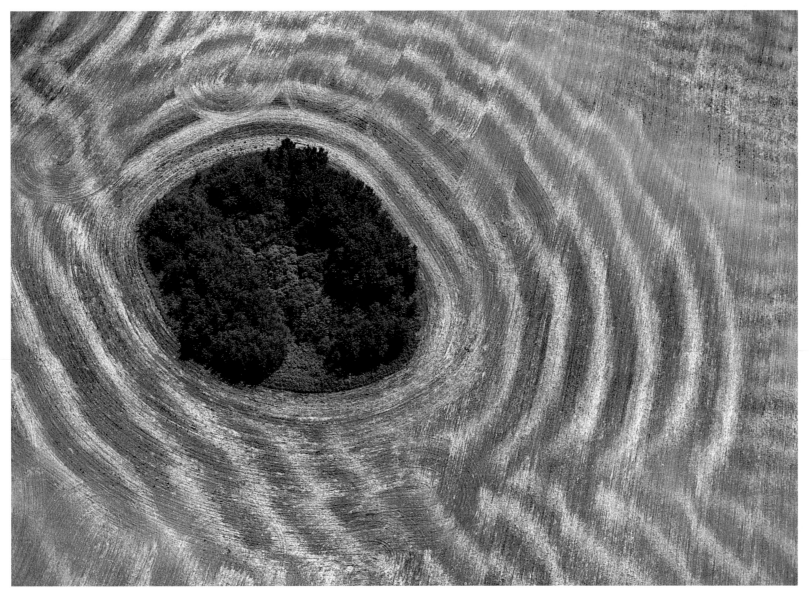

OUTLOOK, SASKATCHEWAN

He is a patient artist. This farmer's landscape was two years in the making. His focal point was the treed pothole,
an area too wet for planting. The previous year's grain crop had left behind telltale swathing patterns. Although
the field was cultivated, as evidenced by the wispy curls at the top of the photo, not all the stubble
had been worked into the soil. The result was this delightful brushed-metal-looking masterpiece.

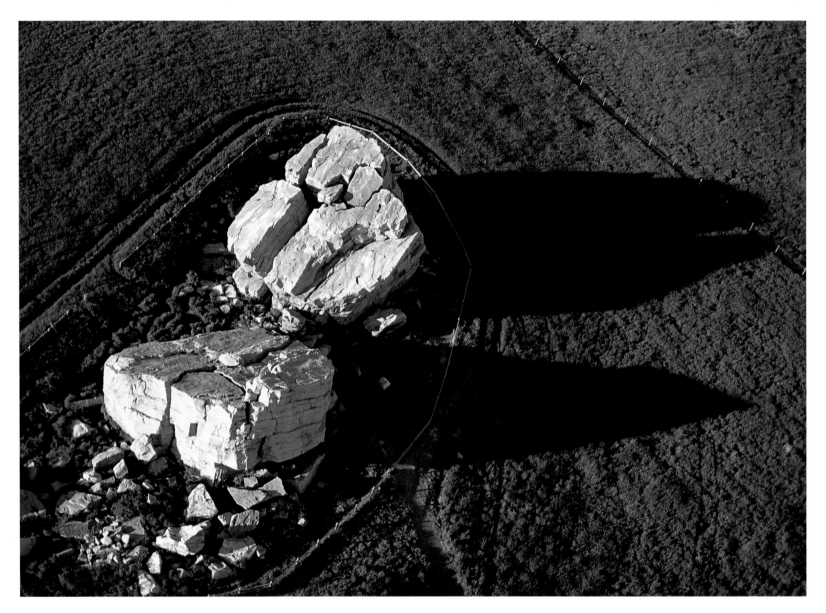

OKOTOKS, ALBERTA

The local Blackfoot tribe have a tale about this rock. It was deadly and rolled around, chasing and killing
people. One day Naapi, a mythical Blackfoot hero, shot an arrow in the air, and when it came down on the Big Rock,
the arrow split the rock into three pieces and finally brought this dangerous thing to a halt. A more banal explanation
is that it is an erratic, carried here by the glaciers thousands of years ago. At 18,000 tons, it is
the largest of its kind in North America and has become a popular tourist site.

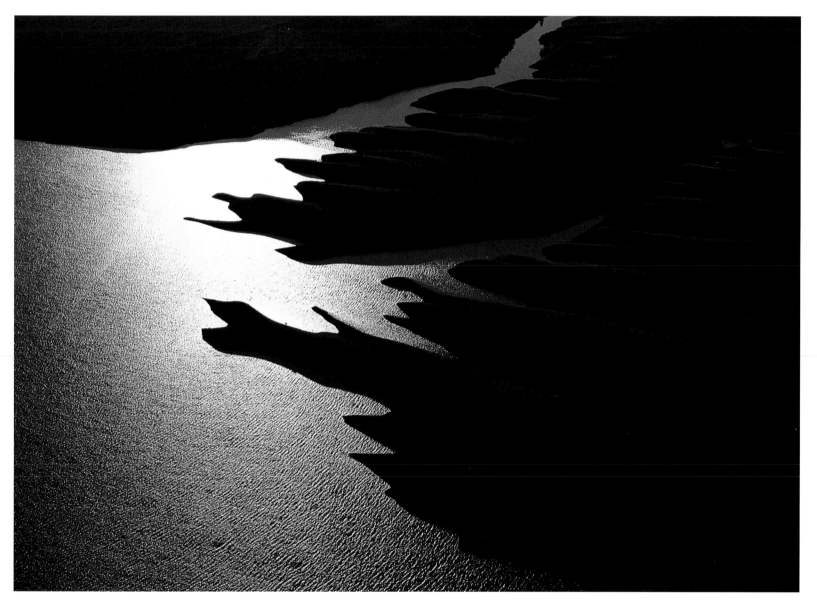

PINCHER CREEK, ALBERTA

These fingers of land reach toward the Oldman River Dam. It would have been impossible
for the engineers to have imagined this art form, caused by waters rising against the edge of contoured land. After two
decades of studies and debates by environmentalists and farmers, the dam was finally completed in 1992. By trapping
the spring meltwater from the Rockies and feeding it into elaborate irrigation systems, the dam will eventually transform
an additional 170,000 acres into productive farmland. And in a spirit of good neighbourliness, the reservoir
also ensures that Alberta is able to meet its water-supply commitment to Saskatchewan.

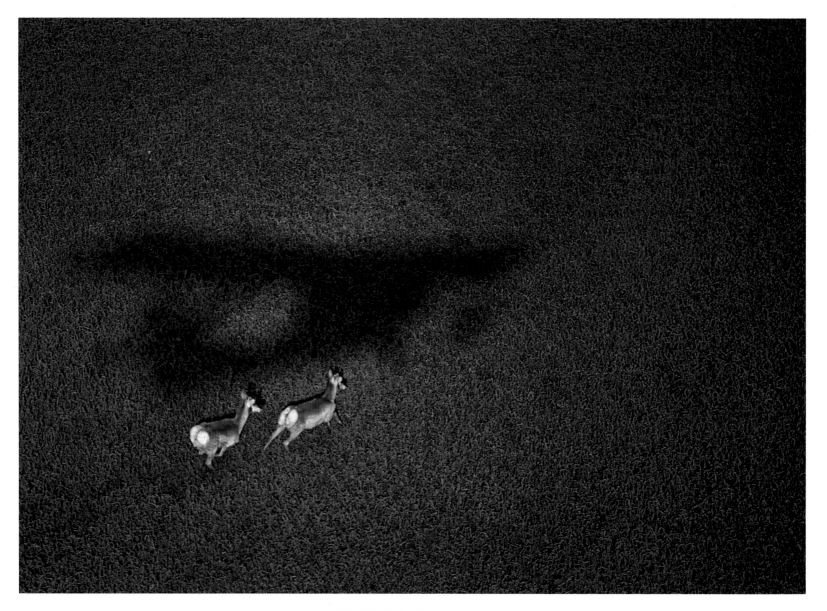

CENTRAL BUTTE, SASKATCHEWAN

It was not an intentional race. On this morning, endless miles of flat fields and breathless skies beckoned
for a ground-skimming flight. Suddenly, there was an explosion of brown beneath me as two pronghorn antelope
burst out of the grass. At 50 mph, we were matched for speed. In a headwind, they would have easily
left me behind. A local farmer told me I was lucky to have tied this race. Pronghorns
are considered the fastest animals in Canada, with recorded speeds of 65 mph!

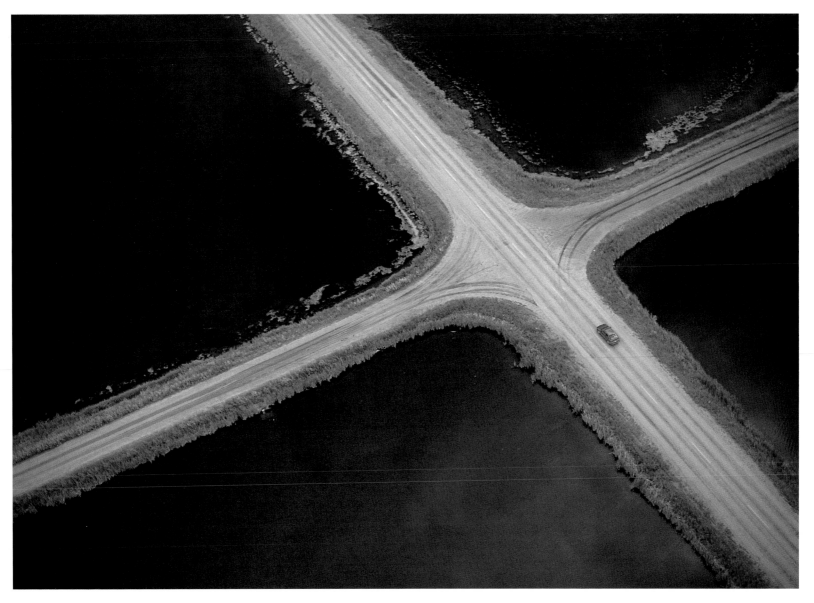

SOUTHERN SASKATCHEWAN

They are trusting souls, these prairie motorists. They drive on floating roads, through intersections bereft of yield or stop signs. And should perchance a meeting of vehicles occur, no guardrails separate them from a guaranteed car-wash in one the surrounding municipal aeration ponds. But the drivers motor on, comfortable it seems with a prairie surveyor's absolutely straight roads, stretching horizon to horizon, crossing at perfect right angles.

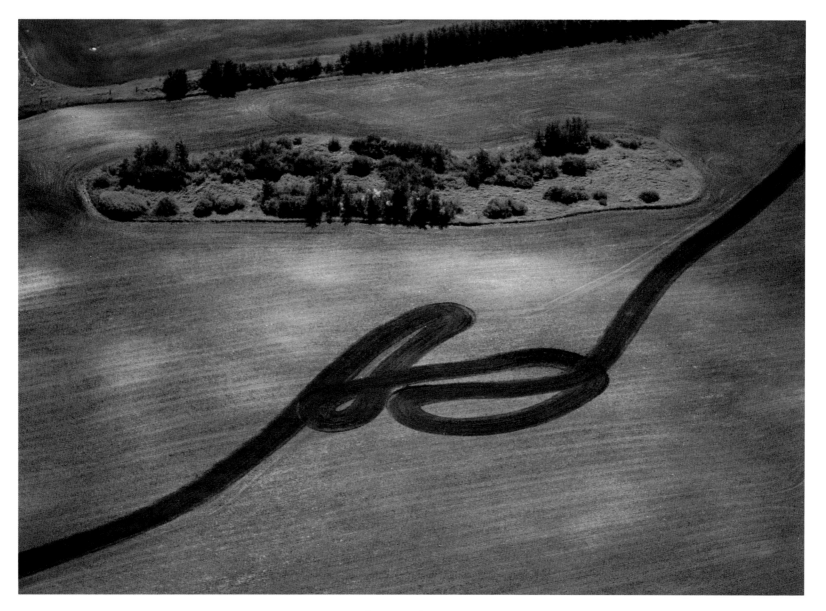

It was surprising how often I found humour through my lenses. I imagined several explanations
for this bit of prairie buffoonery—it was the morning after a local farmer's convention...a bee was trapped inside of the
cab of his tractor...the farmer was practising his hand at calligraphy. Most likely, this creative meandering represents
an exploratory pursuit. After a rain, the farmer wanted to know whether the land was dry enough for tilling.
He traced over his own cultivator tracks to check the soil after it had been cultivated.

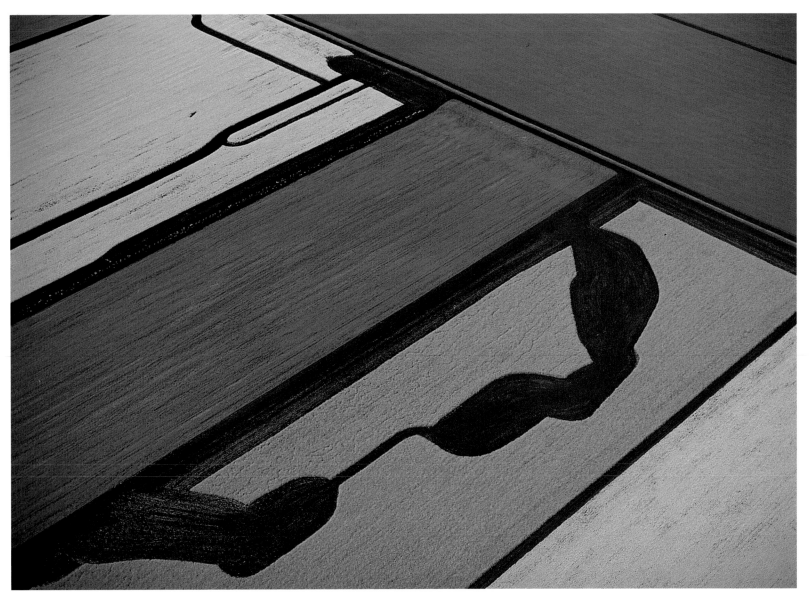

MIAMI, MANITOBA

Charles Vanstone did not plan this artistic piece. Sandwiched between his yellow canola and green flax fields
was a crop of radishes. (They are grown only for their seeds, mostly for the European market.) Unfortunately,
wild mustard seeds found their way into the patch—probably in the spring run-off from a neighbouring farm—
contaminating the purity of his radishes. He had no choice but to strike out with a 24-foot cultivator
and eliminate part of his crop to deal with this unwelcome intrusion.

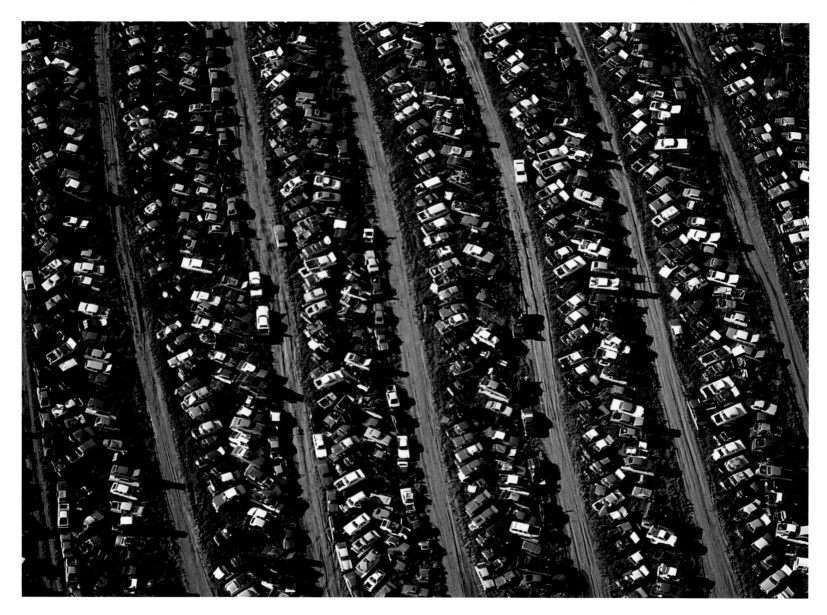

LETHBRIDGE, ALBERTA

Perhaps it was a reflection of my sheltered youth on the farm, but I had never seen "cars on the vine" before.

So this was where they came from. From my vantage point, it was easy to distinguish the various stages

of maturity—with the red vehicles obviously ready to be plucked. I also wondered if the owner of this junkyard

was once a farmer, having arranged his collection in characteristic prairie windrow patterns.

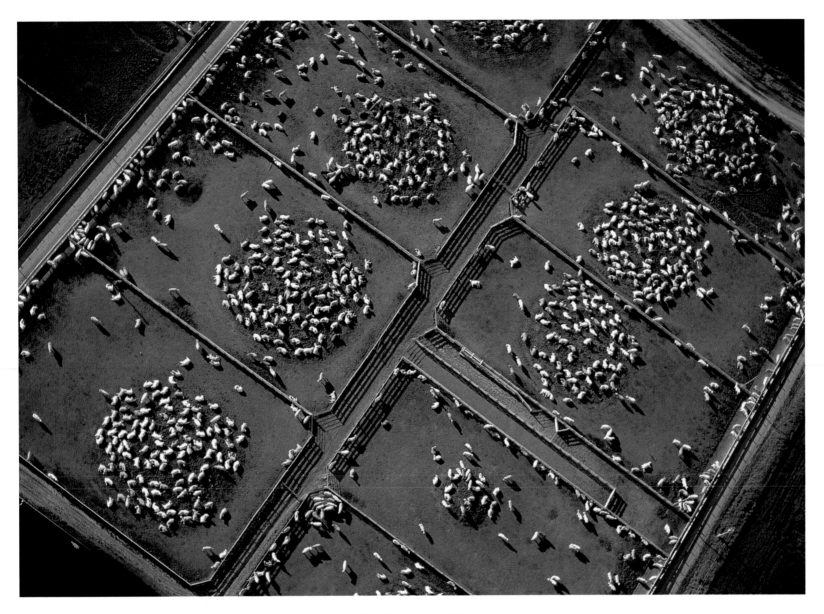

BOW ISLAND, ALBERTA

What might appear to be creative bovine choreography is most likely a basic herding instinct.
Cattle feel more protected in groups and thus assemble together. One slogan associated with this industry asks,
"Where's the Beef?" In Alberta, it's almost everywhere, with approximately a thousand feedlots
in existence. The cattle are kept here until they reach optimal shipping weight.

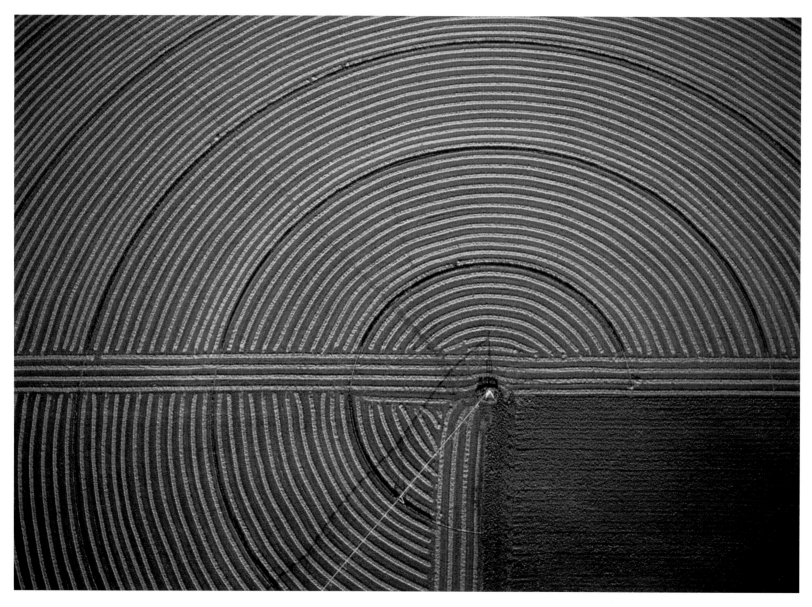

ROLLING HILLS, ALBERTA

A shortage of rainfall makes irrigation essential on over 1.2 million acres of Alberta's farmland. River water is fed to individual farms through an elaborate system of canals. In this field, with its pivotal irrigation, harvesting begins at the outside edge and slowly moves toward to the centre. By the time the farmer is finished, wonderful converging circles appear to roll across the Prairies. On a clear day, they can easily be seen from a commercial flight, even from 40,000 feet. This particular farmer has chosen to use a quarter of his irrigated field for a separate crop.

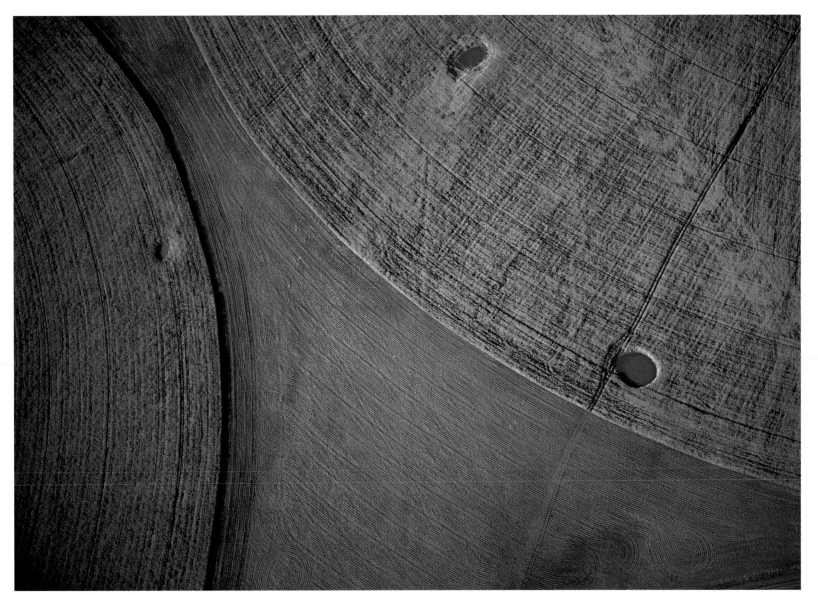

BROOKS, ALBERTA

The near meeting of these two gigantic irrigation circles triggered memories of a poem I had written years earlier:

LINKED

Two wheels turn slow, methodically,
And tooth on tooth,
Gears mesh with solidarity.
Dependency in line
Lays on shoulder upon steel shoulder.
God's wheel of time, and mine
Of personal destiny grind slow,
I know, but steadily.

SOUTHERN MANITOBA

The prairie farmer can only wish this subtle and soothing blend of colours on his land were innocent.
This is a war zone of chemicals and weeds. Tracks indicate he has already twice sprayed his green canola crop. The first
pass was to knock out the grassy weeds. More recently, he has selectively sprayed against the onslaught of yellow wild
mustard. The red-brown patches represent yet another weed—probably lady's thumb or smartweed. Just fifty years
ago, some of these weeds were so sparse they were handpicked out of the fields. Today, chemical companies
race to stay just one step ahead of weed varieties that are increasingly difficult to kill. Next to the
weather, weed control has become the prairie farmer's biggest headache.

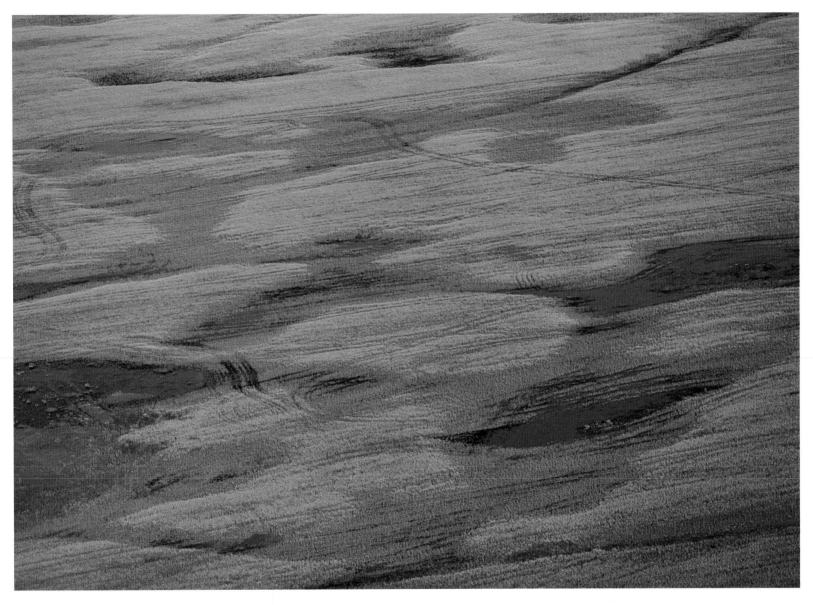

ALTONA, MANITOBA

Each spring, the farmer begins a new guessing game with Nature. This year, excessive moisture has been
his bane. A close look reveals the low spots that were too wet for even seeding. It is now mid-July and the rains are
still excessive. A wet season such as this could easily be followed by a dry one in which yields may be down by as
much as 75 percent. I developed a better understanding of the fickleness of weather when a farmer in this
area told me he has had only one ideal year in thirty years of farming.

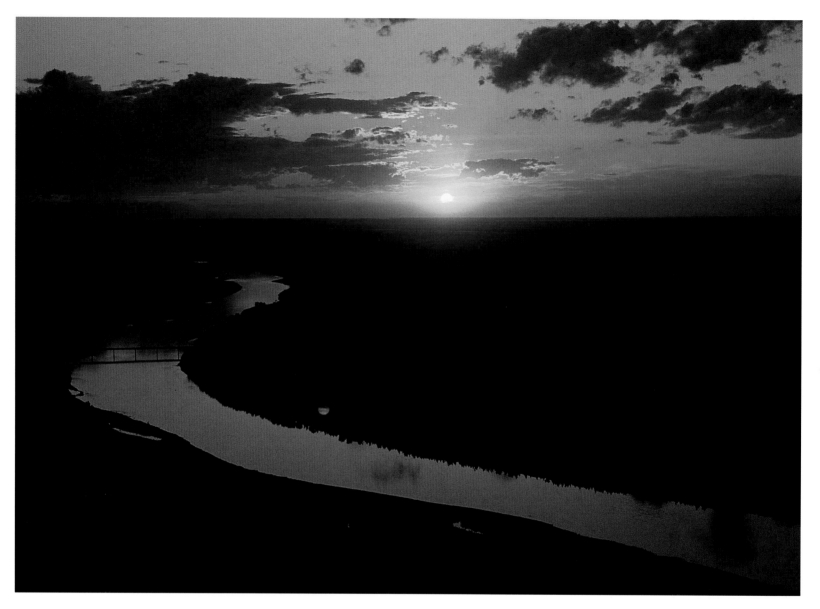

BOW ISLAND, ALBERTA

It was fascinating to hear how many people, in every province, argued that the sunsets
in their locale were the most spectacular in all of Canada. Having once lived on the Prairies,
I knew that prairie folks had a strong case. As seen here over the Bow River, the marriage
of boundless skies and flawless horizons can produce exquisite results.

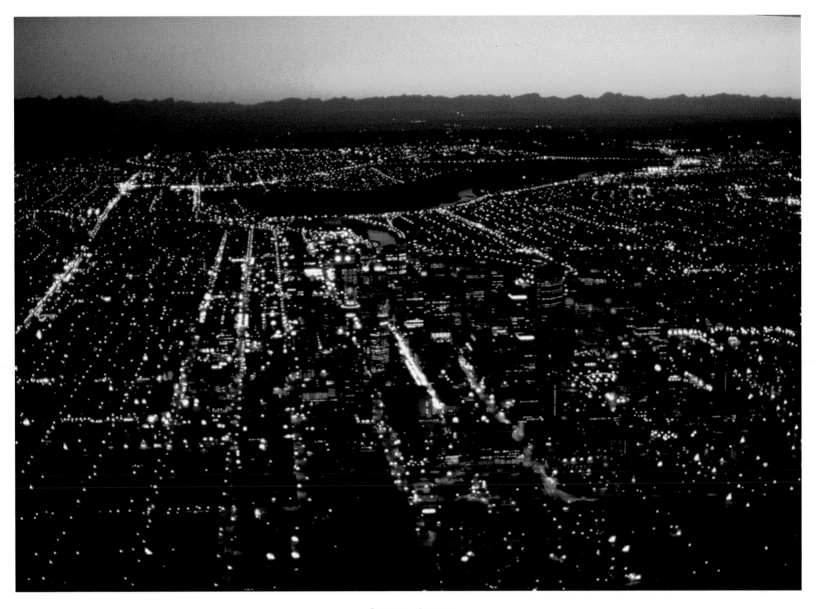

CALGARY, ALBERTA

The day's lingering afterglow provides a perfect backdrop for this bejewelled city just an hour before midnight.
It made me realize that, like the rest of us, Calgarians have had to learn to continuously reprogram their inner clocks.
In midsummer, the prairie sun is slow to find its way to the horizon. Conversely, winter is impatient
to bring on darkness, its sun slipping behind the Rockies as early as 4:30 in the afternoon.

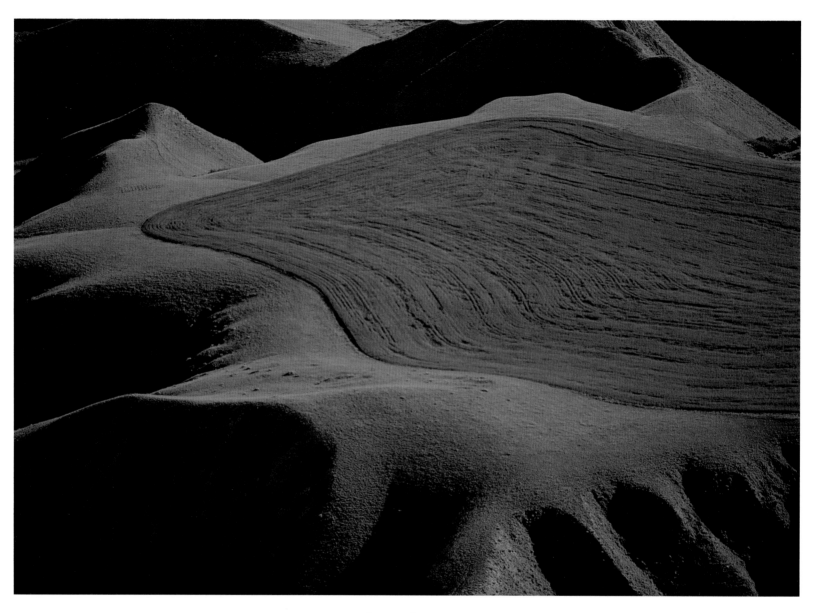

BROOKS, ALBERTA

One oft-quoted formula for good photography is "F-8 and be there." That is, we need to understand
the technical process, but even more important is being on-site when opportunity occurs. Several times on this flight,
just by virtue of flying every available fairweather morning, I lucked into stunning photo opportunities. In this scene,
it looked as though a child had spilled a bottle of green liquid and watched it ooze to the very edge of the badlands.
The lighting and composition were perfect, and I felt privileged to be the one to click the shutter.

INDUS, ALBERTA

Of the various aerial subjects I've photographed over the years, none has been as unusual as this one. It left me scratching my head, momentarily mystified by a bizarre graphic. It is, simply, swimming birds. The brown expanse is a farmer's shallow alkali slough. The seagulls aimless paddling parts the algae and weeds, spreading behind the black ink-trail of the pond's exposed dark bottom. A close look reveals much fainter lines, records of a previous day's travels, where the weeds have almost returned to their original position.

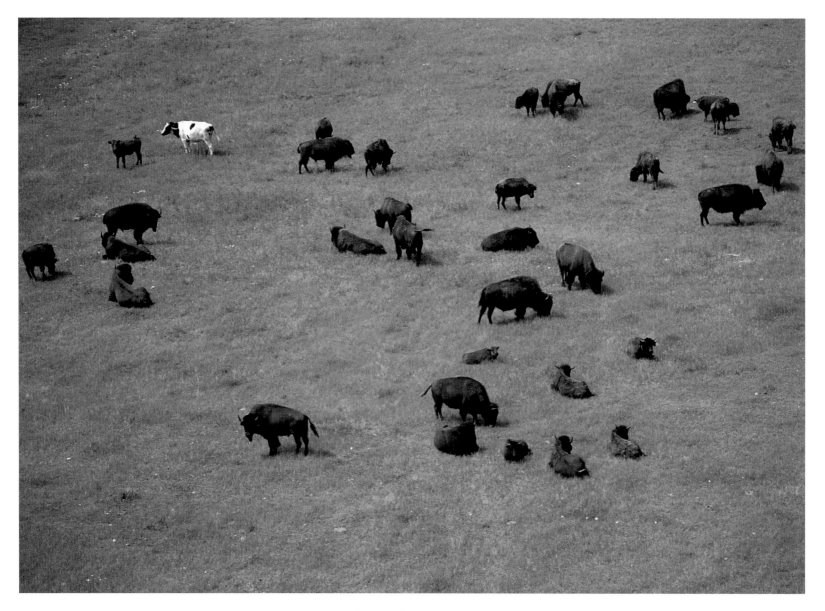

BIGGAR, SASKATCHEWAN

"It's a strange thing," said farmer Norm Nodwell. "Jenny's spots show up pretty clear to us, but the buffalo just don't seem to notice." It appears that ever since Jenny was hand-fed along with Cheyenne, a buffalo calf, she decided she was in good company in the middle of this domestic herd. The buffalo think that's just fine, and have no discouraging words to offer regarding this integrated grazing.

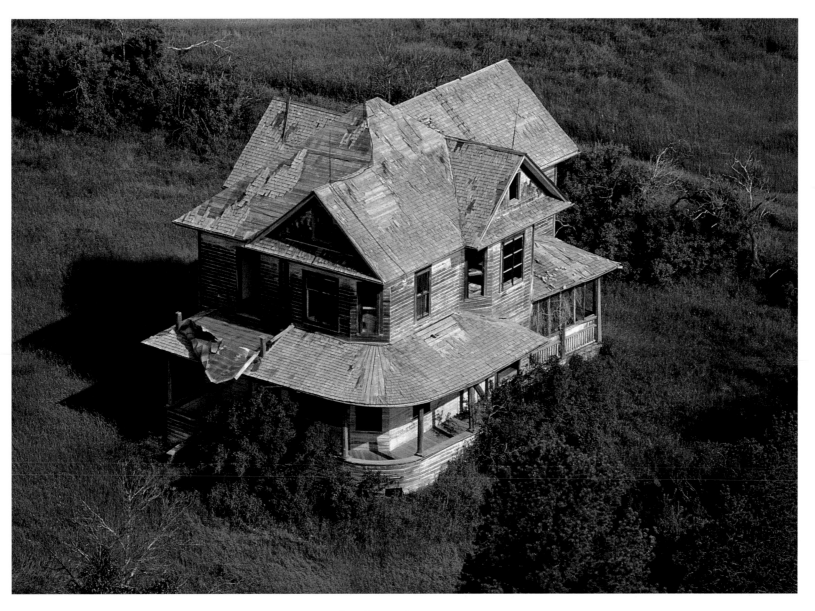

"The times they are a-changin'," rasped Bob Dylan, and nowhere is the process more obvious than
on the prairie landscape. Hundreds of abandoned farmsteads lie scattered across the country, reflecting a previous
era of family farms, closer neighbours and smaller acreages. Even in its arthritic condition, the grandeur of this
mansion caught my eye from more than a mile away. It is visually irresistible. If only these walls could talk.
A piano playing in the parlour...a quiet Sunday-evening conversation with Mom and Dad
on the porch...the back screen-door slamming shut as children run out to play...

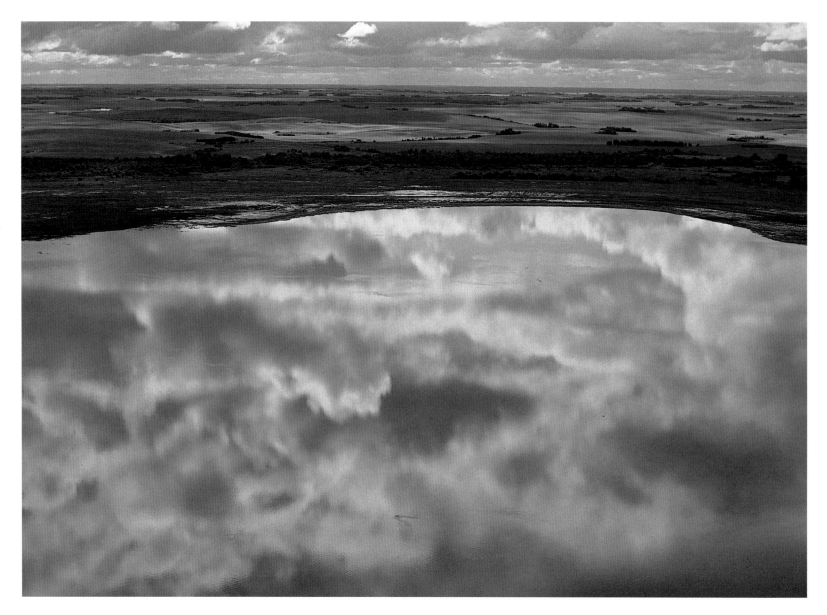

KRYDON, SASKATCHEWAN

There are black holes, but what if? What if our very own Earth contains sky holes—gravitational anomalies
capable of sucking the sky into inescapable vortices, packing it somewhere deep in Middle Earth?
Could we exhaust the sky? What would be left behind? What if? This photograph invites
upside-down viewing, interchanging the illusion of the sky for the reality.

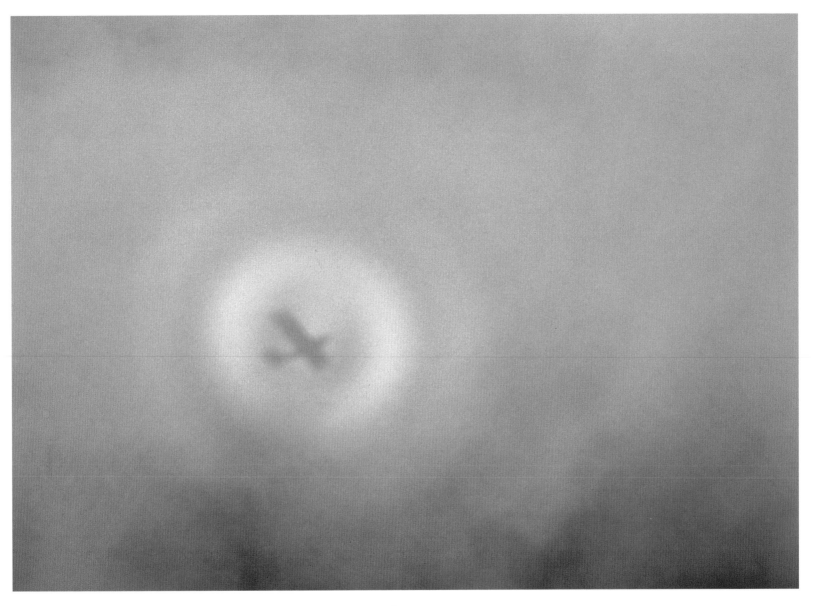

It is called, appropriately, a "glory," and so it feels to see alternating rings of transcendent colour
encompass your shadow and dance along the tops of clouds. The effect is created when sunlight is diffracted and
scattered by water droplets in the clouds. Aviators also call it a "pilot's rainbow" and think it's an enchantment reserved
exclusively for them as they skim above the heavens. The same curiosity, called a "Brocken bow," is sometimes
experienced by mountaineers standing on a peak with clouds below. Even more amazing, skydivers rocketing
earthward at 120 mph sometimes blast through the very centre of their own glory.

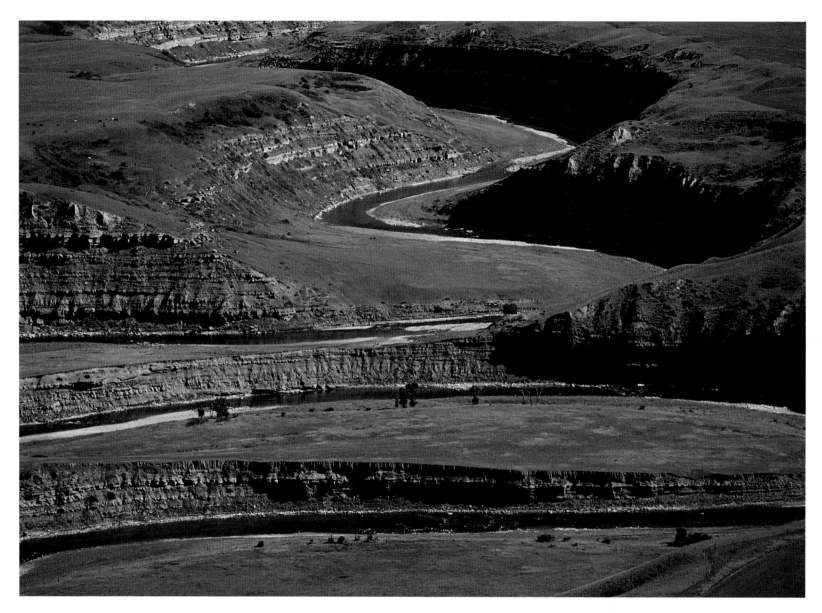

MAGRATH, ALBERTA

Contrary to my initial and naive expectations, the Prairies were anything but flat and predictable.
The aerial camera finds some of its greatest opportunities here. I was amazed to discover this geography lesson
immediately south of Lethbridge, where the St. Mary River has taken approximately 12,000 years to carve out these
bleachers for a prairie coliseum. Not far from this location is the continental triple divide. A single rain-shower
at this point can send water to Hudson Bay, the Gulf of Mexico and the Pacific Ocean.

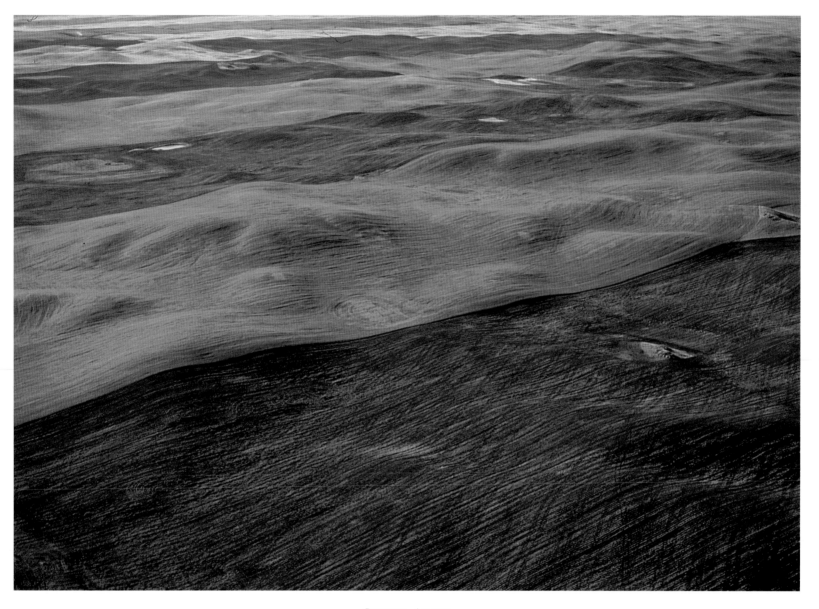

DUCHESS, ALBERTA

As the farmland edges up to the Red Deer River Valley, it begins a characteristic undulation. Besides removing
surface rocks every spring, the farmers also allow the land to rest on alternate years—summer-fallowing—and
as a result, they extract good yields of grain and hay. In the early morning light, it appears that someone
has spent a restless night tossing and turning under a green-striped blanket.

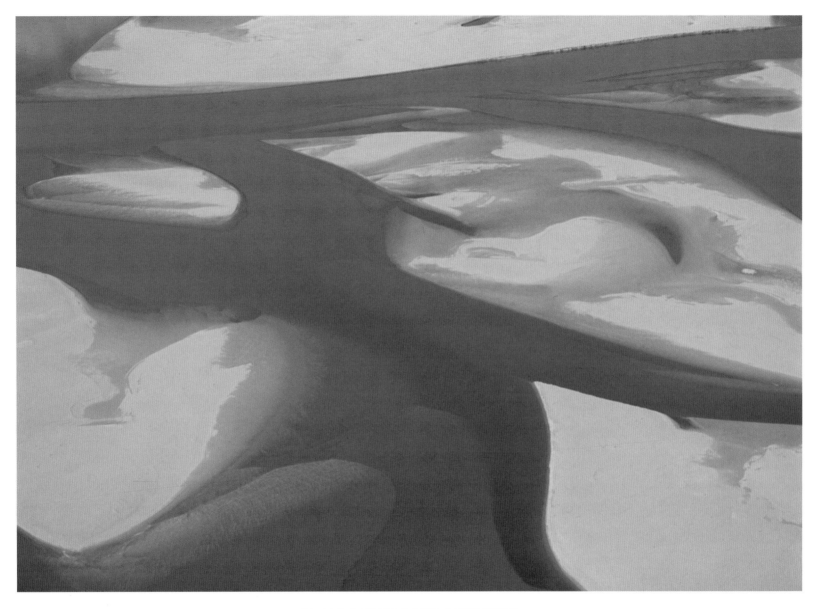

SOUTH SASKATCHEWAN RIVER, SASKATCHEWAN

This river seems undeniably lazy as it meanders slowly northward. Wandering here, hesitating there,
it seems long overdue in its work of draining the land. But perhaps that is because of a commitment to a much
nobler task—the gentle forming of endless sandbars, soothing to the eye, peaceful to the soul.

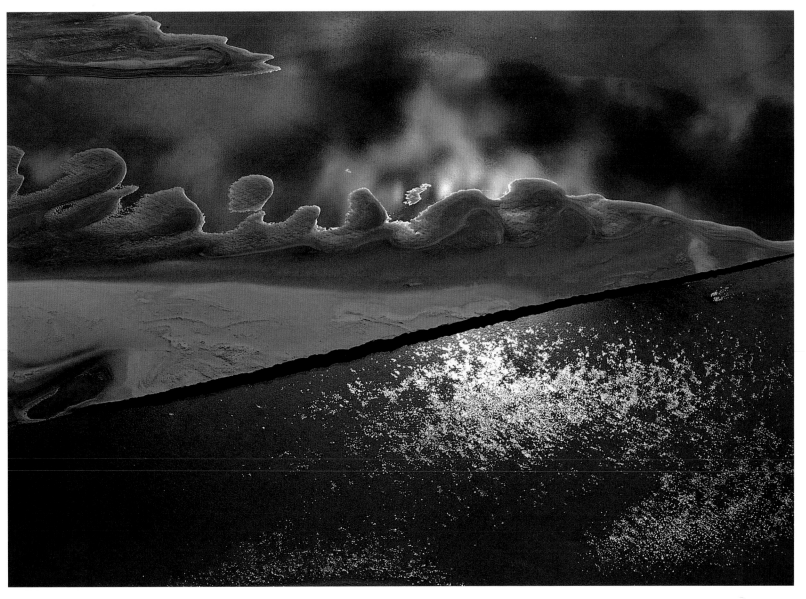

There is a fundamental technical knowledge that is basic to photography. Mostly, however, it is a lifelong
discipline of learning how to see, for most of us only perceive a part of what our eyes take in. This is a picture
of the same sandbars depicted on the opposite page. The difference is a fresh interpretation of lighting.
By waiting for the sun to momentarily fall out from between the clouds, and then shooting straight down
while slightly underexposing the photograph, we are given a bit of graphic magic.

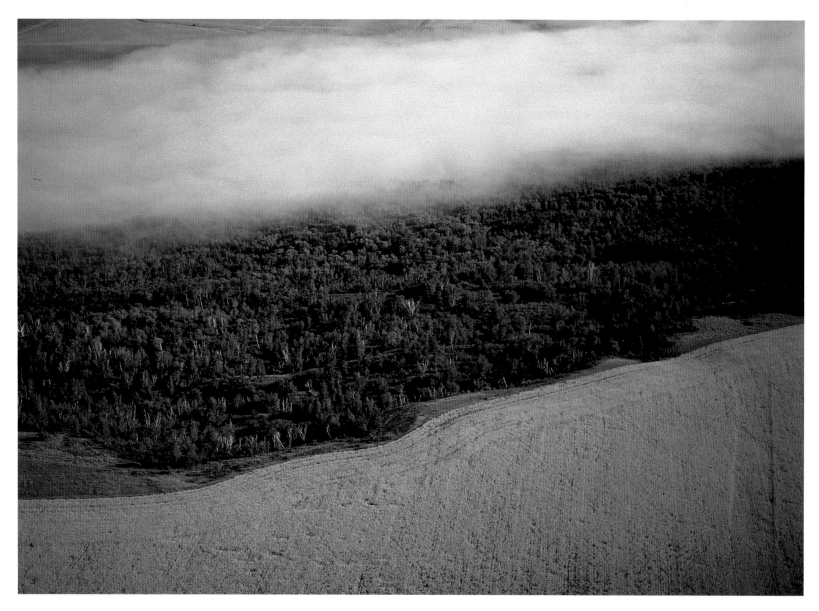

MOOSIMIN, SASKATCHEWAN

There are a number of suggested guidelines for effective composition in photography.
I was fortunate to have at least three elements fall into place in this scene: by framing the parallel lines diagonally
rather than horizontally, a stronger composition is achieved; the odd-number grouping of three components
is more eye-catching than an even number; and finally, the eye finds it both intriguing and relaxing to explore
the softness and variation in both colour and texture.

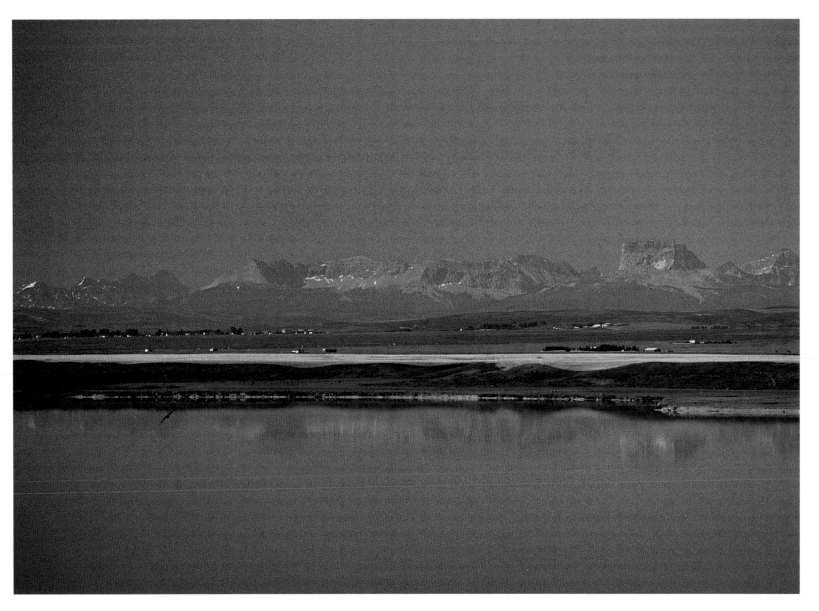

SOUTHERN ALBERTA

The Prairies welcome the Rockies with a subtle grace. As you approach from the east,
the blue-grey shimmer on the horizon gradually becomes a distinguishable skyline, much more irregular than that seen
on the Prairies. Massive walls of granite begin to emerge and the land acknowledges an impending change.
The terrain rises, and grainfields finally give way to forest. Located on the right
of this photograph is Chief Mountain, elevation 9,066.

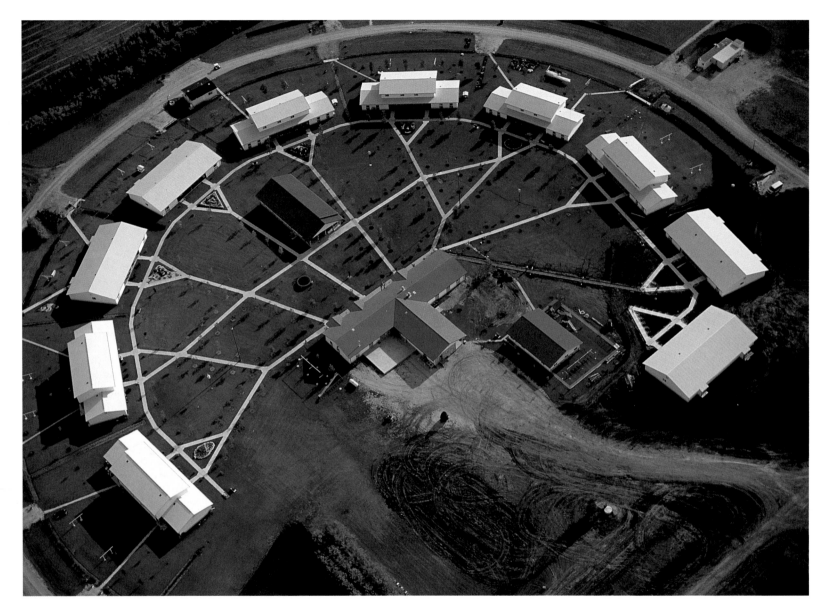

STARBUCK, MANITOBA

"And all that believed were together, and had all things in common..." Acts 2:44. It is on this scripture that
the Hutterites have built their communities—to date, approximately 256 of them across the Prairies. These ringed
duplexes of the newly built Starlite colony near Winnipeg house about eighty people. The network of interlocking
pathways—connecting the residences to each other and to the large central dining hall and church—
seems fitting for a communal lifestyle. Although the Hutterites espouse a simpler way
of life, their farms are highly successful and quite mechanized.

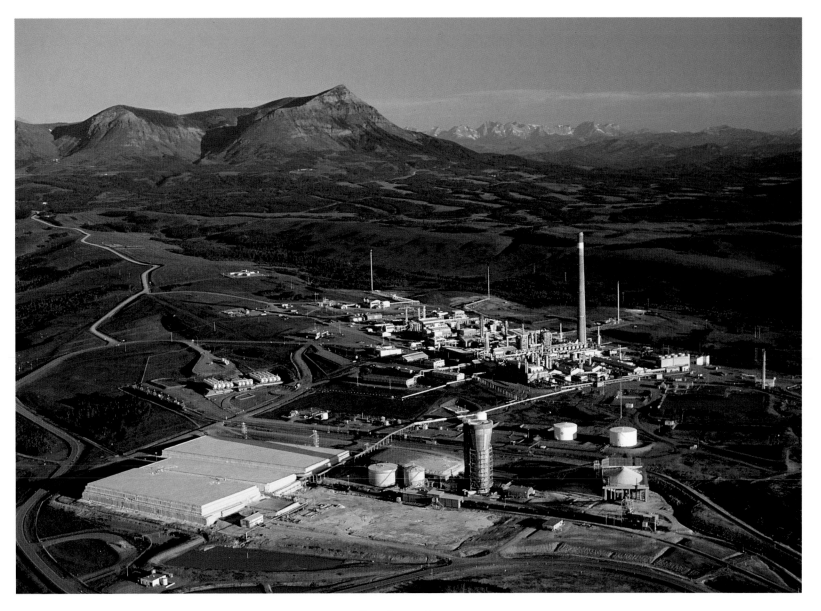

TWIN BUTTE, ALBERTA

Gas and oil are among Alberta's most important exports, and scenes such as this natural-gas processing
plant near the foothills are not uncommon. The huge yellow cakes of sulphur are a by-product of natural-gas refining,
and much of it will be used in the manufacture of fertilizer. Recent annual earnings from gas and oil in this province
were approximately $13 billion, making Alberta Canada's largest provincial producer by a wide margin.

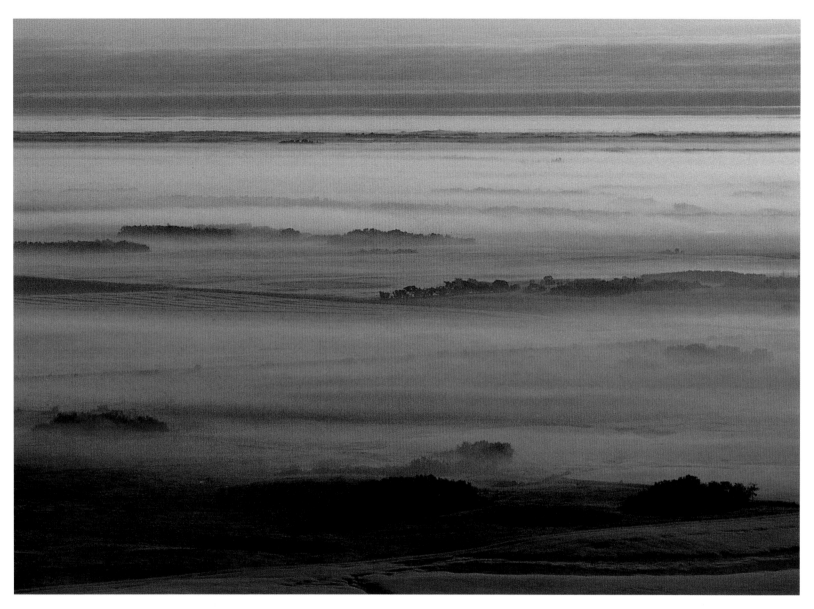

MOOSIMIN, SASKATCHEWAN

It was a dreamlike morning when I took off just at sunrise. During the night, a phantom artist had worked
unrelentingly, brushing the prairie landscape with pastel fog. His was a carefree touch, leaving bare
a row of trees here, a patch of wheat there. It seemed the canvas extended forever, and in the
distance, I could not distinguish where the land ended and the sky began. I flew through
this mystical enchantment feeling wonderfully calm and at peace with the world.

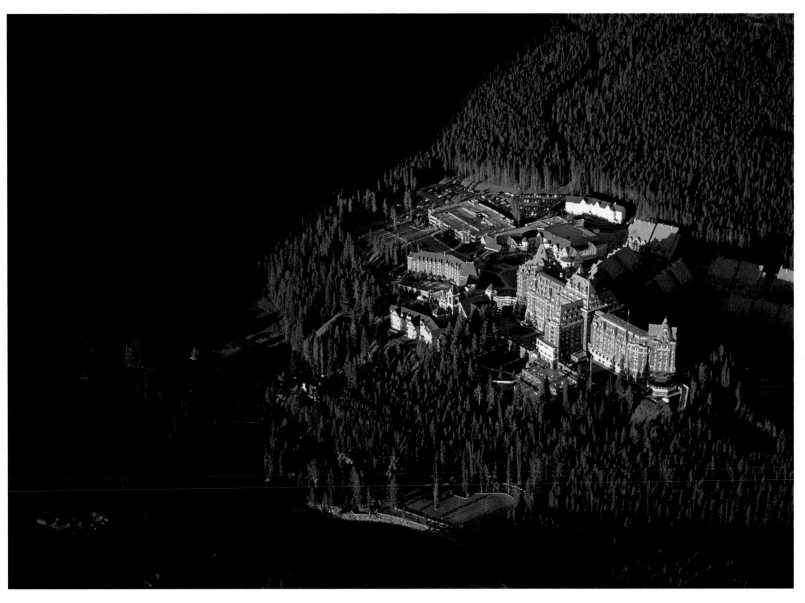

BANFF, ALBERTA

The Banff Springs Hotel's blend of grandeur and seclusion has been an emblem of more civilized
Rocky Mountain majesty for more than a hundred years. William Van Horne, engineer and architect of both
the Canadian Pacific Railway and its premiere resort destinations, enticed people to travel westward.
"You shall see mighty rivers, vast forests, boundless plains, stupendous mountains and wonders innumerable;
and you shall see all in comfort, nay, in luxury," he advertised. His hotel is admired the world over
as a survivor from those grand and glorious years when luxury reigned supreme.

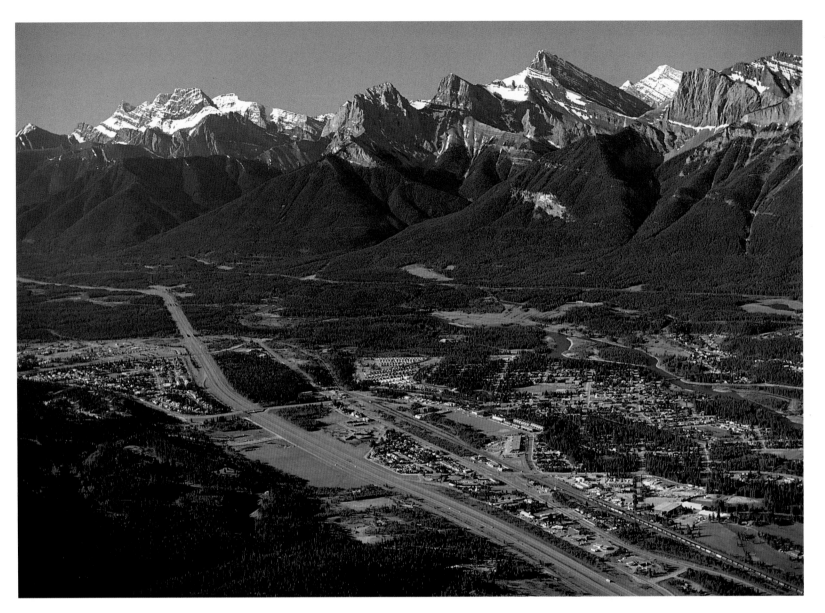

CANMORE, ALBERTA

Nestled just inside the foothills is the charming mountain town of Canmore.

It's been said that this is where the Great Spirit placed his heart. The residents think it is paradise and

can't imagine living anywhere else. One of them told me, "When I set foot in Canmore, it was love at first sight—

the spectacular mountain scenery, the peace and serenity. Eighteen years later, it is just as beautiful."

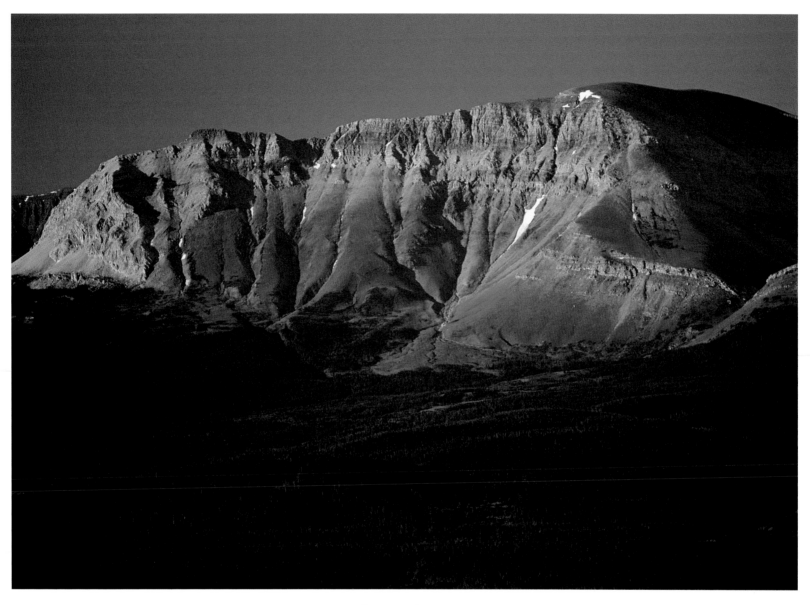

SOUTHERN ALBERTA

The rules changed here—as I recalled from my first cross-Canada flight in 1986. I had flown over the Prairies,
but I had to fly *through* the Rockies. The performance limitations of my 47-horsepower ultralight made it impossible
to fly over top of them. And this was obviously no place for an engine failure. In just two hours, I hoped to land at
the next airport, but it would be the longest two hours of the day. Entering here felt like opening a door marked
"No Trespassing." I thought of the turbulence, the hostile terrain, and my stomach churned. I radioed
my ground crew once more before their signals were lost in the mountains, and then turned
into the pass to begin my journey, simultaneously fearful and exhilarated.

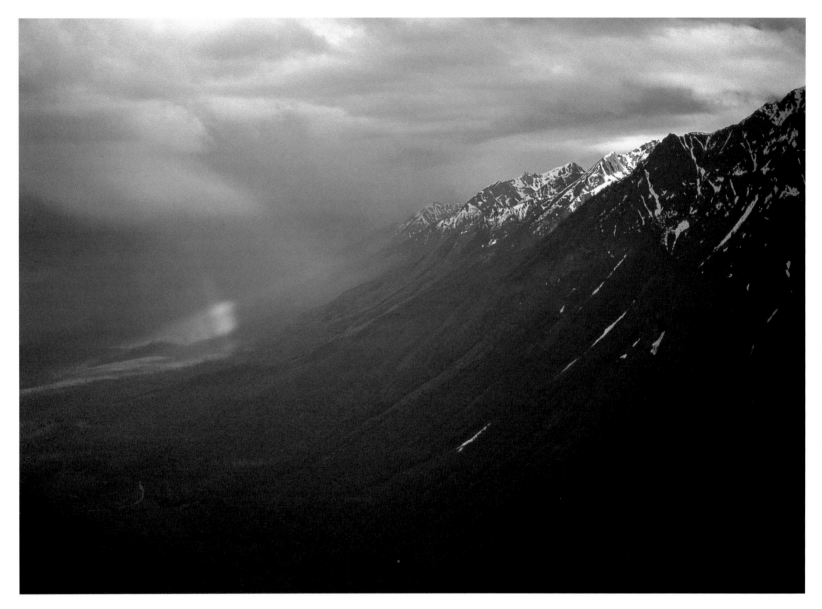

GOLDEN, BRITISH COLUMBIA

It was just a hint of a rainbow rather than a perfect arc through the sky, yet it was just as powerful.

And how appropriate, I thought, that I should find it here—flying through a rain shower toward

another wall of rock that looked impregnable to my ultralight. But the rainbow

led me on and made me feel somehow connected to this place.

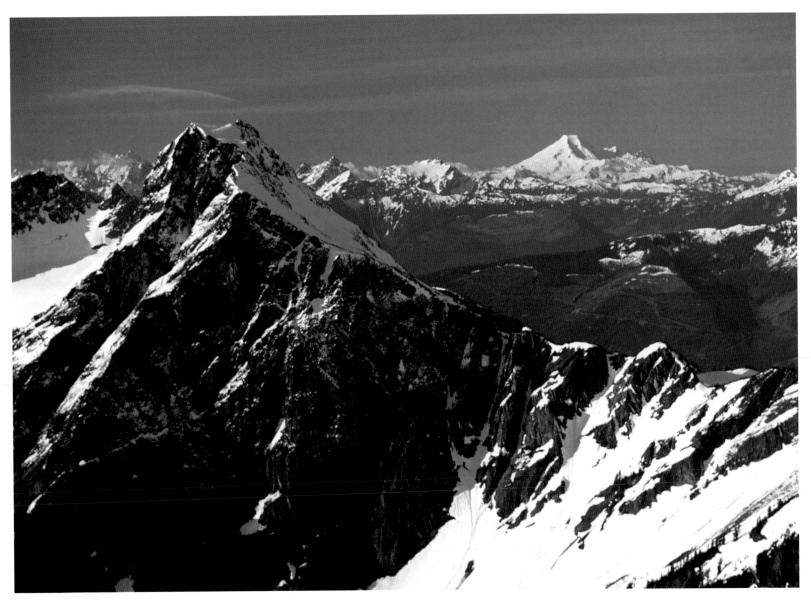

MOUNT CHEAM, BRITISH COLUMBIA

Between Mount Cheam—to the left of this picture—and Mount Baker in the distance, lies the Canada–U.S. border.
It is impossible to see it from above. The convoluted granite extends to the horizon, oblivious to any arbitrarily imposed
boundaries. Perhaps some of our affinity for Nature lies in the lessons she has to teach us.

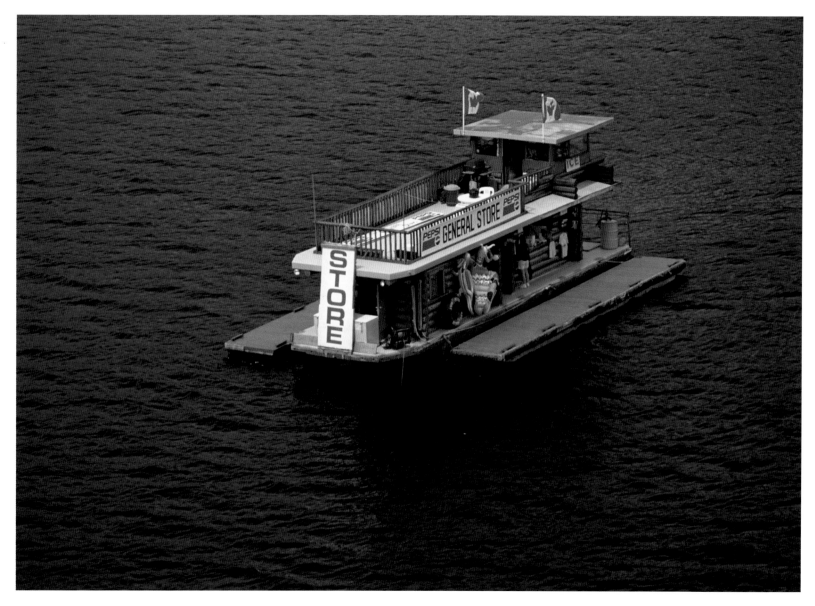

SHUSWAP LAKE, BRITISH COLUMBIA

Canadians love water and own approximately 2.4 million recreational boats to prove it. Despite all this
country's waterways, it is hard to imagine a more superb system than the interconnected fingers of this lake.
Over 600 miles of shoreline and 20 parks are open to adventuresome boaters, who can thrill to bald-eagle sightings
and the discovery of aboriginal pictographs. Not surprisingly, this area has been called the houseboating capital
of the world and comes complete with a floating general store catering to forgetful weekenders.

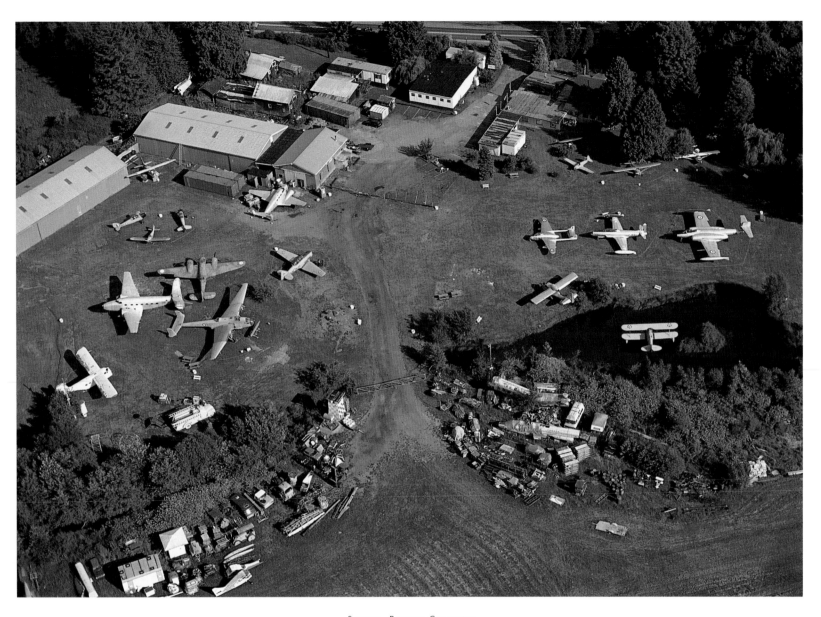

SURREY, BRITISH COLUMBIA

The Canadian Museum of Flight and Transportation has a rich grassroots philosophy.
It is run entirely by volunteers, is self-supporting, and aviation buffs who wander among the sixty outdoor aircraft
feel "it's like being in heaven." The museum was developed to stop the exodus of historic aircraft from Canada,
and its collection now ranks among Canada's best. Says one of the founders, "Watch a seventy-five-year-
old man who flew one of these birds many years ago show an airplane to his grandchild. The pride
in his eyes and the smile on the kid's face—that's what makes it all worthwhile."

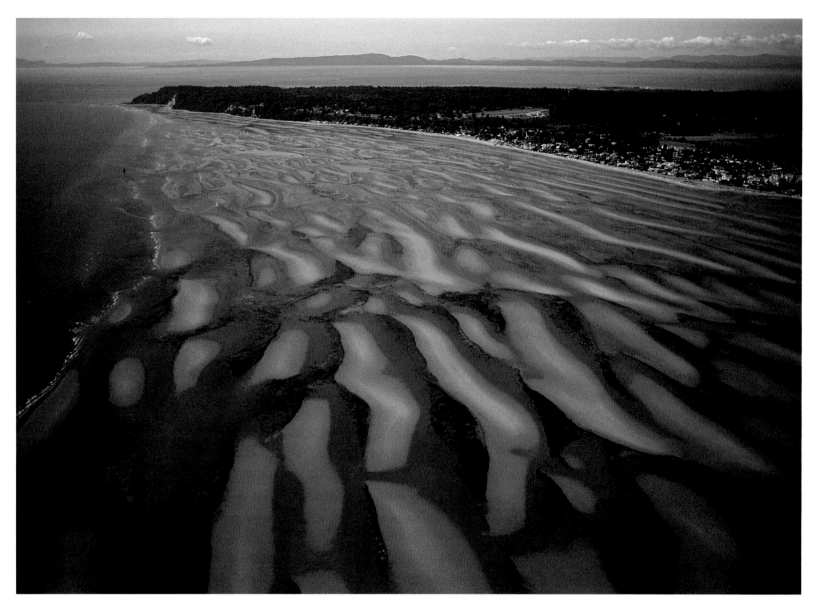

TSAWWASSEN, BRITISH COLUMBIA

I felt as if I had come full circle. My first-ever airplane ride, at age five, was on the West Coast.

My clearest recollections are of strong rhythmic shoreline patterns. I was once again flying over the Pacific Ocean,

reliving a beautiful childhood memory. It seemed fitting that one of the most vivid scenes to catch

my eye was that of these graphic sandbars shimmering in the receding tide.

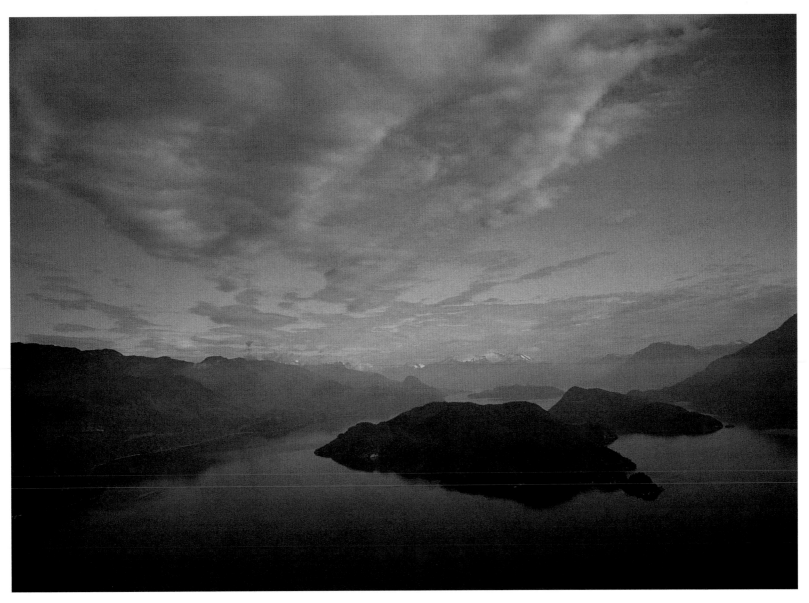

HARRISON LAKE, BRITISH COLUMBIA

A Tolkien "Middle Earth" mysticism characterizes this scene.
The clouds are whimsical, a giant turtle hulks on the surface, and there is a sense of motion both overhead
and below. Many people believe this area to be home to the Sasquatch—a hairy subhuman monster that may actually
exist. The tradition extends from early aboriginal stories to sightings as recent as the past few years. Photographs
and castings of Sasquatch footprints have even awakened some interest among zoologists. This lake and
its shores are likely to give birth to yet more stories of the strange creature.

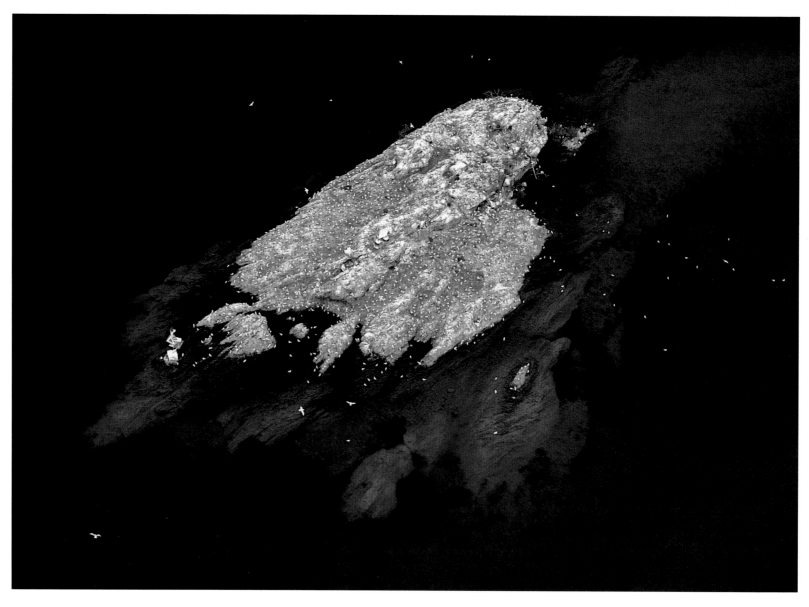

OKANAGAN LAKE, BRITISH COLUMBIA

A photograph may capture the moment, but its interpretation still lies with the viewer. There are
suggestions of both the elegant and the grotesque in this picture—pearls caught on a sandbar or a misplaced gargoyle.
To the local seagull population, this rock island at the north end of the Okanagan is simply home. By using
a polarizing filter, I obtained an unusual view of the rock's malformed appendages past the surface.

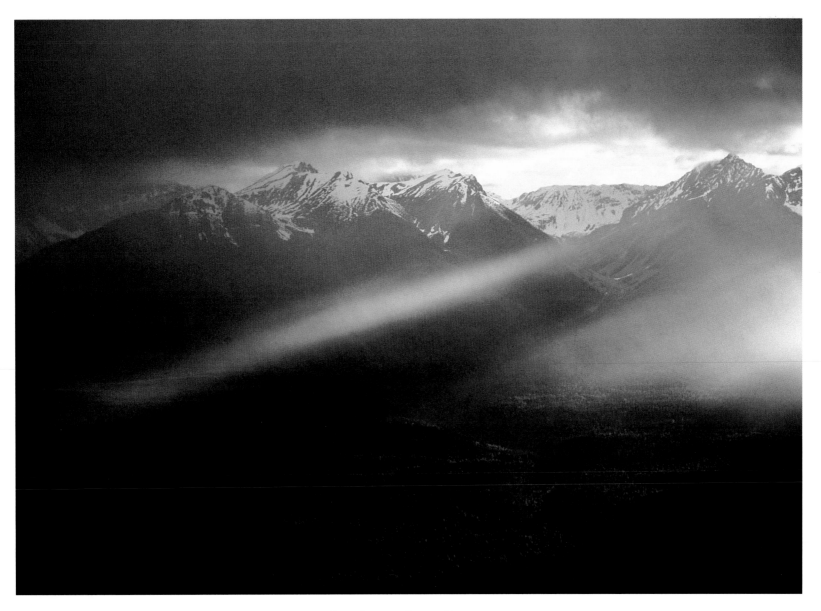

NEAR GOLDEN, BRITISH COLUMBIA

I had just flown through Rogers Pass and was cold, numb and tired. As I turned south toward the airport,
a wall of rain blocked the valley. There was no choice but to continue. Rain blasted through the open cockpit.
And then I remembered something. Experience had taught me to turn periodically and check the light behind me.
I did so and was overwhelmed as, just for a few seconds, the clouds peeled back and glorious ethereal light
streamed into the valley. Ten seconds and five shots later it vanished. I had been handed another gift.

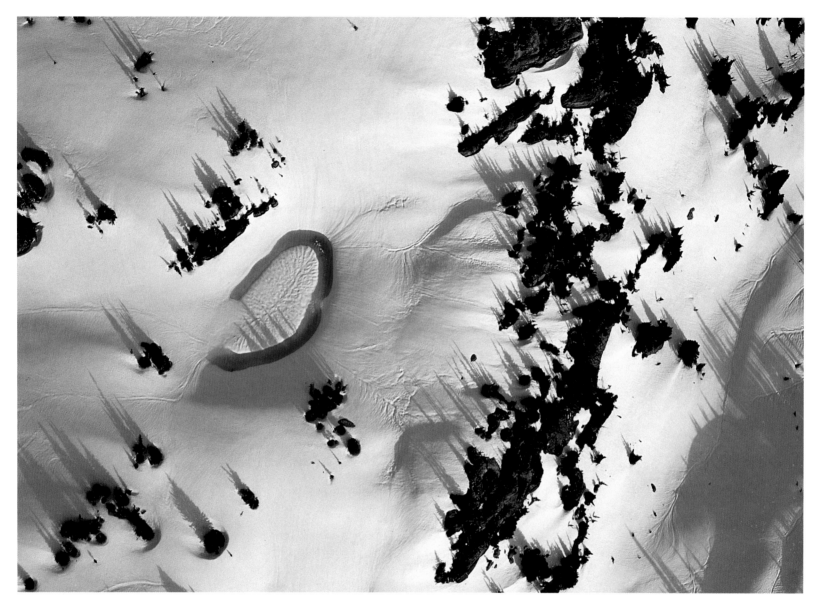

ROGERS PASS, BRITISH COLUMBIA

Although I was flying at 8,000 feet, I just barely cleared the top of this peak near Rogers Pass. But despite all the
fear, and the cold of my open cockpit, it was well worth the flight. How many of us are given an intimate look at
a mountain's balding head? I felt I should shout out my name, for the man of the mountain was listening,
his giant ear cocked in anticipation toward the sky. The midday warmth had melted just enough snow
to form this ear shape, and it had now refrozen, the sun having dropped low on the horizon.

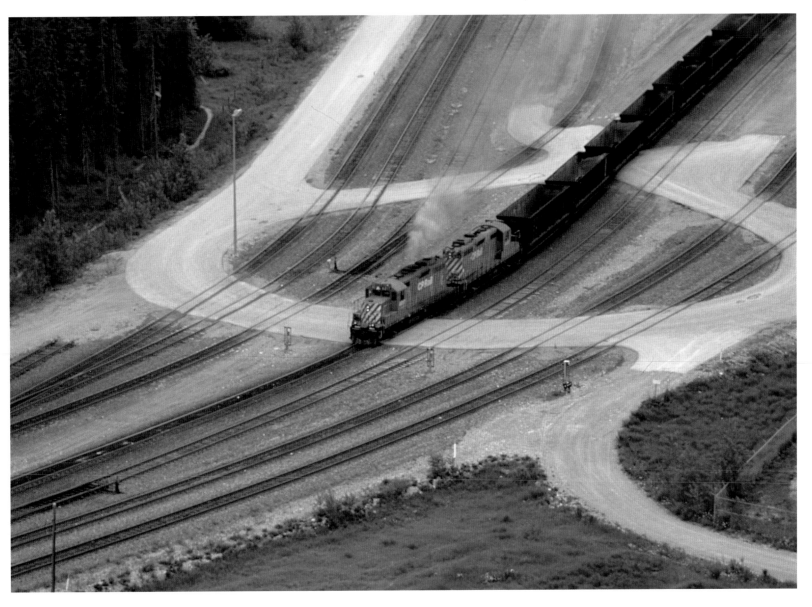

GOLDEN, BRITISH COLUMBIA

Perhaps this is the British Columbia version of New Brunswick's Magnetic Hill, where vehicles appear
to coast uphill. The eye suggests that this train, with its empty coal cars, is a runaway and that smoke should be pouring
from its brakes, not from the engine. It is the converging lines that deceive us, leading us to believe these tracks
slope downhill, when in fact they are perfectly level. If you view this picture with
the train positioned horizontally, some of this illusion disappears.

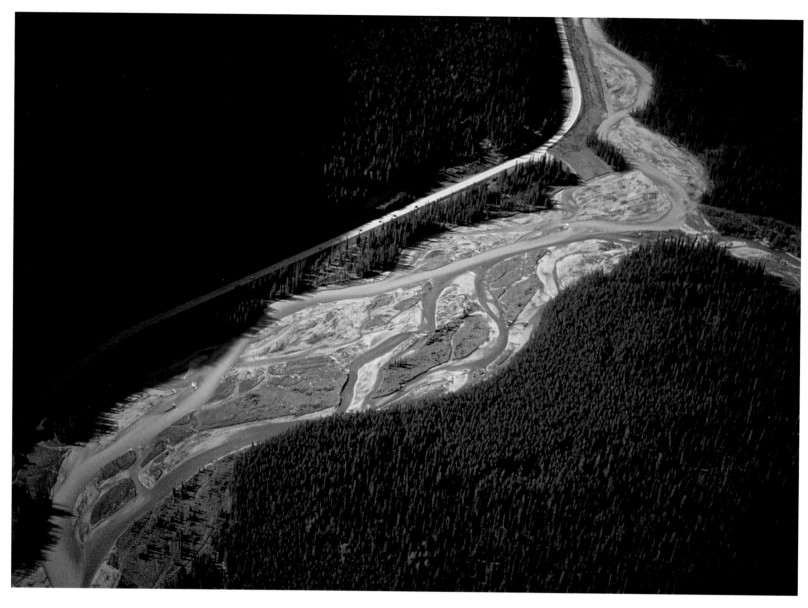

KICKING HORSE RIVER, BRITISH COLUMBIA

This river flows year-round, but it reaches its full stride in midsummer. With the long days, the sun
generates enough heat to gnaw away at the glaciers that are locked in the mountains above 8,000 feet.
What begins as icicle drips eventually becomes a pounding river and provides some of the best
white-water rafting and kayaking in Canada. Through the intermittent breaks in the trees,
passing motorists catch only glimpses of this delightful turquoise ribbon.

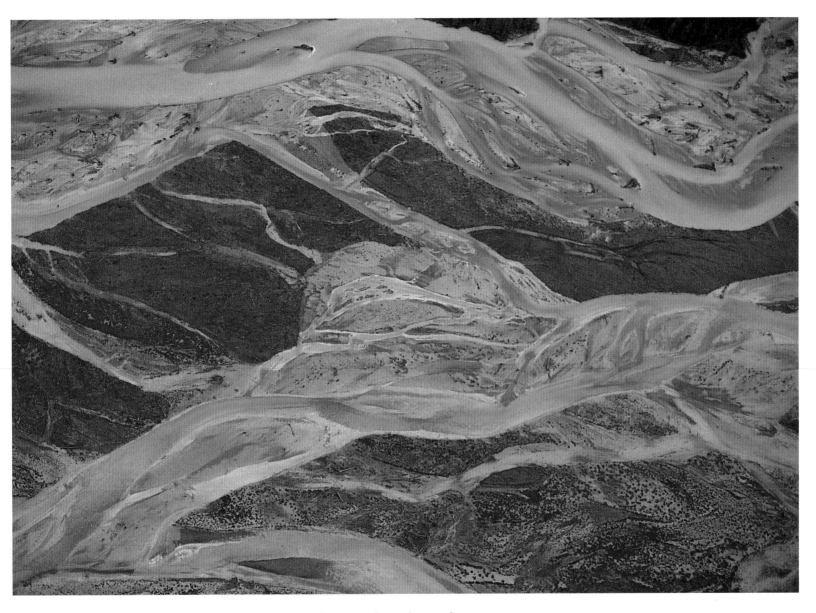

BLAEBERRY RIVER, BRITISH COLUMBIA

It seems contradictory. The water is ice-cold and yet it flows like delicate silk. Several high-altitude
glaciers have contributed to this masterpiece. Their massive weight grinds the rock beneath them to fine
"glacier flour," which then flows into the descending streams and paints them a restful blue.
The amount of "flour" determines the intensity of the stream's colour.

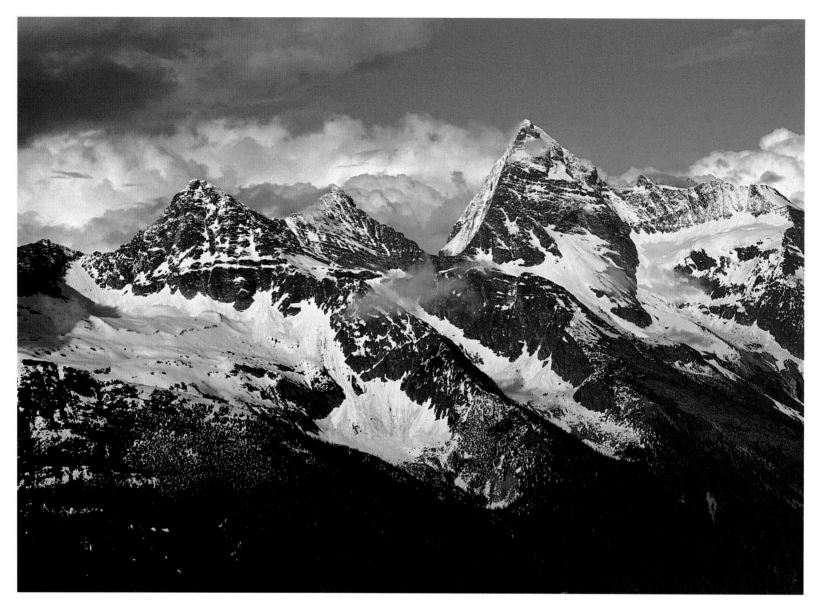

ROGERS PASS, BRITISH COLUMBIA

As I approached the summit of Rogers Pass, I was overwhelmed by the intensity of this skyline.

To the right of centre is Sir Donald, one of the most impressive and highest peaks (10,818 feet) in the area.

Despite its defiant face, a competent climber can reach this summit in a day. We need to keep our accomplishments

in perspective, however, for though a mountain may be scaled, it will always define its own agenda. It was

sobering for me to realize that over 200 deaths have occurred in this area due to avalanches,

including one accident in 1910 that killed 62 railway workmen.

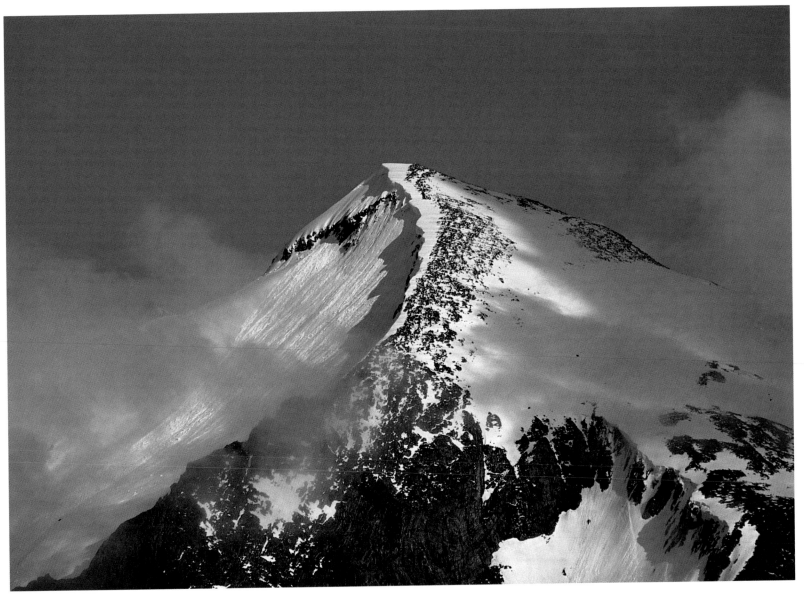

SELKIRK MOUNTAINS, BRITISH COLUMBIA

At 7,500 feet, my ultralight had reached its performance limits and would climb no higher. As I skirted around these fantastic wisps of cotton, yet another majestic peak loomed over my right wing. Each peak was staggering. Each was unique. Blowing snow had defined this one with a sculptured cornice. The snow ridge is fragile, and small sections can break free at any time and trigger avalanches on the slopes below. It is difficult to imagine destruction being precipitated by something so delicate.

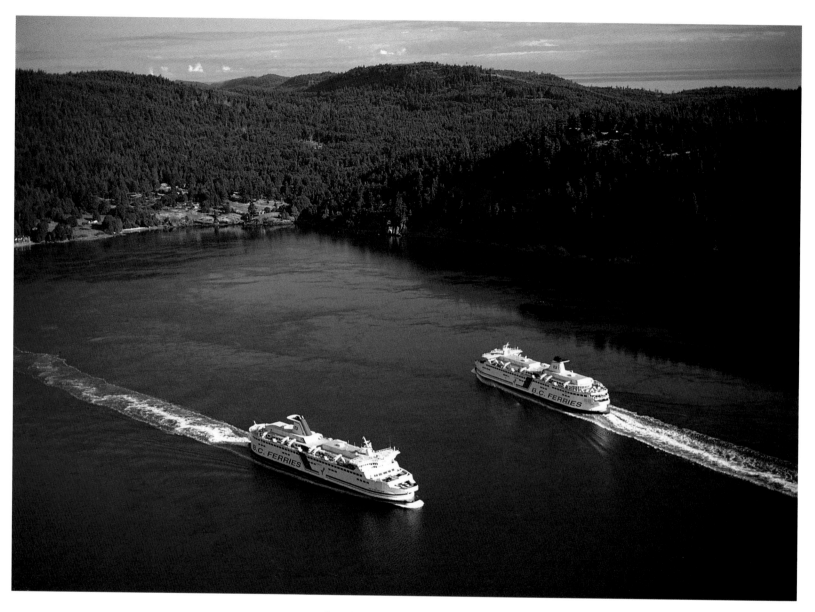

GULF ISLANDS, BRITISH COLUMBIA

Few of us commute to work and have the good fortune to go sightseeing at the same time.

For the ferry travellers between Vancouver and Victoria, the sights are numerous—rolling green landscapes,

charming cottages, and plenty of boat traffic. In Active Pass, where these ferries are crossing,

there is an additional likelihood of spotting seals, whales and other marine life.

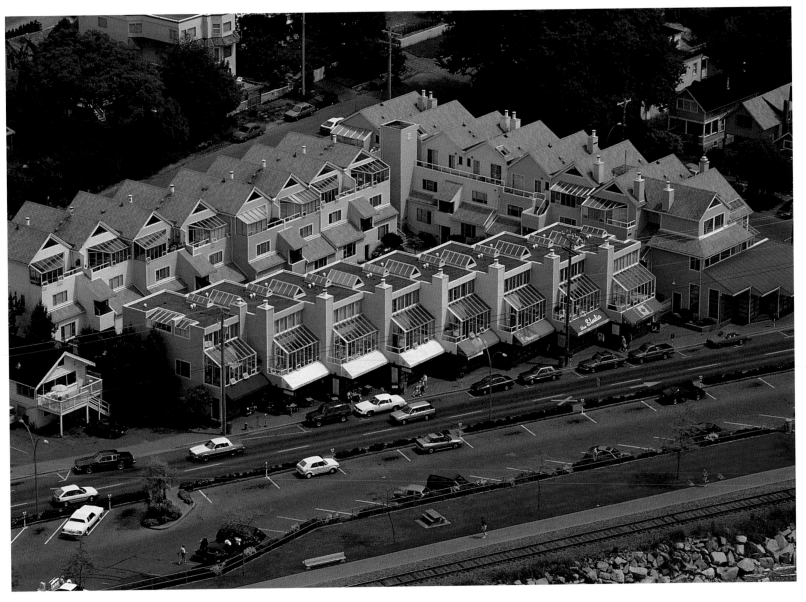

WHITE ROCK, BRITISH COLUMBIA

If there is a Canadian answer to Sausalito, California, it may be the town of White Rock.
Located just outside of the hustle of Vancouver, this seaside community has one of the most moderate
and warmest climates in Canada. It's also been argued that some of the fish-and-chip outlets along
Marine Drive are without equal. With a steady influx of people, new housing developments,
such as these condominiums, are constantly springing up.

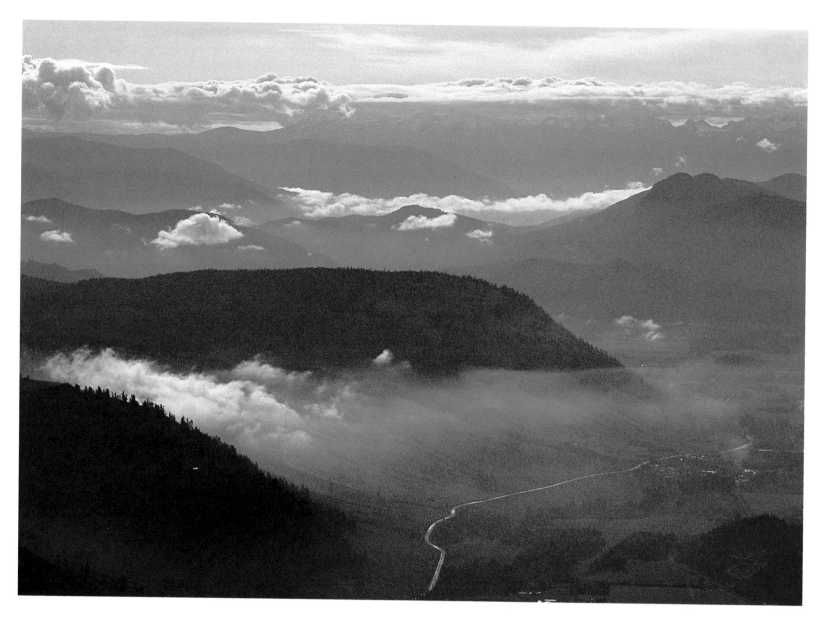

For some time, I became metaphorically lost in this scene of whalelike mountains breaching in
a wave-crested sea. And though all was stationary, I imagined movement everywhere—breaching,
rolling, disappearing. Much of the central part of this province is characterized by rolling mountains;
only at the east and west boundaries of the province do the mountains pierce skyward.

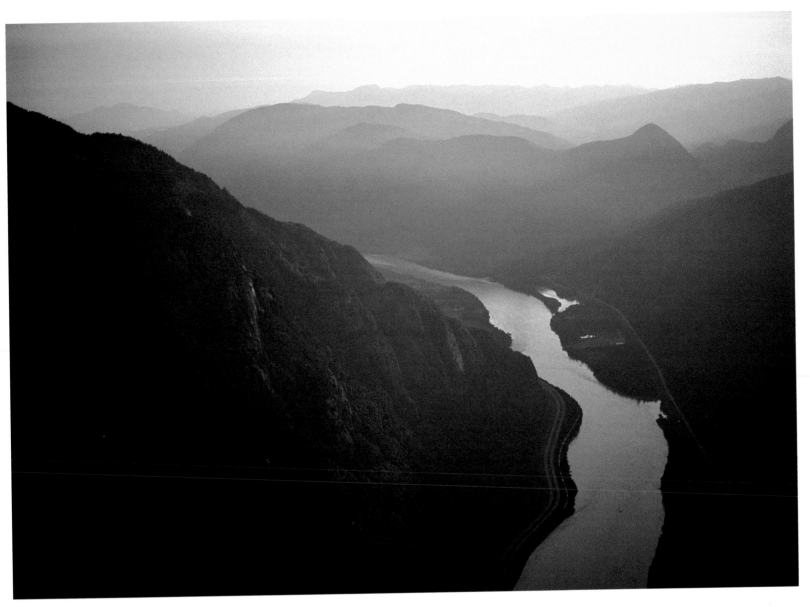

HOPE, BRITISH COLUMBIA

After all its spaciousness and open fields and highways, the Fraser Valley suddenly ends at this point.
It is a dramatic moment for a light-plane pilot flying east, as the mountain walls squeeze abruptly inward.
The tranquillity of this evening light wonderfully diffuses what the pilot will face the following morning:
the choice of three mountain passes—the Fraser, the Coquihalla or the Hope Slide. Each has its own
topography, unique weather patterns, and a reputation from old-time aviators.

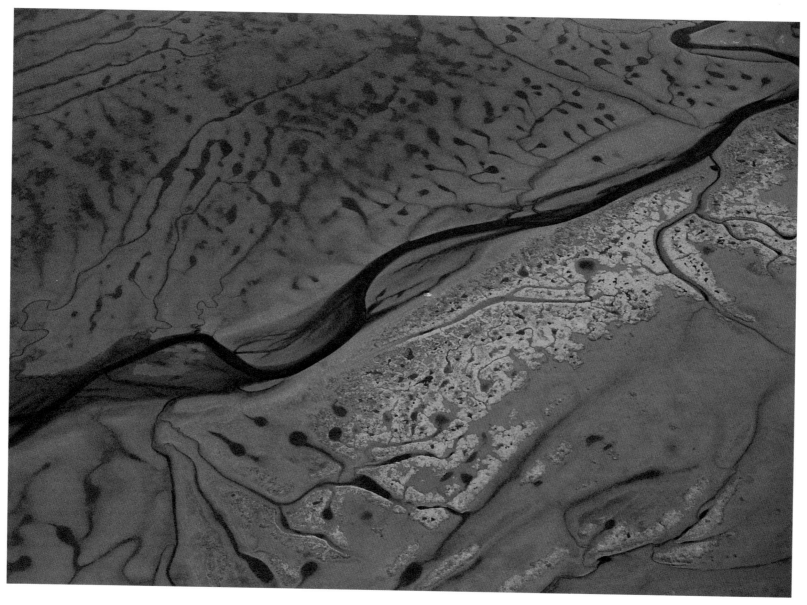

BOUNDARY BAY, BRITISH COLUMBIA

It is as though Nature has designed her own camera, with the slowest imaginable shutter speed.
It would take patience to watch this watery lens open. With every cyclic retreat of the murky brown tide,
a similar but slightly altered presentation of these captivating Pacific coastline mudflats is offered.

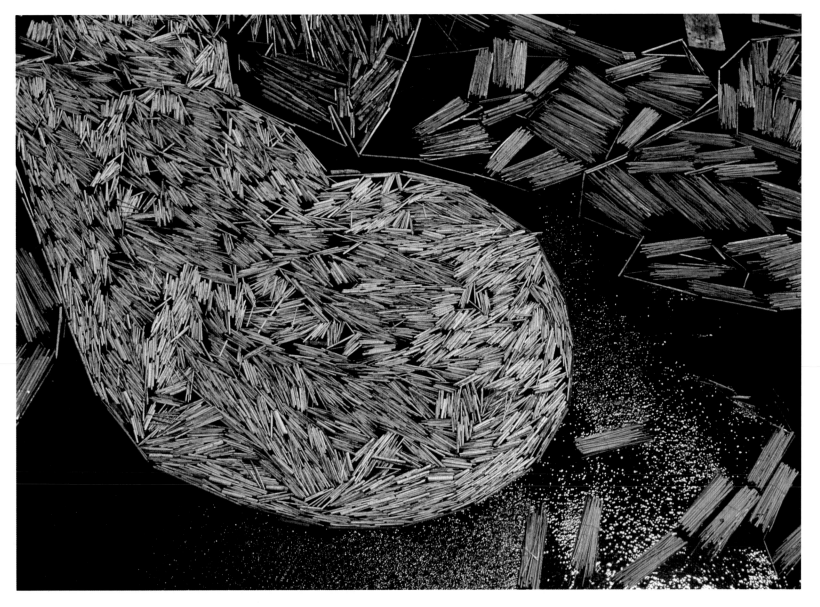

These new logs are western red cedar, which, because of their stringy bark, need to be
debarked separately. They are then returned to the water and are loosely boomed in front of the sawmill to await
further processing. Because of the cedar's unique characteristics—it is rot-resistant, bug-repellent, and beautifully
grained and coloured—it is highly sought after for decking, fencing, siding and interior panelling.

# JOURNAL NOTES

Author's note: I have now flown twice across Canada in an ultralight. My first flight, in 1986, was from Halifax to Vancouver. The second was from west to east, and was completed during the summers of 1993 and '94. The journal notes in this section of the book are taken from my second flight and reflect my journey eastward.

————————

It has been a long time since I've been so conscious of fear. It is hard, raw, and uncompromising. My flight from the Pacific Coast to this point has been effortless over the flat ground of the lower mainland. Here, the valley stops, blocked by massive granite reaching into the sky. The Rocky Mountains.

The scene outside the motorhome window seems irreconcilable. *After You*, my ultralight, looks almost laughably fragile against a mile-high mountain backdrop. It's mind-boggling to think this open-cockpit, 400-pound flying machine is capable of carrying me any further.

At 6 A.M. the sky is overcast and an unforecast east wind blows through the valley. Ahead lies my first mountain pass. It has been called, for good reason, the Killer Pass. In the past month alone, two aircraft have smashed into these rock walls. Eight people died trying to negotiate what has sometimes been called the most dangerous 30 air miles in the Rockies.

Fortunately, there is another alternative—the Coquihalla Pass to the north. Although the pass is longer, and I'll have to reach 7,000 feet to fly safely through, it is less dangerous. The summit is less likely to be blocked by clouds, and should I be forced to land, there is a four-lane highway winding along the bottom of the canyon.

Takeoff. As anticipated, the valley air is turbulent and I gingerly crisscross the upwind mountain face, using the ridge lift to gain altitude. Finally, at 4,000 feet, I turn in to the canyon and begin my journey of simultaneous fear and exhilaration. My climb rate becomes slower and slower as I reach the performance limits of my modified snowmobile engine. Several times, unexpected downdrafts overpower my ability to climb, even with full throttle. I quickly turn for another part of the ridge, trying to outrun this descending elevator.

I trust my ability to fly and make decisions. The fear comes from the unknown—the winds, the turbulence, the reliability of my two-stroke engine. At times, the wind seems an unpredictable monster. In one 5-mile stretch, it changes direction three times, each time generating new areas of turbulence, lift and downdrafts.

Besides having to worry about the tumultuous air, I can't help but wonder what would happen if my engine died. The only option would be to try to land on the highway that snakes its way along the bottom of the canyon. Gliding down at approximately 500 feet per minute, I would soon be surrounded by canyon walls, giving me less and less room to manoeuvre. At the same time, the turbulence would increase, much like that generated at the bottom of a waterfall. Finally, would motorists below see me coming in time to stop and make room for an adequate runway? I shiver at the thought and glance once again at the engine temperature and RPM gauges. Everything looks fine for the moment.

Assistance arrives from an unexpected resource —my former hang-gliding experience. In over 1,300 flights, I learned invaluable lessons on how to ride the wind without the benefit of an engine. Now, when my ultralight is unable to climb any higher, I am grateful for that experience. I head for a sun-bathed

rock face, ready to grab the first available thermal, and corkscrew my way toward the tops of the surrounding peaks. My flight path takes me as far as possible from the leeward side of a mountain, where the turbulence is bound to overpower me. The irony does not escape me: I broke my back hang-gliding, yet the lessons from this sport now carry me safely through these awe-inspiring canyons.

Although I'm here to photograph, I am sometimes so tense from the flying I don't even think of my cameras. My left hand grips a support tube, the other clenches the control stick, and I almost become an white-knuckle flyer. In hang-gliding, we called this "rodeo air," the imagined equivalent of riding down a wild bronco. Several times, the turbulence causes me to go negative, meaning the ultralight drops so quickly that only the lap belt holds me in my seat. There is a sense of complete vulnerability, sitting in an open cockpit without doors or windows, and I instinctively pull my security belt even tighter.

Even when I do begin shooting, my efforts are largely misdirected. It takes several rolls of film before I realize that being here is so overwhelming that I'm shooting indiscriminately, with little thought as to lighting or composition. Never have I experienced such a simultaneous visual and emotional overload. I have to slow down and refocus. Still there is a sense of hopelessness. I have three cameras and eight lenses at my disposal—more than enough equipment. But it seems inadequate, for nothing can begin to capture this magic. Snow-capped peaks pierce the horizon on all sides and stretch out to the north as far as I can see, probably 100 miles or so in this rarefied air. I can't imagine a more powerful landscape than this one.

When the air quietens long enough to allow my heart to settle, and I can swallow the tension in my throat, the flight becomes more of an inner journey. It occurs to me that perhaps my frustration with my shooting is self-induced, for I'm probably not photographing mountains as much as trying to capture an emotional and spiritual experience.

Seen in terms of mountain scale, from the far side of the pass, I am insignificant—a tiny white dot creeping along these gigantic granite faces. This ancient rockscape contains a sense of infinite power and leaves me feeling ultimately alone. Even my radio offers little comfort, for its signals are usually blocked by the mountains, cutting me off from my ground crew.

And yet, as this surrealistic flight continues, I also feel a profound connectedness to the universe and God. To be here is to be humbled, awestruck, and touched to the very core with wonder. Is this what astronauts feel? It is as though I have been handed a gift, similar to what I have experienced in the past—diving through ocean waves at night, snowshoeing in Canada's North in the dead of winter. It is an experience of extremes, an awareness of the limitations and fragility of my humanness and of a divine centredness.

———⊰⊱———

Exercise in humility today. Time to eat my own words. How many times have I heard stories of some pilot who got caught trying to outrun the weather and thought: Dumb decision. Why did he even try that?

Why indeed? Why did I end up in the same situation today? How could a series of such minor decisions lead me into this near disaster?

It starts off as a ideal morning. I'm up at 5 A.M., with a perfect clear-sky day. In two flight legs, I hope to make it to Drumheller, Alberta, about 170 miles away. The air is a pilot's delight—cool for good aircraft performance and smooth as silk. This is open prairie grassland. There are no fences, hydro lines or buildings. Perfect for low flying. At times I skim a mere few of feet above the gently rolling terrain, surprised to see an occasional jack-rabbit or pronghorn antelope suddenly burst into flight just

BACK *to the* CLASSROOM

below me. In half an hour, I shoot five rolls of film. This couldn't be better.

A glance westward brings a surprise, a cloud mushrooming up from the ground. It must be smoke from a massive grass-fire, I think, since a cloud wouldn't descend right to ground level. I bank west, looking through my telephoto lens for telltale signs of yellow flame. Nothing. I'm slow to realize that the cloud is the leading edge of a huge fog bank. Not to worry, the sun's hot enough to start burning off the fog. I'll keep flying and just skirt around the edge of this three-dimensional stop sign.

The wisps of white become increasingly dense and eventually form a thin cloud cover about 700 feet above ground level. Not a problem, I think, there's lots of room to fly underneath. The cloud ceiling, however, continues to slowly fall. This has to dissipate, I remind myself, and besides, I only have 12 more miles left to go. "Homeitus" it's been called, and it's probably killed more pilots than any other cause—pushing those last few miles for all the wrong reasons.

To keep clear contact with the ground, I am forced to fly ever lower, and am finally down to 100 feet, zigzagging from one patch of light to the next. It does not look good. "Gulliver, this is Wings," I radio my ground crew and slip even lower. "I don't like the looks of this and am going to do a one eighty." Although I've lost sight of the motorhome, I know it's only a half mile or so ahead. "Actually, it's brighter here," Tom radios back. "It's not bad at all." I decide to continue.

Suddenly, the ground beneath me is obscured! I instantly shove the stick forward to slip beneath this white curse. To my momentary relief, a patch of green flashes into view. Ground contact. But there are also clusters of sky-reaching bushes scattered everywhere, less than 30 feet below. I'm trapped! This is one of a pilot's worst nightmares. I've allowed myself to get sandwiched between the ground and

an ever-lowering cloud bank. How incredibly stupid. My heart races. I can't climb into the fog and I can't find a clear path long enough for a safe landing. Gingerly, I bank into a shallow left turn, hoping to reverse my direction and head back to clearer skies. The windshield mists over, and I'm forced to lean out of the cockpit to see. I've never scanned the skies so anxiously as I do now, desperate to find a flight path clear of obstructions. At this height, at 50 miles per hour, almost anything could easily tumble my ultralight out of the skies— an irrigation pipe, a stand of poplar trees, a hydro line. The turn only takes ten seconds, but it is one of the longest ten seconds of my life. Finally, there's a lighter patch of grey with a few more feet of space between me and the ground. In another minute, the fog suddenly folds back like covers pulled from a bed, and I can see blue skies ahead. I find a hayfield that has just been cleared and I circle in for touch-down. "Gulliver, I'm landing. You'll see me beside the road."

*After You* bumps to a stop on the rough ground and I flick off the engine. I'm safe, but I could just as easily have demolished my ultralight and injured myself, all because I ignored my own caution signals and pushed on with a cocky self-assurance. For three weeks, I had slowly threaded my way safely through four mountain passes, pushing myself and my ultralight to maximum limits. The Prairies, I thought, with their flat ground and predictable winds, would be a piece of cake. Today is a reminder that flying accepts no excuses from fools or the careless. I am humbled. I have learned my lesson well.

---

As a grassroots, keep-it-simple aviator I'm not looking forward to flying into controlled airports with radios and air traffic controllers. In fact, the prospect is intimidating. I remember when I obtained my radio licence sev-

eral years ago. Given the choice, I'd rather have spoken to a crowd of 400 people than talk to one solitary controller, 5 miles away, whom I'd never met and likely never would. It was a long while before that paradox made any sense. Most likely, it had to do with being the new kid on the aviation block, having to learn a new protocol with strange, almost cryptic jargon. And if I didn't master this dialect, I'd be a laughingstock. Dozens of pilots, from Windsor to Niagara, would be beside themselves listening to this rookie who had just called the Waterloo control tower and identified himself as "Yalfa Ankee Tango" instead of "Alfa Yankee Tango" (an aircraft call sign). I knew it could happen, because it had—to me. On a previous flight with a friend, I had, with great anxiety, offered to call the tower as we approached the control zone. Had there been enough room on the floor of that Cessna 150, my friend would have found himself there, holding his gut in laughter. Yalfa Ankee Tango, indeed. I had reason to be intimidated.

Here I am, embarking on a cross-Canada flight and intentionally routing myself through major airports—Calgary, Winnipeg, Toronto, Quebec, Halifax—all bristling with radio antennae, ultra-light-seeking radar dishes, and unsympathetic controllers. Then I remember the wisdom of Laurie Skreslett, the first Canadian to climb Everest. He said that the best way to deal with fear was to meet it head on. Do that, and it would get smaller and smaller. Run away from it, and it would become unbelievably large.

I meet it head on, once and for all, by flying into Pearson Airport in Toronto. This is Canada's busiest airport, with a daily average of a thousand takeoffs and landings. I spend a restless night before my intended visit, full of visions of my arrival—a radio transmission too garbled for understanding, a mistaken runway number, an improper flight path, and then a 747 vortex from 2 miles upwind finding my aircraft in its path and flipping it like an autumn leaf.

My landing is scheduled prior to 6 A.M. I need to arrive before the bulk of the "heavies," the DC-10s and 747s, end their night journey and reach down for their concrete beds, their reverse thrusters thundering. As I fly toward the airport, I push the transmit button on my radio, and across the awakening skies make an invisible but comforting link to a voice 10 miles away. The response is almost immediate. "This is Toronto tower. You are cleared left base for Runway Zero-six Left. Report three miles back." Perfect. I am being given my own runway, almost 2 miles north of my jet-engined brothers. A jewelled city gradually slips by below as the airport lights grow nearer. I feel as if the controller is sitting next to me, very matter-of-factly asking for my present location, telling me what landmarks to follow and where I can expect to see other traffic. And after touchdown, "Welcome to Toronto." How wonderfully easy. I couldn't have felt like a more welcome guest.

Having gained confidence with airport procedures, I visit the control tower unit-chief to discuss my intended, but not so normal, departure scheduled for the following morning at 5:30. A departure sequence, taped to my instrument panel, starts with a six-minute taxi and then a wait for my ground crew—an Air Canada operations truck and video cameraman. Given 10,500 feet of runway, I am curious to see how many takeoffs and landings I can do in a single pass. Even with a stiffening, quartering tailwind, I complete at least a dozen "flights" before climbing for altitude. By agreeing to stay south of the incoming arrivals, I am allowed fifteen minutes of circling over the main terminals buildings. Three rolls of film later, I head south for Toronto Island Airport, across a city still mostly asleep. Conversation with my it-almost feels-like-I-know-you controller provides a morning smile at this point.

"Echo Charlie Victor (my call letters), let me know when you reach Dundas," he asks. (Dundas, of course,

is a city located 30 miles in the other direction.)

"Negative on Dundas, sir. My destination is Toronto Island."

"Echo Charlie Victor, that is Dundas *Street,* your reporting target."

Dumb. Dumb. Dumb. "Understand... approaching Dundas just ahead."

What amazes me time and again is how accommodating the air traffic controllers can be. Ultralights are a rare sight around large airports, and more than a few voices express surprise when I announce my arrival and request permission to land. I remember approaching the controlled airspace that surrounds Ottawa airport and asking for permission to fly through the zone. "Say again your aircraft type. Hmm, an ultralight. I guess you probably don't have a transponder [a radio signalling device to indicate my altitude and exact location] on board. Okay. Maintain two thousand and steer zero-seven." A few minutes later, "Do you have the threshold for two-five in sight? Steer for that heading." And finally, "Contact Rockcliffe Tower 122.8, and nice seeing you."

Grenfell, Saskatchewan, has to qualify as the most laid-back air strip in Canada. I arrive at 11:45 A.M., fly over mid-field to check the wind sock, and then circle downwind for landing. Located precisely in the centre of the single grass runway are a tractor and mower moving slowly toward one end. As I line up on final approach, I am surprised to discover that the driver has not yet moved to one side. I can only assume this is old hat for him—he's been doing this for years and is an expert on last-minute airplane avoidance. Obviously, he'll pull over at the last instant and not waste any more time than is necessary for my slow arrival. I am now down to 200 feet, but he still hasn't deviated from his course. I'm beginning to wonder, is he completely nonplussed or is this a game of chicken? One hundred feet—his tractor hasn't budged! This man is definitely making a statement

as to who was there first. I quickly add power and extend my glide path to miss him. When only 50 feet directly overhead, I pull back the throttle and yell down as loudly as I can. He doesn't flinch, but continues to stare impassively at the grass directly in front of him, persevering with his methodical task. I land uneventfully, and as I taxi to the tie-down area, glance back at this most casual air traffic controller. He reaches the end of the runway, turns onto a laneway, and heads for home. It is noon and time for lunch. Not once does he look back. If perception is reality, no plane has landed on his runway. Nothing new has happened in the life of this small prairie town on this hot and lazy day.

My arrival at Weyman Airpark, a 3,000-foot strip in New Brunswick, becomes almost a matter of tonnage rights. It is a heavily wooded area, and I radio in from 2 miles back to announce my intentions. "Oh, there's no rush," replies one of the local pilots over his hand-held radio. "There's a bull moose on the runway right now, and you might want to wait till he decides to move on." The moose is obviously in no hurry, and for as long as he stands on the centre line, neither am I. Years ago, I witnessed the results of a rendezvous between a moose and a car on a Northern Ontario highway. I don't need to be reminded that I am flying an aircraft that is ultra-light. No competition for this ultra-heavy, who looks as if he owns the place. I have plenty of time for a several passes over the runway and a half-dozen photographs before he finally ambles off into the bush and I am able to land.

Summerside International Airport, in Prince Edward Island, adds a fine twist of humour to my logbook. I am circling at 500 feet, photographing hay bales near one of the runways, when the captain of a scheduled flight announces his arrival over the airwaves. Summerside radio acknowledges his intent and also advises him about my activity. "Check remarks on the ultralight," replies the captain. "Don't worry, we have him in sight, we won't

hit him. That's why they pay us the big bucks."

My favourite air-to-air conversation happens over Quebec City. Once again, it is another early-morning arrival into the control zone and a request to circle the city for photos. My request is acknowledged. The surprise is the guided tour. By this time, the controller has me pegged on radar. Flying at 35 miles per hour upwind, I'm not exactly racing across his fluorescent screen. His voice, delightfully French Canadian, cuts through the hazy morning sky. "I tink I 'ave you on radar and right now you are approaching da two bridges, right? So, you are interested our city? Well, on your right you gonna see two types of distinctive architecture. The first was brought to us by the French in the late 1600s, the other being much more contemporary. You will notice on your left, about nine o'clock, some large brown buildings...." And so we share in this wonderful impromptu tour of the city of which he is so obviously proud—me, at 1,000 feet, winging through the morning air, while he has his comfortable morning coffee in a glass-walled office 7 miles away. Conversations between strangers don't get any better than this. What a fine way to bridge some of the cultural barriers that have sometimes limited us in celebrating a unified Canada. I feel a warm glow inside as I think about this conversation for the rest of the day.

<center>⇒>●<⇐</center>

Another five-day weather delay before there's a chance to fly. Even so, I wait till early evening before the head wind slows enough to allow an attempt for Moncton, New Brunswick. To add to the variables, my engine once again switches to "periodic rough," after three days of smooth running. I climb for altitude and decide to push on, anxious to catch up on a self-imposed schedule that is slipping further and further behind. At 1,500 feet, the haze precludes any serious photography, but I can't compromise safety for photos. Other than adding another 90 miles, the trip will be a worthless chapter in the project. Little do I know that the biggest surprise of the day is still to come.

"Moncton Tower, Charlie India Echo Charlie Victor is seven miles back at one-point-five, in-bound for landing." Thus begins this unexpected adventure. An Air Nova Dash 8 readies for takeoff as I descend through the last 500 feet. Fully aware of the air blast from its turboprop engines, and not wanting to delay its departure, I inform the tower that I'll roll past the intersection and the Dash 8. Power off, slide slip, I line up with the runway and pull back on the stick, waiting for the slight jolt of wheels on tarmac. Something's not right! Why is the right wing dipping down? What the... And then everything stops. Silence. I sit slightly askew on the runway, and a foot lower than I'm used to, directly behind the Dash 8 still waiting for takeoff clearance. A quick glance down explains every-thing. Painfully so. Two wheels have taken the day off and sit unperturbed above the abrasive run-way. A gear-up landing. What happened? How badly have I damaged my airplane? How do I explain this to the tower? What next?

"Moncton Tower, Echo Charlie Victor has a gear problem and is momentarily disabled." I try to downplay this embarrassing state of affairs while my jumbled brain tries to grasp what has happened. The controller advises me to wait. I have little choice, not having informed him I need a wheel-chair before I can even get out of my wounded bird. The radio chatter continues, vectoring arriving air-craft to the other end of the runway and tracking down my ground crew. I wait for what seems for-ever in the middle of all this space, and bound not to move one inch in it. Suddenly, with roaring, belching black diesel smoke and red lights flashing, three airport firetrucks charge out of their berth and race toward me. They lurch to a halt, surrounding me on three sides, corralling this wounded calf in

the middle of the runway. What am I to expect? To be buried in 5,000 gallons of fire-smothering foam? Really, gents, I wasn't exactly planning on going anywhere.

"Are you hurt? No? Good. Well, welcome to Moncton." And then there is talk about ultralights and where are you from and where's your ground crew and we should get this thing off the runway. Five people and 30 seconds later, the wheels are locked down once again. "Moncton Tower, Echo Charlie Victor is now ready for taxi back to the ramp." This is surely the most embarrassing radio transmission of my life.

Safe once again in the hanger, we do a quick evaluation of the damage. It's surprisingly light. Nothing structural, just one small crack in the hull that's easily repaired with a couple of layers of fibreglass. The integrity of this aircraft is amazing. A good 500 pounds grinding to a halt on just a few square inches of fibreglass, and it's not even worn through. A closer look at the gear mechanism reveals a burred edge where the locking pins failed to slide into place to lock the wheels. Twenty minutes of filing, a little lubricant, and it's ready for the sky once again. I wish it were that easy for me. My emotions have ranged from disbelief to embarrassment. That evening, a local pilot takes me for a flight in his open-cockpit homebuilt. As we line up for landing on Runway 11 and slide over the threshold, I glance down to see two short white fibreglass skid marks on the runway—a reminder that flying will never quite empty its bag of surprises.

During this venture, I gained insight into at least one aphorism: The person who once said that there are lies, more lies, and then weather forecasters must have been a Canadian pilot. Notwithstanding farming or a weekend junket to Vegas, planning a flight based on weather forecasts has to be one of the great gambles in this country.

I have had questions about this profession for some time, particularly when I've had to shovel four inches of "sunny skies" out of my driveway. But the real turning point came when I was weathered in at a major East Coast airport.

I'd been there for five days, waiting for the heavens to open up. Finally, at 7 A.M. on the 5th day, I reached the local Flight Service Station on the phone. The authority in the man's voice certainly didn't suggest he doubted his own message. "Continued light rain-showers," he said. "Rain?" I asked. There wasn't a drop on the parking lot, and from what I could read of the sky, none within 50 miles. Amazing. I was speaking to someone in a building just 500 feet away, and yet we had completely differing interpretations of the skies. I had to wonder: Was he locked in a basement office deprived of any outside windows? What if he had just driven to work in his Miata convertible and wasn't wet? Would he would still have to read the official forecast, "continued light rain-showers"? Where had the system gone wrong?

Not that forecasters have an easy task. Their work is hardly a hard science. Within the last couple of years, scientists have even given us the "The Butterfly Theory," developed, I assume, to generate empathy for weather forecasters. Why the butterfly got nabbed to explain this problem isn't clear, but my interpretation of the theory goes something like this. A butterfly sets out for a local cross-country flight somewhere over the steppes of Outer Mongolia. If he knew the consequences of his trip, of course, he would never have left home. Three hundred feet en route he suddenly changes direction, an impulsive decision to drop in at Tom's Nectar Diner. And that's where the problem originates. His wings beat an extra 300 rpm as he banks left. A vortex spins off his wingtip, mixes with the unstable air, and initiates a series of increasingly complicated meterological developments. Back at Tom's Diner, of course, our

friend is just polishing off another floribunda rose stamen and is oblivious to the reaction he's just set off. And without the Weather Channel, he'll never hear the news a week and a half later. His little course-correction manoeuvre has replicated itself exponentially into madness and halfway around the world a force nine tropical storm is bearing down on the Texas Gulf shoreline.

When computer databases become sophisticated enough to log the worldwide flight paths of butterflies, we may no longer need weather forecasters. In the interim, we'll have to work at the dubious relationships most of us have with these people. Twelve million species of butterflies will continue to make their work anything but easy.

In my two summers of searching for fair-weather flying days, I also learned this: Each locale perceives its own weather patterns to be unique, quite unlike any other part of Canada. The most overworked cliche I heard was, "In this part of the country, if you don't like the weather, just wait five minutes."

I recall being stuck in Ottawa for five days, waiting for some clear skies, when this insight was first passed on: "You have to recognize that the weather here is unique. Systems get trapped in the valley and can't move on because of the Gatineau Hills. Once you're out of this area, you'll be fine." Fair enough, let's move. With the first marginal flying day that came along, we headed through Quebec, up the St. Lawrence, and in two days arrived at Riviere-du-Loup. By then, of course, we had used up our quota of fair-weather points and we were dumped on again. Another five days of rain, fog and incessant winds. We should have anticipated the explanation proferred by the local soothsayers. The rough French-English translation went something like this: "This place is unusual because the weather gets stuck between the mountains on each side of the river. It can be bad like this for days. If you can just get over the ridge south of here, you'll be fine."

What added even more flavour to this particular location were the Laurel and Hardy responses from the two local weather-briefers. One worked the day shift, the other nights. Typically, calls made in the evening were responded to with the kind of encouragement we were looking for: "No problem. Tomorrow looks good. Winds will be dying down and it should be fine by noon." And then a phone call the next day to find out why we were still wearing our raincoats: "Sun? Oh, you must have been talking to the night guy. He tends to be overly optimistic." Rain or sun, it seemed the choice was ours. It was simply a matter of which operator we wanted to speak to.

<hr />

I t often seems to happen like this—one must first pay homage before being blessed. After sitting in Windsor for three days, my patience has been tried once more by grey skies, rain and winds. But it's worth the wait, for today is a day of heady perfection.

This 200-mile flight along the Lake Erie shoreline will take me to Port Rowan, town of my childhood. The day unfolds in a series of stunning scenes, and in just four hours, I shoot eighteen rolls of film. A high-pressure ridge has stabilized over the province and there is not a breath of wind. The results are exquisite. Early morning ground-fog drapes delicately over the land, offering just a hint now and then as to what lies beneath. At 6:30 A.M., there is only a sense of the sun, a pink glow, distant and faint on the horizon. But it is the simplicity of the Lake Erie shoreline that I fall in love with. Without wind, not a wave exists, and the water has settled into a surrealistic blue-green. It reminds me of flying over the Caribbean islands. Never have I seen such pure colours in this lake.

I become lost in the images in my viewfinder, almost forgetting that I am flying. The spell is only broken by the blinking icons in my T-90 Canons,

reminding me to feed them more film. The experience is so wonderfully intense that it takes several hours after I've landed before my mind finally touches down as well. Lying in bed that night, as I try to shut down the mental activity, the stronger images of the day keep sliding into focus—an unusual combination of still images that carry their own inherent motion. Perhaps that's not surprising, in that it reflects the uniqueness of this kind of photography.

In landscape photography, the process is virtually static other than arriving at the location. Aerial photography, especially at lower altitudes, creates its own dynamics. Multiple images flash by at 50 miles per hour in this "fast forward" movie. Within this dazzling demonstration are individual scenes that suddenly jump out and wave for attention. These are the scenes I try to grab as they flash by underneath. I hope in one thousandth of a second to arrest one picture in this wonderful movie. Perhaps it is this inherent contradiction of motion that cannot be stopped, that makes this process so exhilarating.

Traditional aerial photography generally works best as a team effort. One person flies, the other photographs. For low-level work, however, that process falls apart. At minimum heights, everything happens too quickly and there simply isn't enough time to pick a target, choose a shooting angle, communicate this to a pilot, and then shoot. Flying and setting up the shot must be fully integrated.

When I discover a "must" subject, the line between my flying and shooting virtually disappears. Having determined my shooting angle based on light direction, I quickly check for potential hazards such as hidden hydro lines or rising terrain, bank the aircraft, and arc toward my shooting point. As the scene approaches, I grab the camera in my right hand and fly with my left. At this point, the flying becomes reflex, having predetermined my flight path by the direction of both wind and light. The scene grows rapidly in my viewfinder as I wait for the right moment of composition and balance. There. Click, click, click. Three shots in less than two seconds. I quickly drop the camera, jam the throttle forward, bank the aircraft through a 180-degree turn, and approach the target from the opposite direction. Another pass, more images.

The straight-down vertical shots, which are often my favourites, are also the most difficult to take. It begins with banking the ultralight in a tight turn while maintaining extra speed. While holding the stick in one hand, I lean out of the cockpit for an unobstructed view. Composition is always a challenge, as the image now rotates in my viewfinder. It's easy to see the centre of the picture. The trick is to note what is happening in the corners of the frame while all is motion. With slide film, there's no opportunity to recompose once the shutter is clicked. There is a lot of information that must be processed quickly as I simultaneously deal with the mechanics of flying and the more subjective element of photography. It is only when I'm back on the ground and photographing with a tripod that I truly appreciate the challenge of this kind of high-speed composition. The tripod is a luxury, allowing what seems an eternity to evaluate, compose and execute a shot.

For reasons of safety alone, low-level shooting demands complete mental focus. Four hours of this concentrated flying is tiring. Altitude restrictions have to be observed, depending on the terrain. Even though ultralights fly much slower than conventional aircraft, it's amazing how unseen wires and trees can jump out of nowhere. Safety is foremost. I once heard of a pilot in Alaska who went in especially low to photograph a large brown bear. Annoyed, the bear struck back, damaging the plane enough to send it back for an emergency landing. The bear, I'm told, was unable to fish for a week because of a sore paw.